IMAGES
of America

TRENTON

IMAGES
of America

TRENTON

Linda Mierzejewski
for the Trenton Historical Society

ARCADIA
PUBLISHING

Published by Arcadia Publishing
Charleston, South Carolina

Library of Congress Control Number: 2012938914

For all general information, please contact Arcadia Publishing: Telephone
843-853-2070
Fax 843-853-0044
E-mail sales@arcadiapublishing.com
For customer service and orders:
Toll-Free 1-888-313-2665

Visit us on the Internet at www.arcadiapublishing.com

*This book is dedicated to the people of Trenton, Michigan—past,
present, and future—and to those who help preserve Trenton's history.*

CONTENTS

Acknowledgments 6

Introduction 7

1. From Swamp to City 9

2. Battles of the War of 1812 23

3. Prominent Folk 27

4. Shipbuilding 53

5. Making a Living 61

6. How to Get from Here to There 91

7. The Good Life 101

ACKNOWLEDGMENTS

Images of America: *Trenton* benefited greatly from the authors of *Truaxton, Truago, and Trenton*, published in 1976, and from Lucy Armstrong Shirmer for *Snug Harbor, Early Trenton by the River*, published in 1983.

This book also could not have been published without the help and support of many hands. Thank-you to the Trenton Historical Society, Carol Hendricks, John Holmes, Bill Olson, Peter Poulos, the Trenton Historical Commission, and to all those who provided images and information from their private collections.

A special thank-you goes to the Trenton Veterans Memorial Library for the use of its local history collection for our research.

Images, except where noted, are from the collection of and appear courtesy of the Trenton Historical Society. We hope this book about Trenton will inspire its residents for years to come.

INTRODUCTION

The area that comprises present-day Trenton was the home of the Potawatomi Indians. They hunted, trapped, and fished and planted corn, beans, squash, and melons. Other tribes living around Trenton were the Wyandot, Iroquois, and the Huron.

When Antoine de la Mothe Cadillac landed at what is now Detroit in 1701, roads were unknown. Travel was done primarily by water, and any communication to the interior was done via Indian paths.

To journey to Michigan and the Northwest Territories from the East, three main routes were used. The best option was by way of Niagara, New York, through Canada and then across the Detroit River. The second route was by land, which followed the southern shore of Lake Erie, where one had to struggle through an area known as the Black Swamp. The third route was by water, which took travelers across Lake Erie by ship from Buffalo, New York. This was risky because of storms and high seas well known on the lake; many ships were lost before reaching their destination.

In the late 1700s, due to the push of settlers to open up the West, the Michigan Territory became part of the great frontier for homesteaders. The government sold the land for $2 an acre. It also gave land as a bounty to those who fought against England in the Revolutionary War.

In 1812, the British carried out searches of American vessels for British-born seamen to man British war ships. The added impressments of several thousand American sailors were the primary cause for President Madison to order British ships away from the American coast. In June of that year, an uneasy peace between the British and Americans ended when President Madison declared war against England—the War of 1812, which is also known as "the Forgotten War" and the "Second War of Independence." This was hard time for Michigan and Trenton, as the Detroit River was the only separation between Canada and the United States. Many friendships and intermarriages occurred among the French, English, and Americans as well, as the Native Americans living on both sides of the river.

In 1816, Abram Caleb Truax, who served under Colonel Hull and was a bounty land surveyor from New York, acquired a large tract of land that became Trenton. In 1834, he platted the land for the village and named it for himself, calling it Truaxton. A few years later, in 1837, the name was changed to Truago. It was derived from a swamp disease carried by mosquitoes and called "the ague," which afflicted settlers in the 1800s. When the swamps were eventually drained, the nickname "True Ague" was corrupted to Truago, an infamous reminder of the disease. Ten years later, the name was finally changed to Trenton in honor of the type of special limestone strata underlying the town. In 1855, the village was incorporated, and Abram Truax became the first township supervisor and postmaster.

By 1880, Trenton's population consisted of 1,103 citizens, and as the village of Trenton grew, farming gave way to diversified manufacturing.

Due to its location on the Detroit River, Trenton was also an important shipbuilding area. Many vessels that have gone into nautical history were built in the village between 1866 and 1917. At

one time, 250 to 350 men were employed in shipbuilding, and there were as many as five vessels on the stocks at once. These were the splendor days of Trenton, with over $1.5 million worth of vessels being built over an eight-year span.

Prior to the 1930s, the village of Trenton was mainly on the east side of Fort Street. With the completion of the viaduct in 1938, many of the farms on West Road were sold and turned into subdivisions for the city's future growth. In 1957, Trenton became a city.

Trenton is located in Michigan's southeastern Lower Peninsula on the banks of the Detroit River. It is bounded by Grosse Ile, across the Trenton Channel to the east, Riverview to the north, Brownstown Township to the west and south, and Woodhaven to the west. In the early days, it was the last high ground from Detroit to Monroe and an overnight stop during a journey from Detroit.

One

From Swamp to City

The Black Swamp ran along the southern edge of Lake Erie from Lower Sandusky, Ohio, and passed through Trenton to within nine miles of Detroit. There were no roads, and the first effort at road building was a horse trail that ran along the west bank of the Detroit River through the swamp known as the French–Indian Trail. This whole area, with a small exception, was Indian land. From Fort Meigs in Ohio to within nine miles of Detroit, the only settlement was at the River Raisin. Settlers bypassed this area not because the land was poor but because it was inaccessible.

Trenton is 16 miles south, downriver from the city of Detroit, and was once was part of Monguagon Township. The township's jurisdiction in 1812 included the villages of Trenton, Sibley, Brownstown, and Grosse Ile, as well as the smaller islands of Hickory, Elba, Calf, Fox, Stony, and Celeron.

Trenton annexed the village of Sibley in 1929, extending the city's northern boundary to modern-day Sibley Road. Trenton's incorporation as a city in 1957 enabled it to receive recognition as the 23rd city in Wayne County, Michigan.

In 1813, Lewis Cass, governor of the Northwest Territory, established the boundaries of Monguagon Township. An 1876 map of the township shows Trenton's location on the banks of the Detroit River. Beyond Grosse Ile and across the river lies Canada. Section No. 19 is Slocum's Island, later named Elizabeth Park. Section No. 7, owned by F.H. Sibley, is the location of the Sibley Quarry.

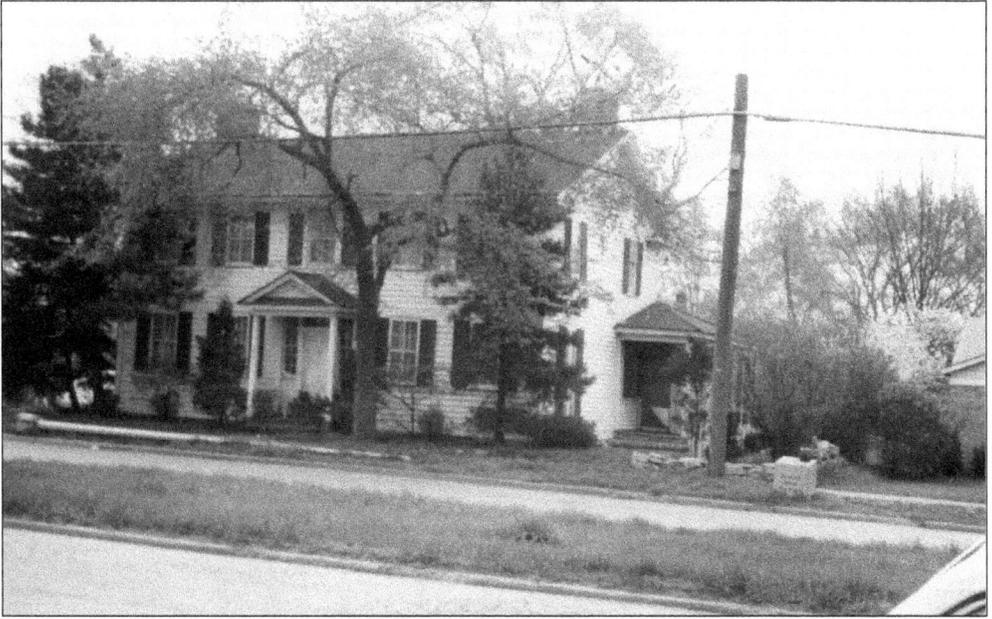

The Truax homestead in Trenton, built in 1820 by Abram Caleb Truax, was called the Halfway House because it was halfway between Detroit and Monroe. The stagecoach line used the house as an overnight stop. The family home also became the location of the post office and town hall. The original house still stands on the land and is now an assisted-living facility called Coach Stop Manor.

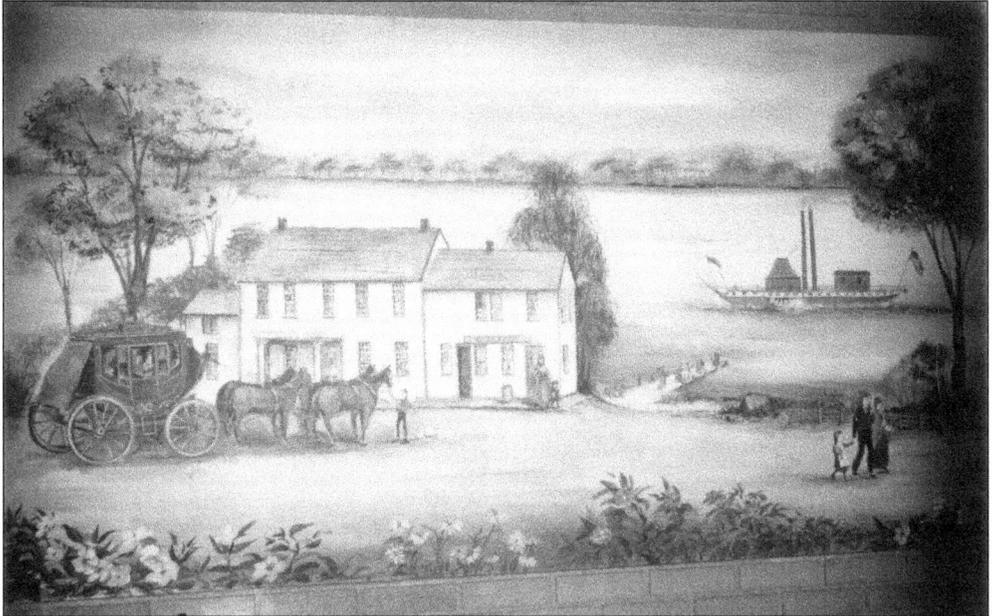

Abram Truax also established a cash-and-barter dry goods store called the Exchange Tavern. Its location on the river served boats and the stagecoach lines by land. By 1830, it was possible to buy safe, regular, and fairly comfortable passage from the Atlantic Ocean to Michigan for less than $10. In 1836, stagecoach fares from Detroit to Monroe through Trenton were 6.25¢ per mile. (Painting by Mary Ann Clark.)

The first Trenton roads were dirt and thus impassable during the winter and wet seasons of the year. Coaches and wagons had to plow through the mud in the spring, and in the summer a fine dust came through open windows. Don Dickinson promoted the purchase of a horse-drawn street sprinkler, which helped keep the dust down.

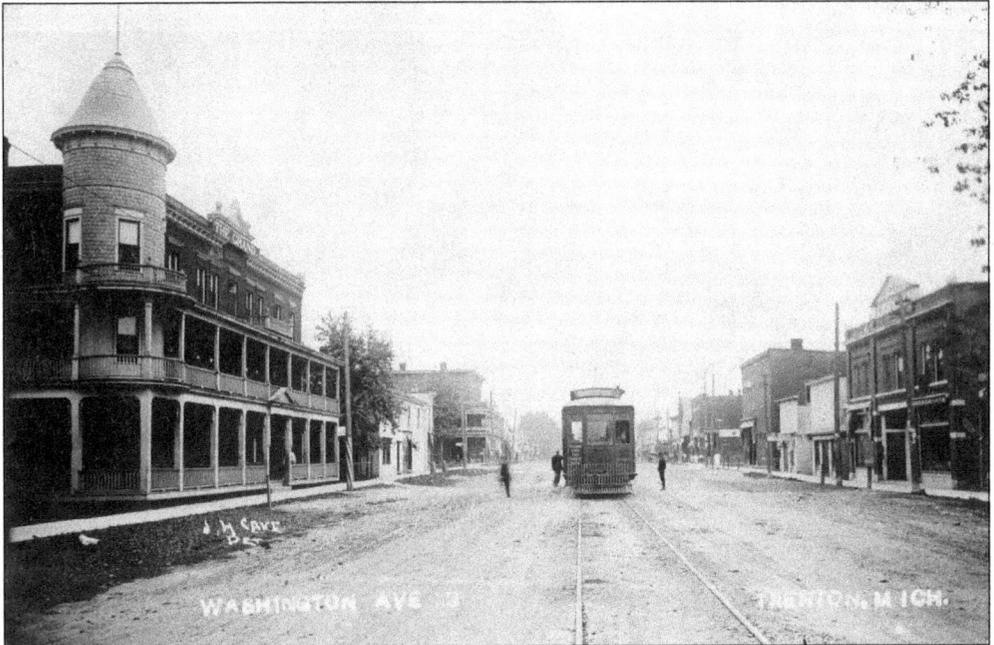

By early 1907, different types of road surface material had been tried, such as dirt, macadam, limestone, and crushed cobbles. Only the main roads were paved. Edward Hines of the Wayne County Road Commission conceived the first highway centerline stripe. In 1911, he painted a white line down the middle of Trenton's River Road (Jefferson Avenue) to keep the two directions of traffic safe. It is said that Hines got the idea by watching a leaky milk wagon leave a white trail of milk down a dusty road.

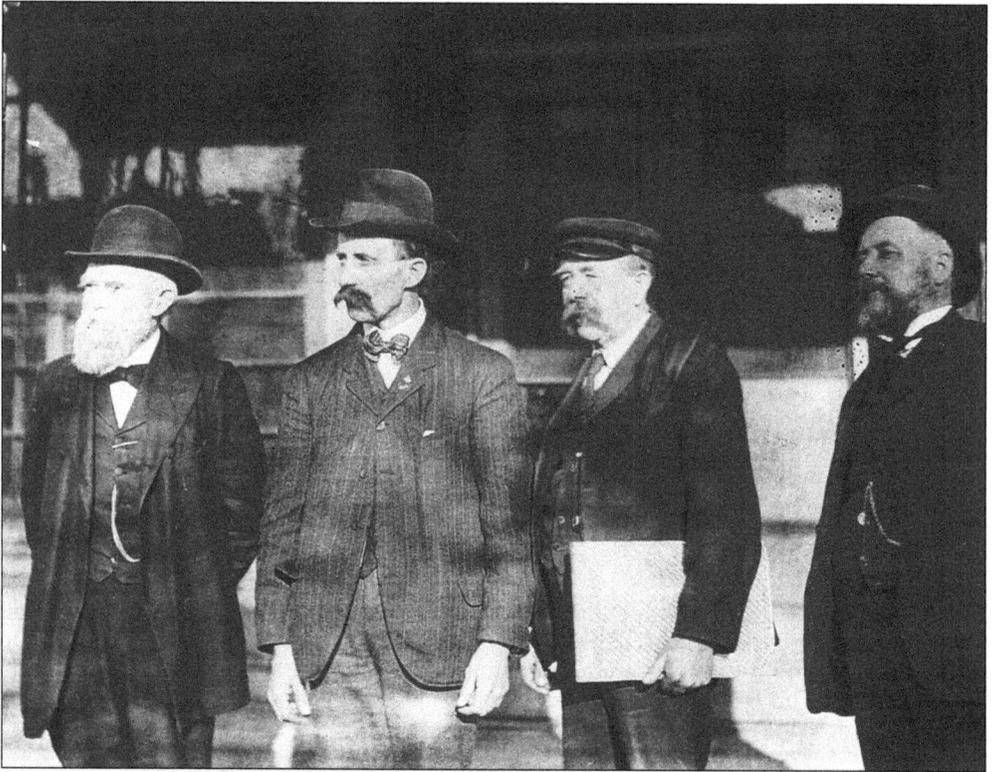

Monguagon Township, Michigan, held its first meeting on May 22, 1827, approximately 10 years before Pres. Andrew Jackson signed the bill making Michigan the nation's 26th state. Members of the 1907–1908 Monguagon Township Board of Supervisors are pictured here. They are, from left to right, Justice George A. Capac Funston, Justice Leonard Frebes, Clerk Theodore Busha, and Superintendent J.L. Anderson.

People did not like the idea of asphalt and believed it was bad for horses. Also, the sound of horse hoofs at night kept sick people and light sleepers awake.

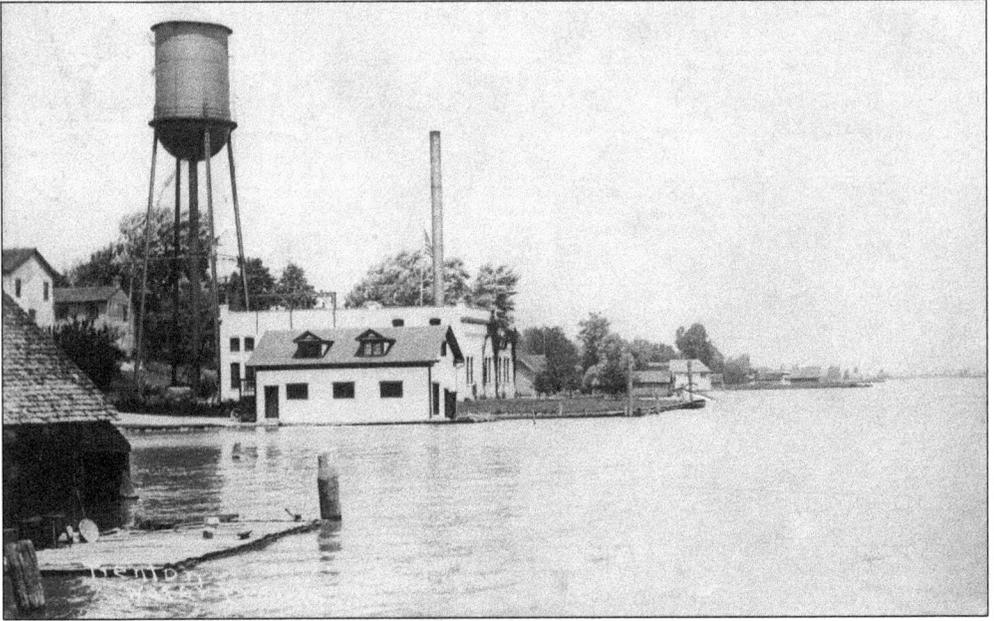

Large river water–filled barrels were hauled around town by horse-drawn wagons. In 1896, the town council approved a bill for a Detroit firm to install a complete water system for Trenton at a cost of $8,900. The Trenton Water Works, pictured here in 1917, was located along the Detroit River and St. Joseph Avenue. (Courtesy of Jeff Wagar.)

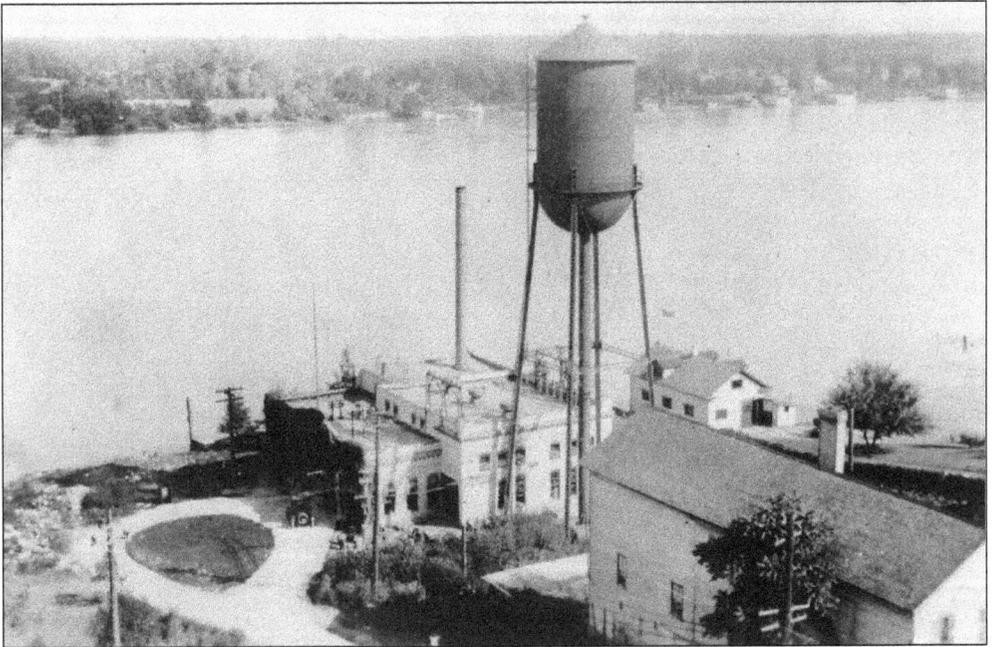

During the summer of 1898, the water main was extended north on Jefferson Avenue as far as the village limits. Water rates were set at $4 per year, and an additional 20-percent fee was added onto all bills not paid within 30 days from the time they were due. Not all homes, however, had running water, and many had the water pipes run just to the house, where a faucet was attached to the outside of the building.

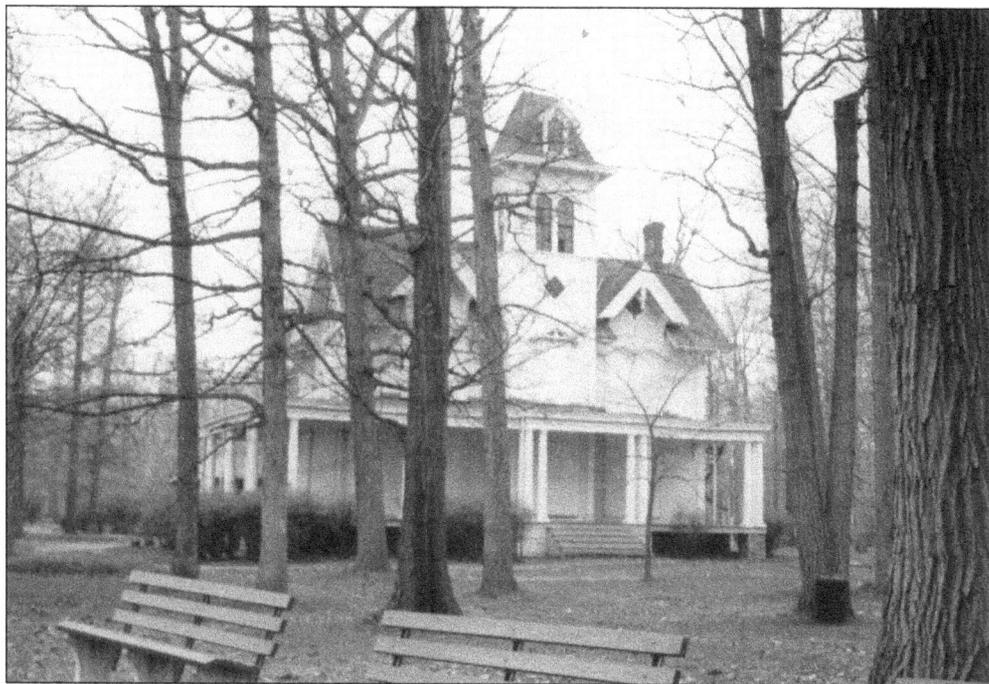

One of the many tracts of land owned by Giles Slocum, the husband of Sophia Truax, was an island separated from the mainland by a canal. There, he built his home. In 1919, the heirs of his daughter Elizabeth donated the estate and island to the City of Trenton with the condition that it be set aside as Elizabeth Park in honor of their mother. The Slocum residence was destroyed by fire in the late fall of 1975.

"Slocum's Island is free to all comers when they wish to camp there, play ball or have a good healthy time generally," reported the *Trenton Times* on August 8, 1913. Seen here being enjoyed by a group of people in 1915, the island made for a fun day. The county installed a 40-foot-wide paved roadway around the island and a 2,400-foot-long public walk.

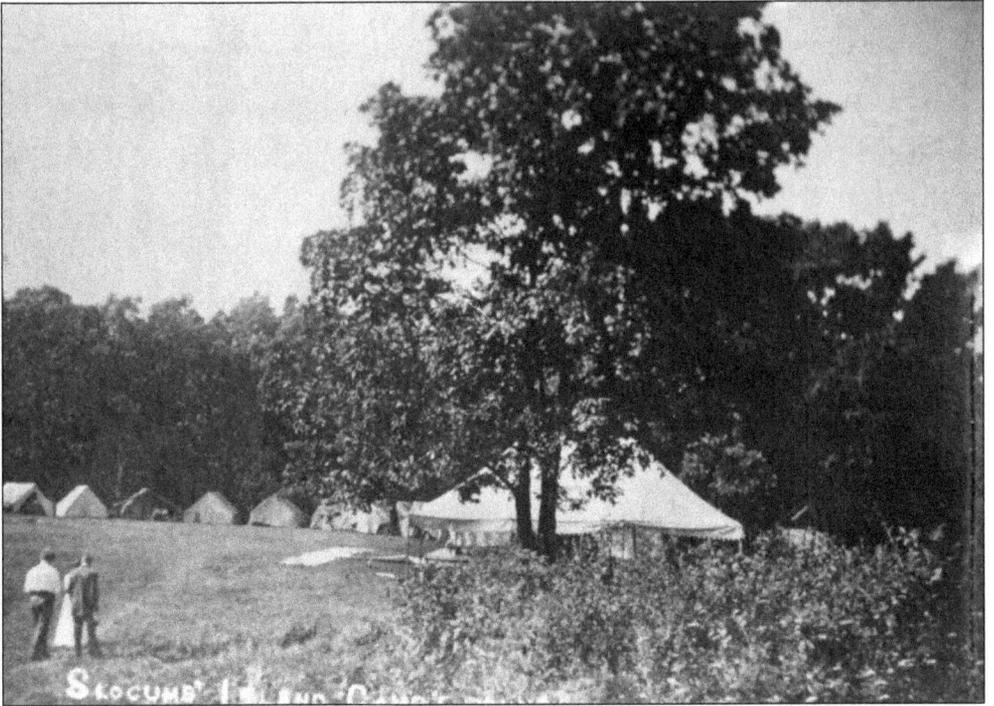

Trenton residents often went to Slocum's Island to walk in the forests, take in the picturesque Detroit River, picnic, and camp. Families dressed in their Sunday best went to Elizabeth Park for strolls, stopping along the shores of the Detroit River to catch the mild summer breeze.

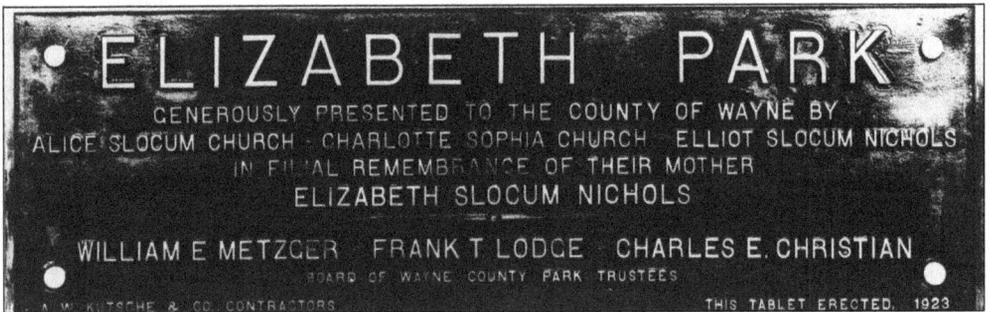

City officials donated the land to the Wayne County Parks Division. Elizabeth Park opened on October 31, 1922, and was dedicated on July 4, 1923. The park occupies 162 acres, with 1,300 feet of riverwalk along the Detroit River, linked to Trenton by bridges. (Courtesy of Jeff Wagar.)

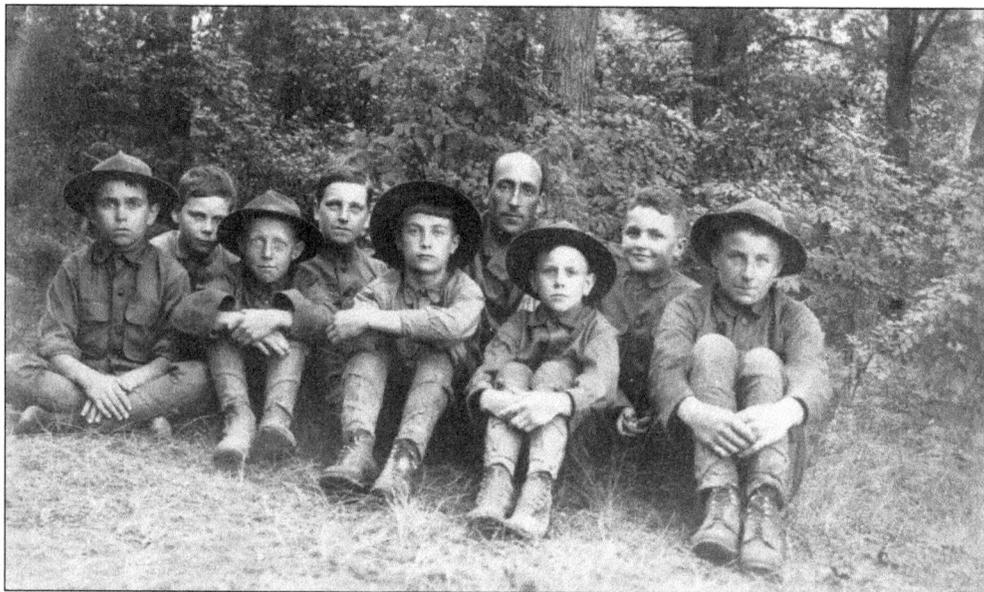

Pictured in 1914, the Trenton Boy Scout Troop often took camping trips to Slocum's Island. Reverend Hershey, a Presbyterian church minister, organized the first Boy Scout troop about 1914. Members pictured here are, from left to right, Gordon Strohm, Elton Discher, W. Hedke, unidentified, James Holden, Reverend Hershey, Wilson Armstrong, Dunton Barlow, and Wellington Lewis.

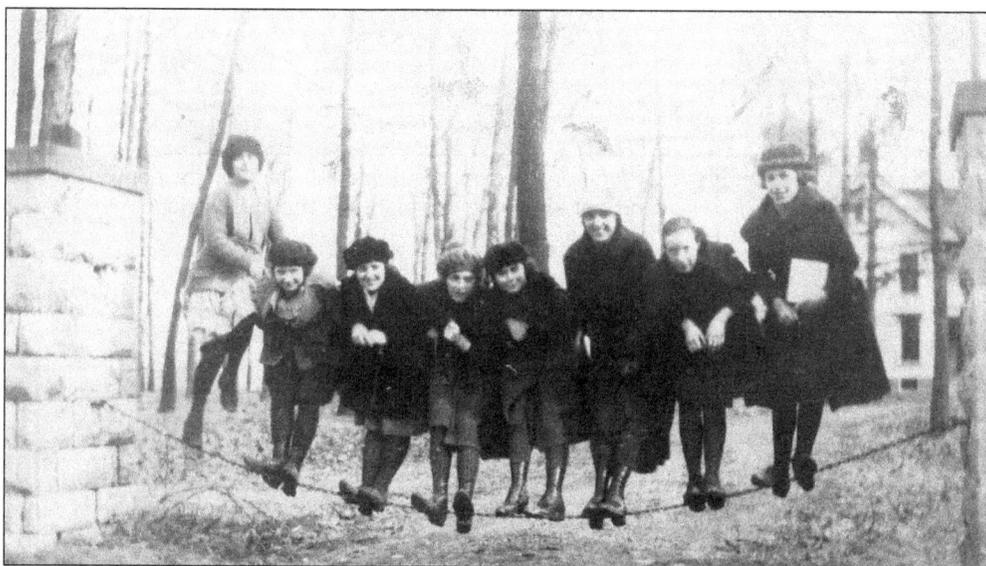

The Trenton Camp Fire Girls also held hikes on Slocum's Island. Camp Fire Girls of America was under the leadership of Myrtle Buck. Members seen here are, from left to right, Edna Brown, Lucy Armstrong, Elizabeth Hornauer, Genevieve Hedke, unidentified, Rose Vickery, Lucy Upper, and Doshia Brockmiller.

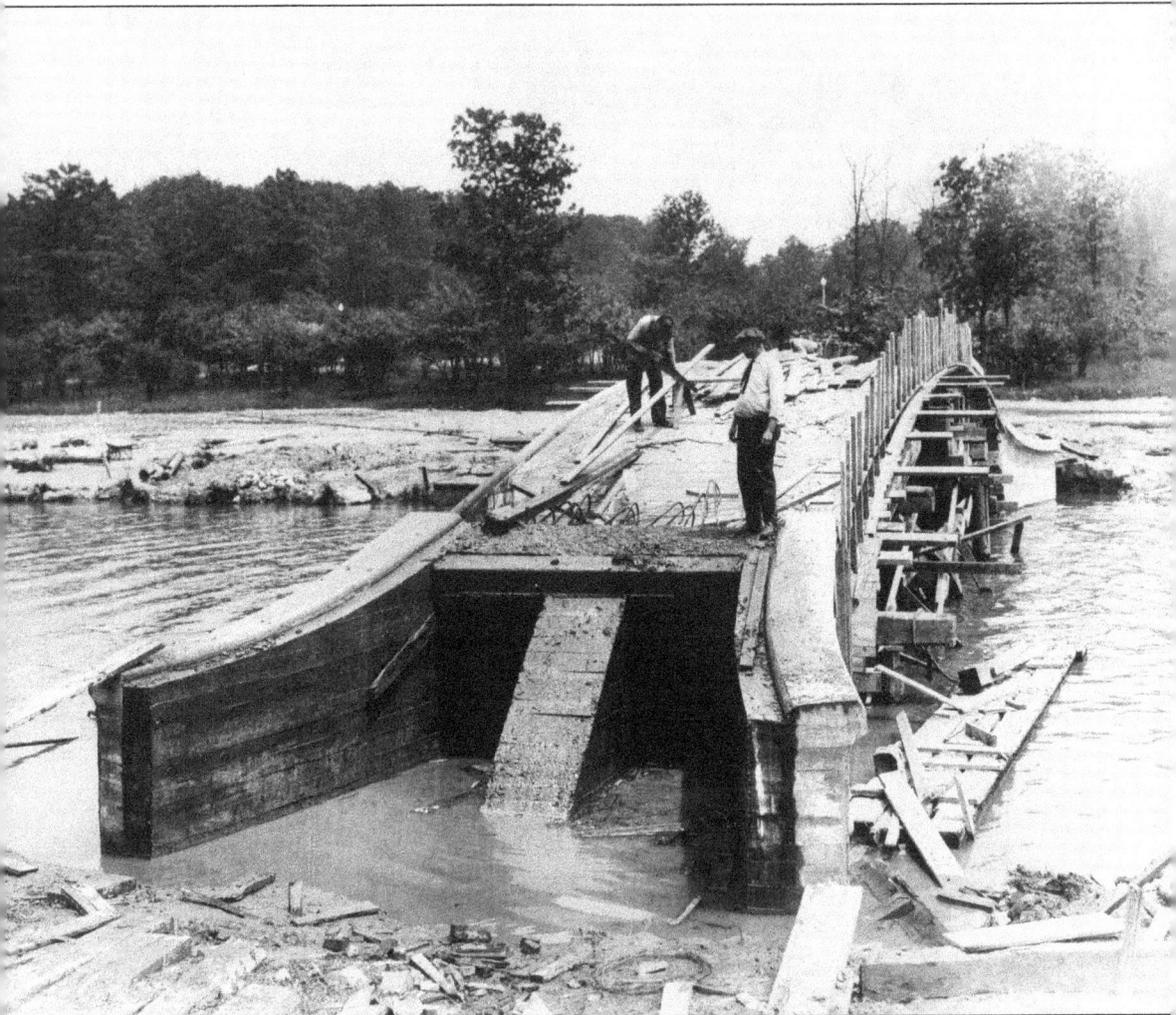

In 1924, bridges were built over several of the canals in Elizabeth Park for the convenience of walkers. In 2012, the US Army Corps of Engineers has plans to rebuild the bridges.

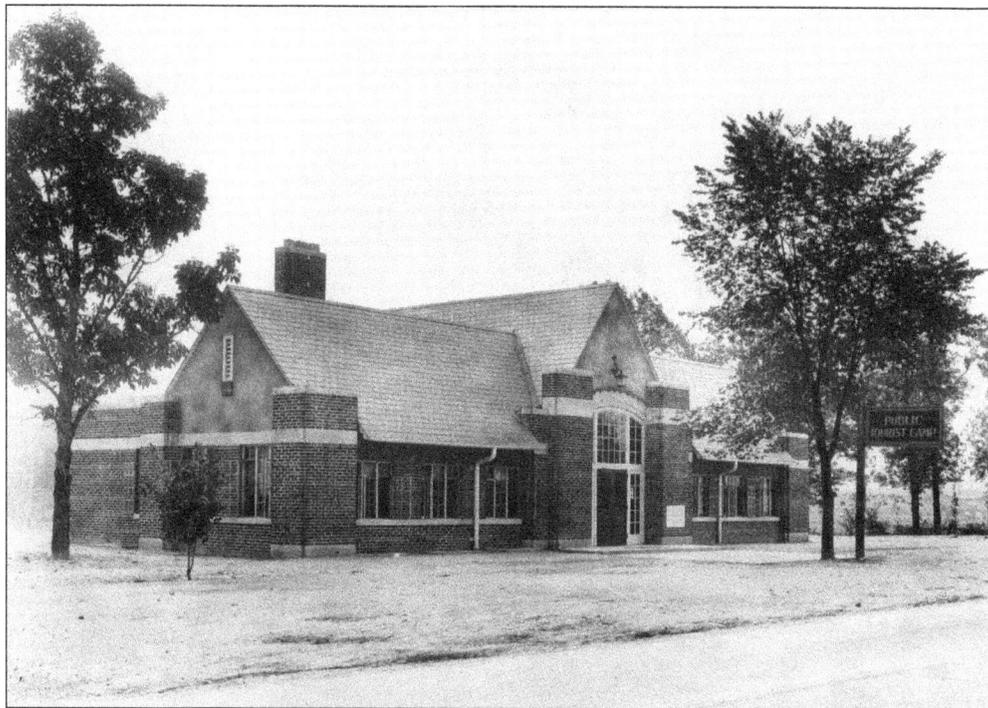

The Elizabeth Park rest pavilion, later the traveler's lodge, was built on West Jefferson Avenue next to the Grosse Ile Bridge.

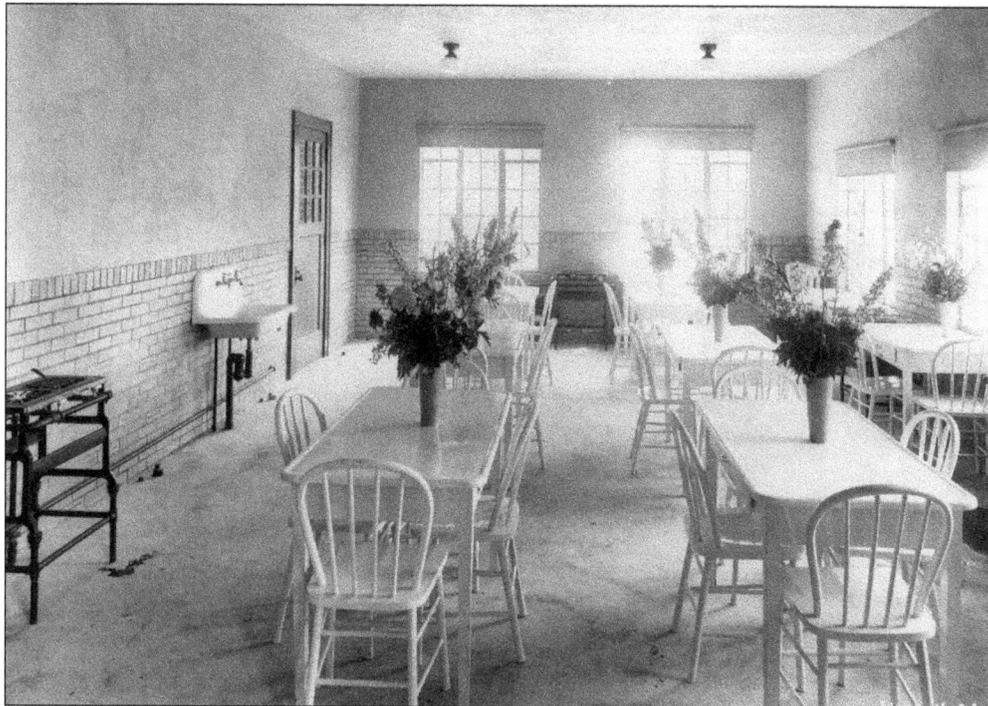

This photograph of the inside of the lodge, taken on June 15, 1925, depicts its accommodations for indoor eating and washrooms.

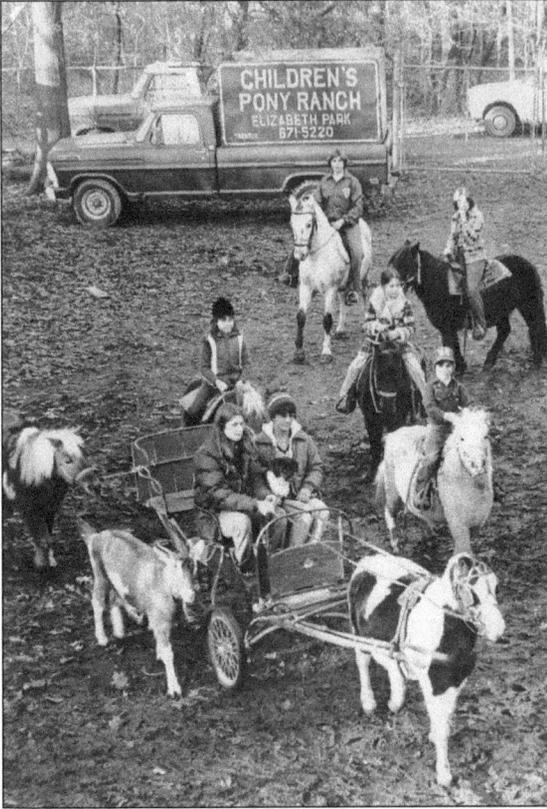

The Children's Pony Ranch at Elizabeth Park has been around for generations and has provided weekend enjoyment for children of all ages. This photograph was taken in 1982.

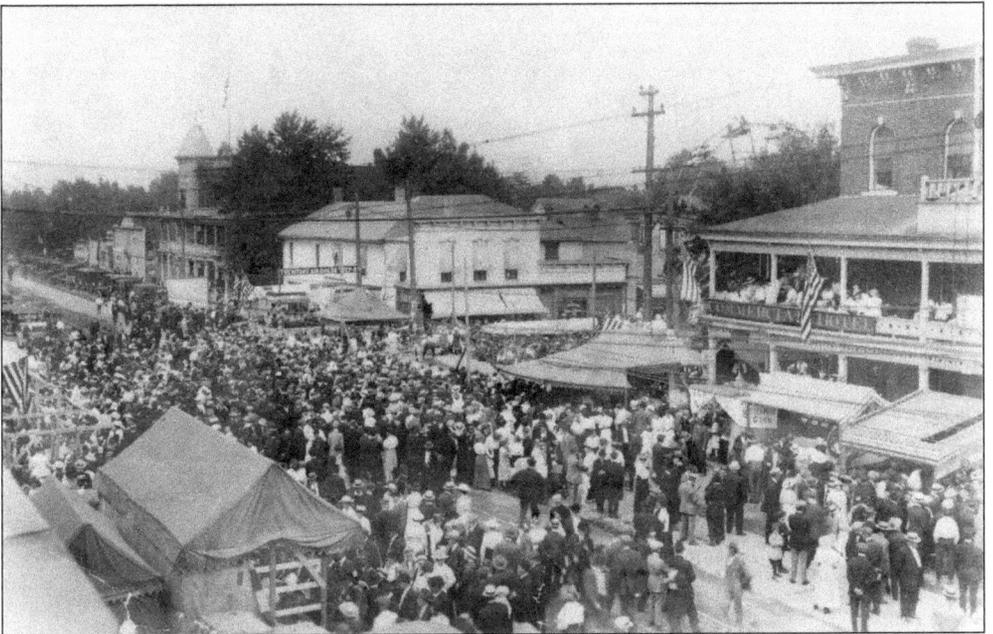

The Monguagon, Brownstown, and Grosse Ile Tri-Township Street Fair kicked off the 1915 summer season with a parade, tents filled with crafts, entertainment, and mouth-watering food. (Courtesy of the Trenton Historical Commission.)

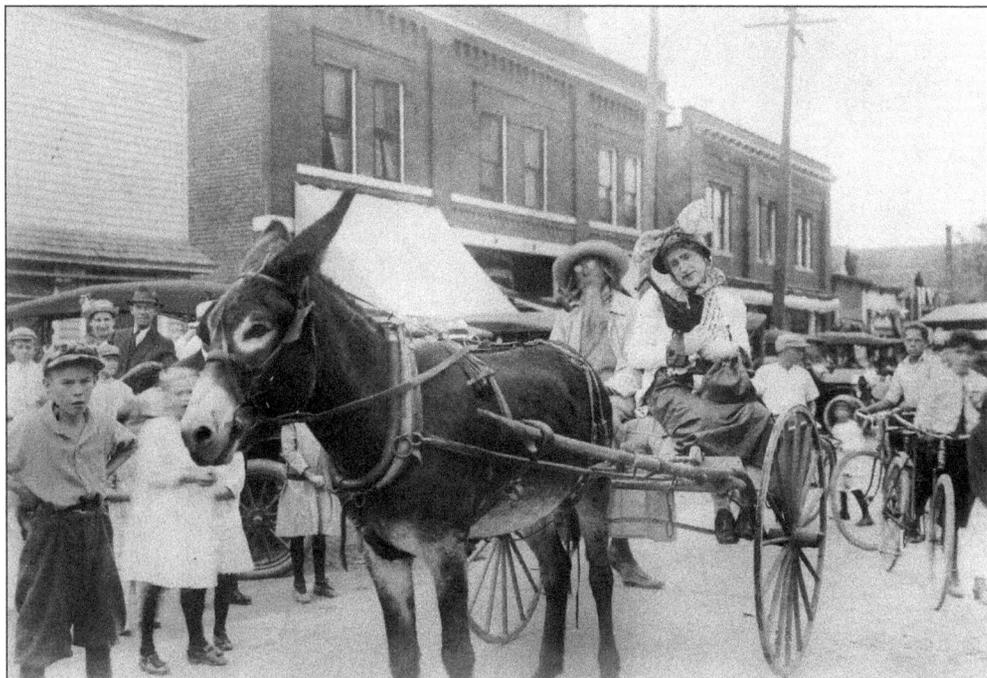

The fairs usually began with a parade with bands, carts drawn by horses or donkeys, clowns, and children parading their favorite pets.

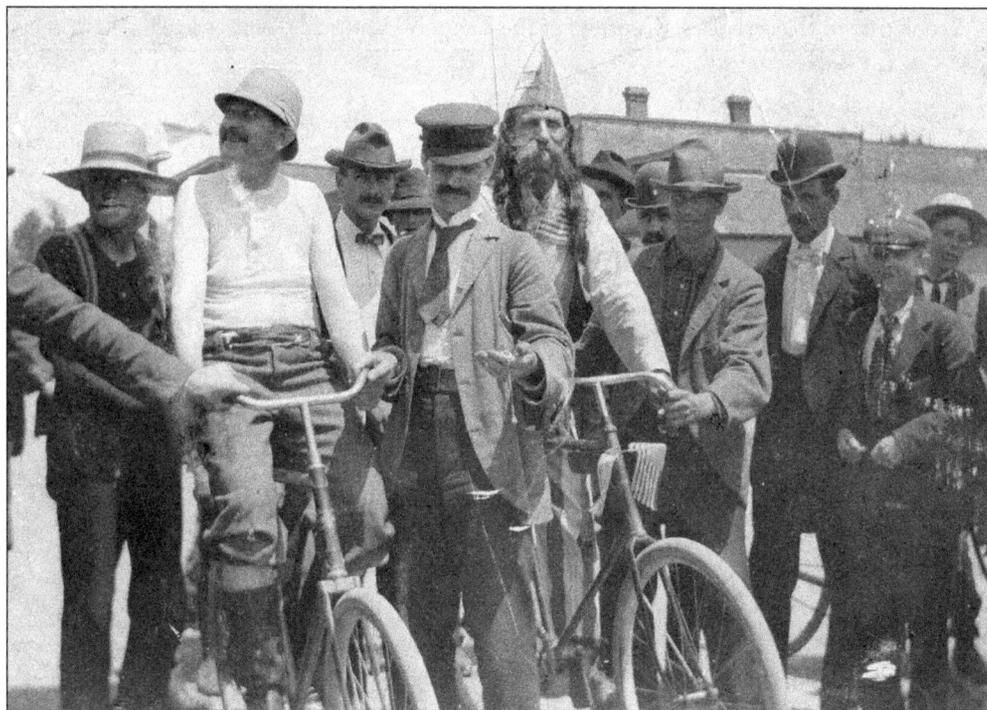

The 1898 Fourth of July parade included a bicycle race. Jake Rieger (left), the local barber, won the race against John Todd (center), the town's funeral director. Rieger's daughter Rosebud Rieger Sanger was one of many owners of the Trenton Hotel.

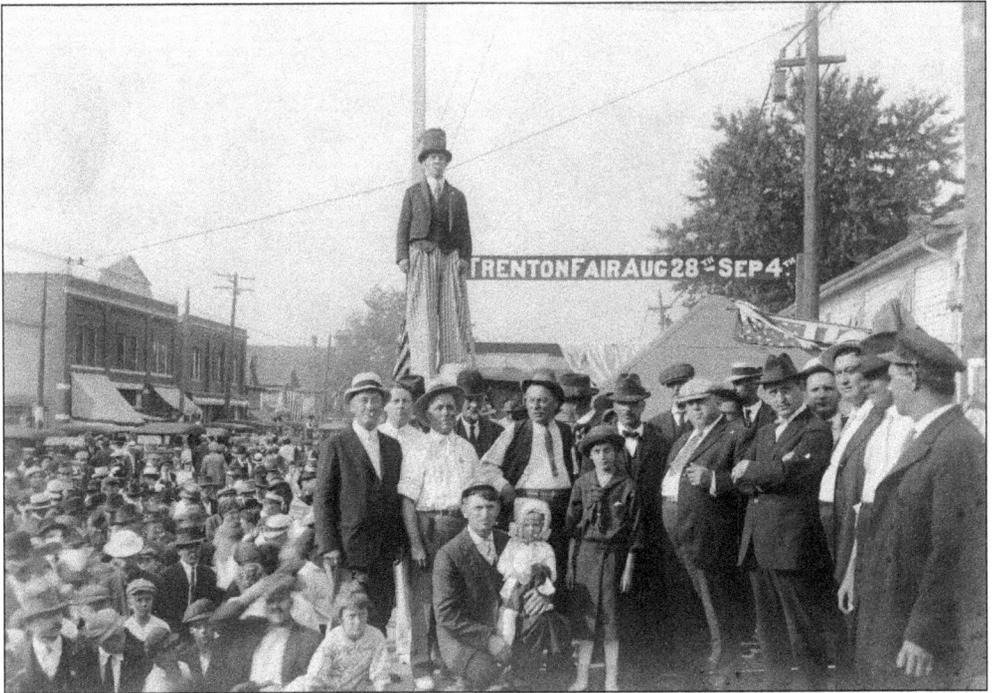

In the summer of 1916, the Trenton Street Fair was held on the main street. Horses and goats paraded to kick off the festival. When bicycles were the rage, residents put on riding costumes and took part in the activities. (Courtesy of the Trenton Historical Commission.)

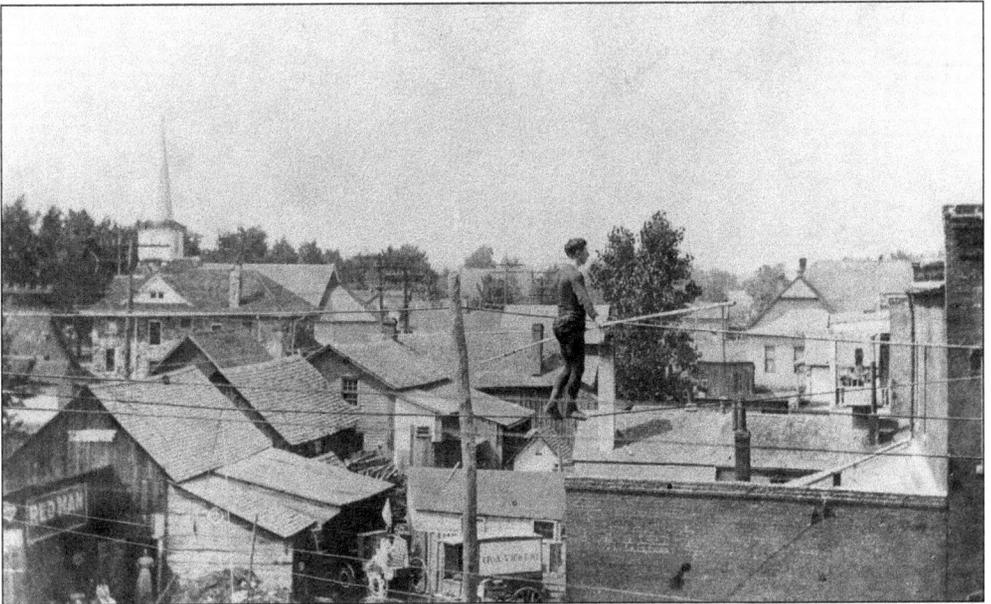

The 1917 Trenton Street Fair also included a performance by William C. Jenkinson, who walked the high wire. After years working for the Ringling Brothers and Whitney Family Circuses, Jenkinson moved to Trenton and opened a barbershop. Interestingly, Jenkinson's death was not caused by the high wire, but by walking into the path of an oncoming automobile. (Courtesy of the Trenton Historical Commission.)

22

Two

THE BATTLES
OF THE WAR OF 1812

Two early battles of the War of 1812 were fought in and around Trenton. The English Navy began stopping and searching American vessels for English-born seamen and taking them by force to man British warships. This was called impressment. Unfortunately, many American seamen were also taken. While these impressments and other incidents were taking place, Col. William Hull was in charge of Fort Detroit, located across the Detroit River from Canada. Colonel Hull was running out of supplies, and the only place he could obtain them was in Ohio.

On August 5, 1812, Hull sent Maj. Thomas Van Horne and 200 US soldiers south to the River Raisin, where they were to pick up cattle and other desperately needed provisions and escort them back to Fort Detroit. Van Horn and his troops were attacked by Shawnee Chief Tecumseh and some English troops. Although the Americans outnumbered the British eight to one, they were defeated. This event came to be known as the Battle of Brownstown. Van Horne ordered a retreat and was able to save only half of his command, and Colonel Hull did not receive his supplies.

A week later, Lt. Col. James Miller, with 600 American troops, moved down the River Road in a second attempt to reach Frenchtown (Monroe) and bring back supplies. At Monguagon, Miller's command found their path blocked by English major Adam Muir, with 205 British and Canadian troops and Native American warriors. In this engagement, called the Battle of Monguagon, the Americans drove the enemy back and across the river into Canada. Although the Americans claimed victory, history debates whether Miller disengaged or actually pushed the British across the river.

Results of the skirmishes of Brownstown and Monguagon caused General Hull to surrender Fort Detroit, with a total of 2,200 men and 33 cannons, to the British a week later. After the surrender, Hull lost all confidence in his ability to command. He was court-martialed for negligent duty, cowardice, and treason. Found guilty of the first two counts, he was sentenced to be shot. Pres. James Madison spared his life due to his Revolutionary War service and advanced age.

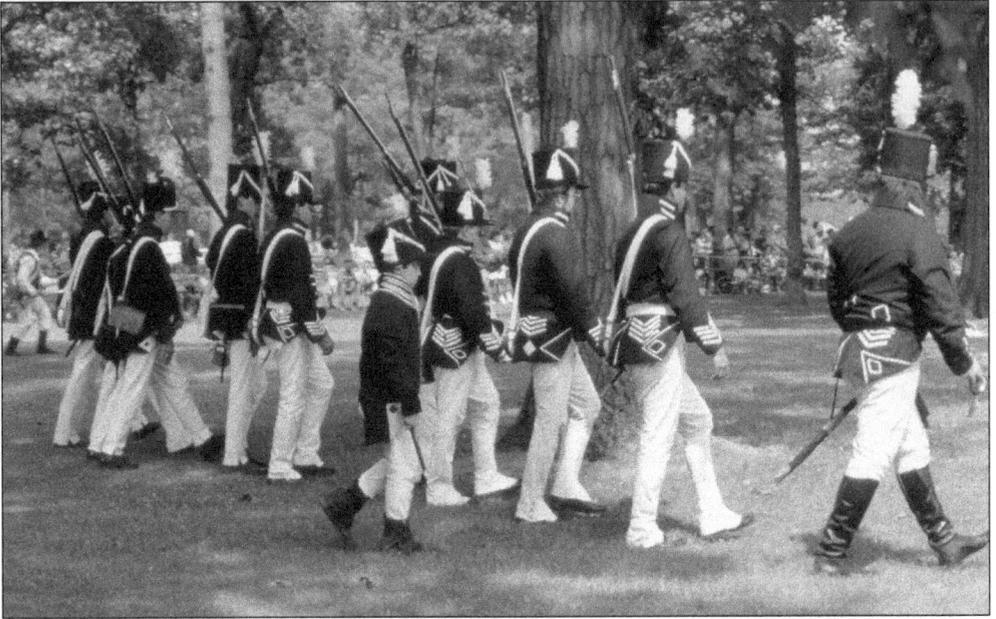

In 1812, when Pres. James Madison declared war on England, Col. William Hull was in charge of Fort Detroit. He received word that Ohio volunteers, under Capt. Henry Brush, had followed the River Road and had arrived at the River Raisin in Monroe with the much-needed provisions. (Courtesy of the War of 1812 Reenactment Committee.)

Maj. Thomas Van Horn, with about 200 volunteers, was sent to meet the reinforcements. Arriving at Brownstown Creek on August 5, 1812, Van Horn and his forces were ambushed by Shawnee war chief Tecumseh, Chickamauga war chief Daimee, Wyandot chief Roundhead, and 24 of their men. (Courtesy of the War of 1812 Reenactment Committee.)

American forces retreated, and a running battle was kept up until the column reached the Ecorse River. A message was sent to General Hull of the disastrous ambush. Of the US forces, 18 were killed, 12 wounded, and 70 were either captured or missing. Only one Native American, a minor chief, died in the battle. Two of Van Horn's officers killed in the battle were Surgeons Roby and Allison. (Courtesy of the War of 1812 Reenactment Committee.)

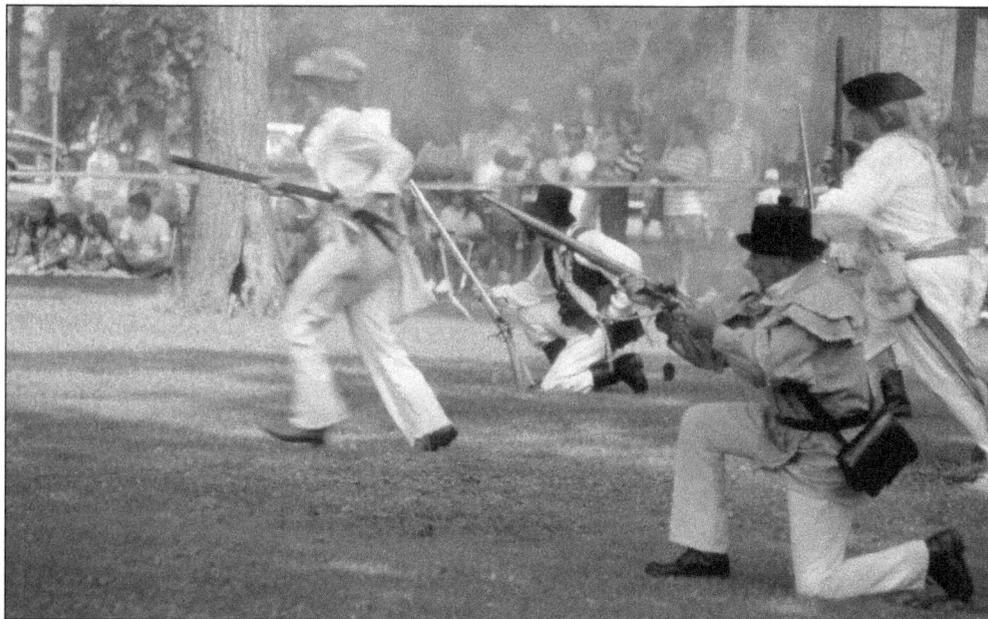

After the skirmish of Brownstown, General Hull was determined to reopen his severed supply road to Ohio. On August 8, 1812, a regiment under the command of Lt. Col. James Miller left Detroit and marched south toward the River Raisin, accompanied by two cannons and a cavalry totaling approximately 600 troops. (Courtesy of the War of 1812 Reenactment Committee.)

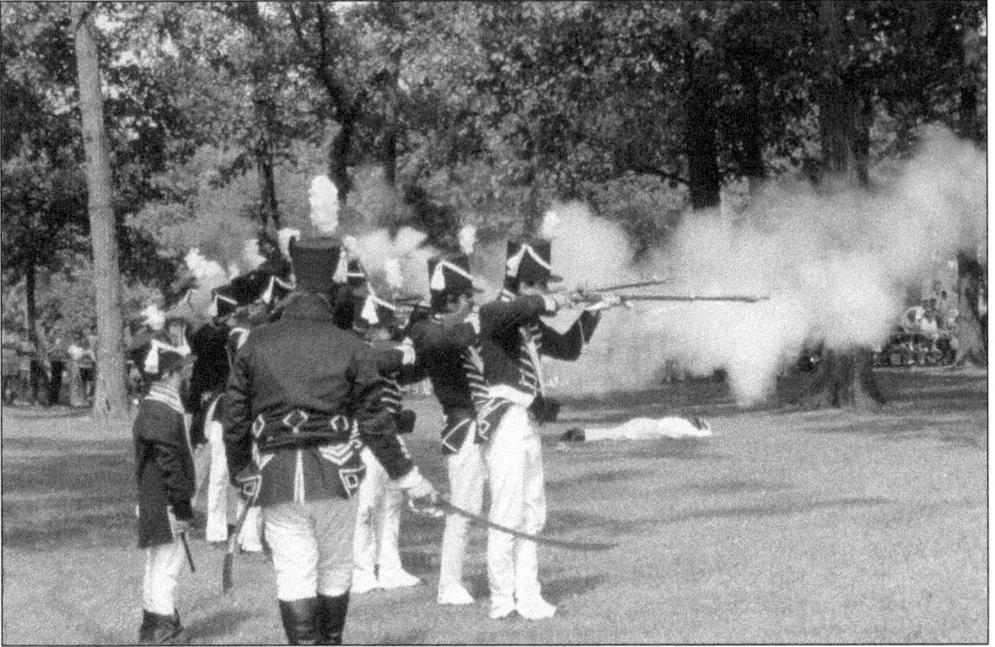

On the afternoon of August 9, American forces approached the Indian village of Moguoga, where they were ambushed by a detachment of 75 British regulars, commanded by Maj. Adam Muir; 60 Canadian militia; and 70 Indians, under Chief Tecumseh. A running fight took place from near Ecorse to Slocum's Island. (Courtesy of the War of 1812 Reenactment Committee.)

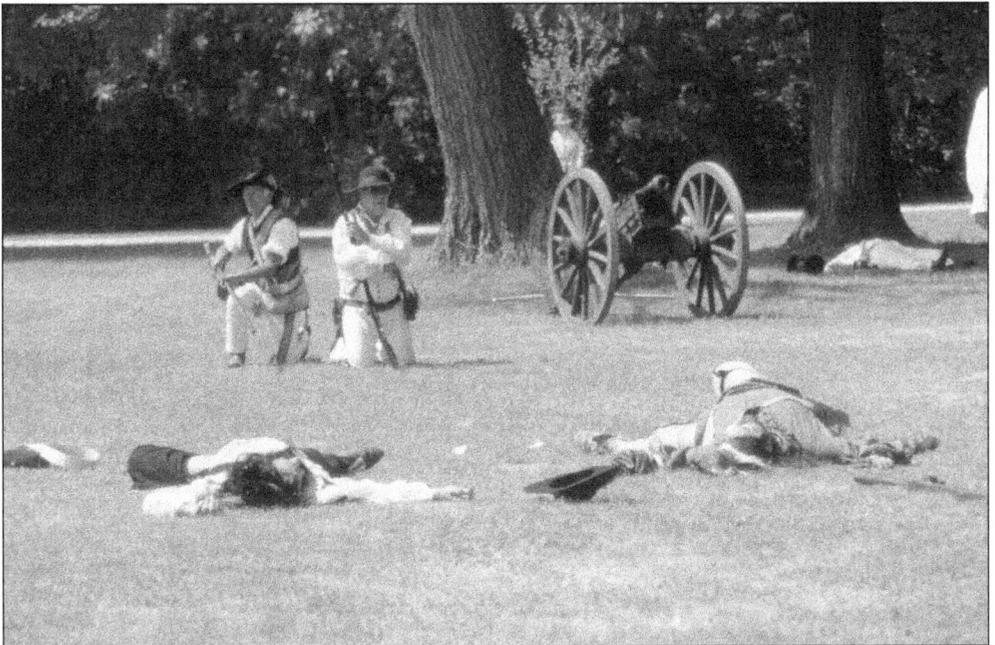

The British and Native Americans retreated to boats and crossed back to Fort Malden in Canada. Losses were heavy on both sides, and bodies were buried where they fell. The Battle of Brownstown and the Battle of Monguagon were the only two battles in and around Trenton. (Courtesy of the War of 1812 Reenactment Committee.)

Three

PROMINENT FOLK

Born on February 11, 1778, in Schenectady, New York, Abram Truax was one of the earliest settlers in Michigan and the "founder" of Trenton. Truax acquired a large tract of land in the Michigan Territory along the Detroit River, where he built his home, a sawmill, an exchange tavern, a church, and a store. He married Lucinda Melinda Brigham of New Hampshire. They had a daughter, Sophia Maria Brigham Truax, who later married Giles Bryan Slocum. Abram became the first postmaster and township supervisor when Monguagon Township was organized in 1827. On June 25, 1844, the steamship *William Vance* was leaving a Windsor, Ontario, dock with a full load of passengers. Shortly after, a high-pressure boiler blew up. The boat sank near the Canadian shore with Abram Truax aboard.

Many people over Trenton's 177-year history have contributed to the town. William Dusablon and Charles Shaw were cobblers, George Bird was a brick maker, Nathaniel Alvord started the Episcopal church Sunday school, and Captain Dana perfected the davit system used for raising and lowering lifeboats.

Up until the mid-1900s, women, in a reflection of the battle to stand on equal footing with men, usually used their husband's given and surname. For example, Jane Smith would be referred to "Mrs. John Smith" or "the wife of John Smith." This practice can be found on these pages, but that is not to say the women of Trenton do not deserve a share of the credit. In those early Trenton days, though, jobs outside the home were scarce. The only significant example of employment was a teaching position, which required unmarried women only. Proper ladies were expected to keep house, raise children, attend church with the family, and work on charitable causes. Two exceptions of this were Mrs. B. Dion, who ran the Dion House Hotel, and Anna Felder, who owned the Hotel Felder.

Giles Bryan Slocum, an industrialist from Saratoga Springs, New York, opened the first general store and dock in Truaxton, operated a ferry to Grosse Ile, and ran a mercantile business. On May 17, 1838, he married Sophia Maria Brigham Truax, the daughter of Abram Truax and Lucy Melinda Brigham. Sophia was schooled in an old log cabin adjacent to her father's land and attended a private school for young ladies in Monroe, Michigan.

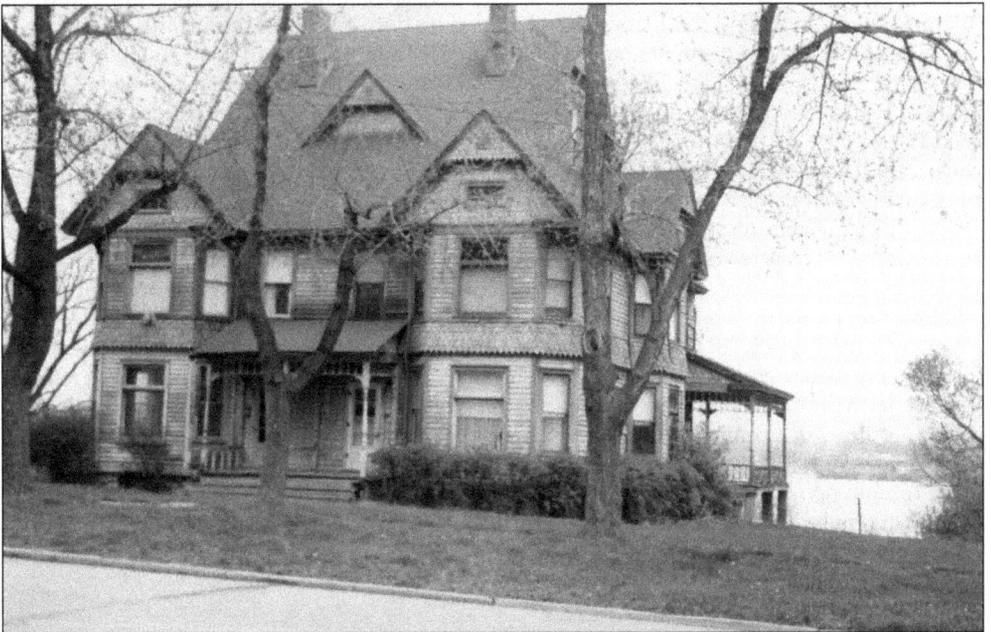

John Felder Sr. was born in Sandusky, Ohio, in 1845, and came to Trenton in 1872. He had various businesses, including the operation of a steam ferry to Grosse Ile. In 1893, he and his wife, Anna, opened the Hotel Felder. When he retired in 1905, he owned four different stores on Jefferson Avenue's main business block. His slogan was "If you can't find it elsewhere, you'll find it at Felders." This photograph is of his home on the Detroit River.

28

Phineas Earl Saunders was employed by the Detroit, Toledo, Sandusky, and Cleveland steamer lines, acting as chief engineer of the steamers *John Owen*, *Bay City*, and *Arrow*. In 1860, Phineas was appointed to the Office of US Inspector of Steam Vessels under the administration of Pres. James Buchanan. (Courtesy of the Trenton Historical Commission.)

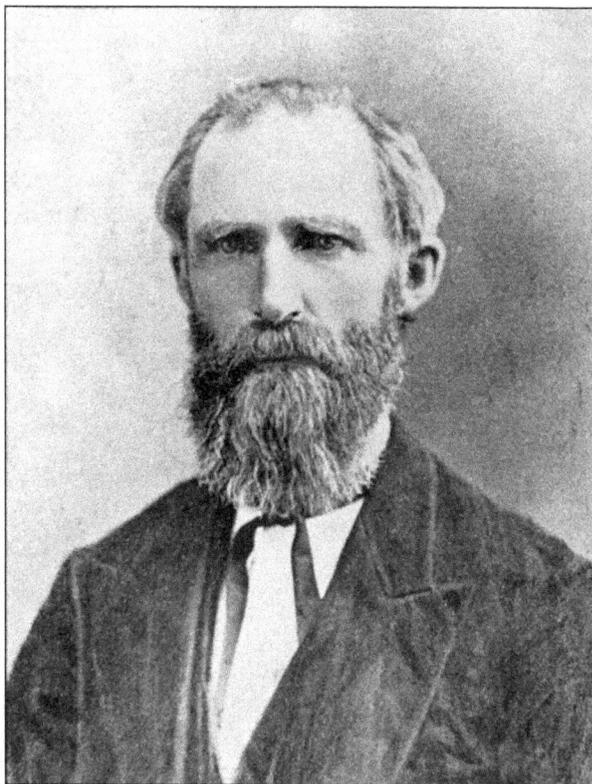

Saunders's home was located on Third and Pine Streets (West Road). Phineas married Clarenda C. Bill of Trenton. He died of cholera in 1881. (Courtesy of the Trenton Historical Commission.)

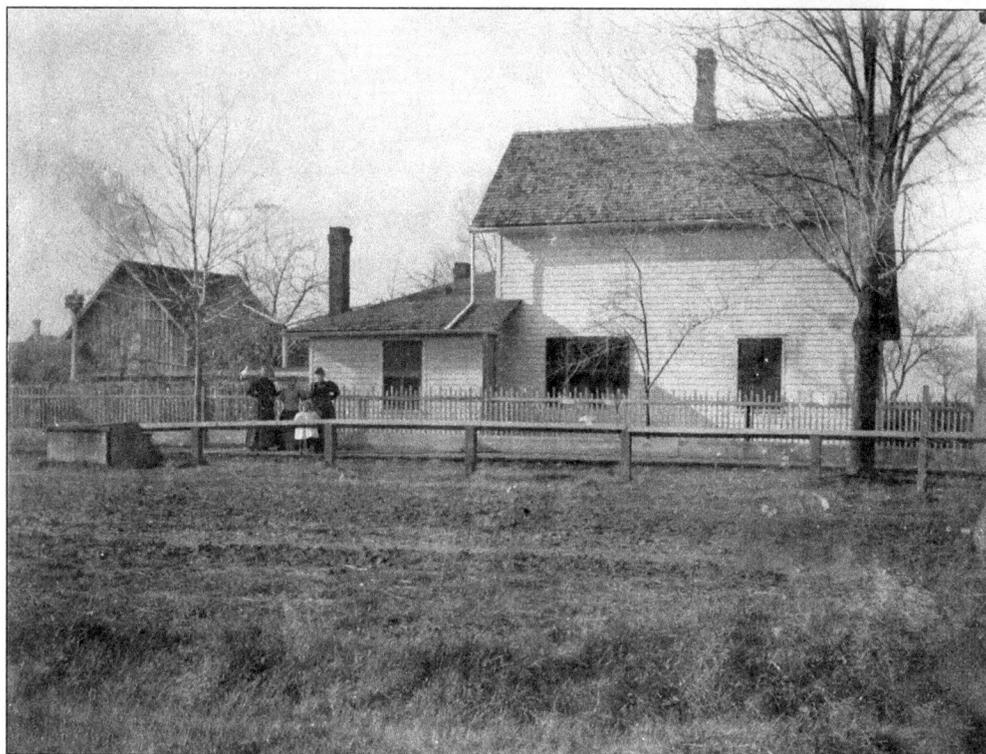

John Clee and his wife, Hannah Frye, moved to Trenton, Michigan, from England, where he started a general store in Trenton's first brick building. This photograph is of John and Hannah and an unidentified granddaughter. In 1866, John purchased a flour mill located at the foot of Atwood Street. The mill had been built by James David Sr. and Mr. Abbott but owned by various people, including Arthur Judkins, until Clee bought it. In 1846, the first wheat was ground there. Eventually, it was converted into an all-roller process mill, with a capacity of 125 barrels of flour. (Courtesy of Marion Clee.)

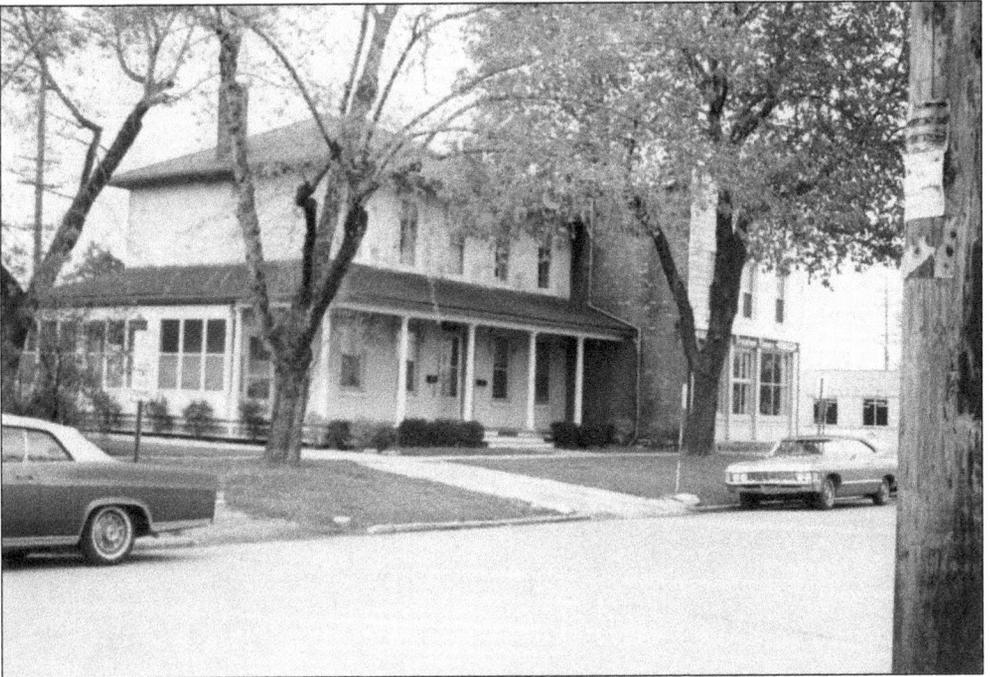

John Clee's home on Front Street (Riverside Drive) had a building attached to it (far right) that was the Clee Mill at one time. Later, it became the office of the *Trenton Times*. (Courtesy of Marion Clee.)

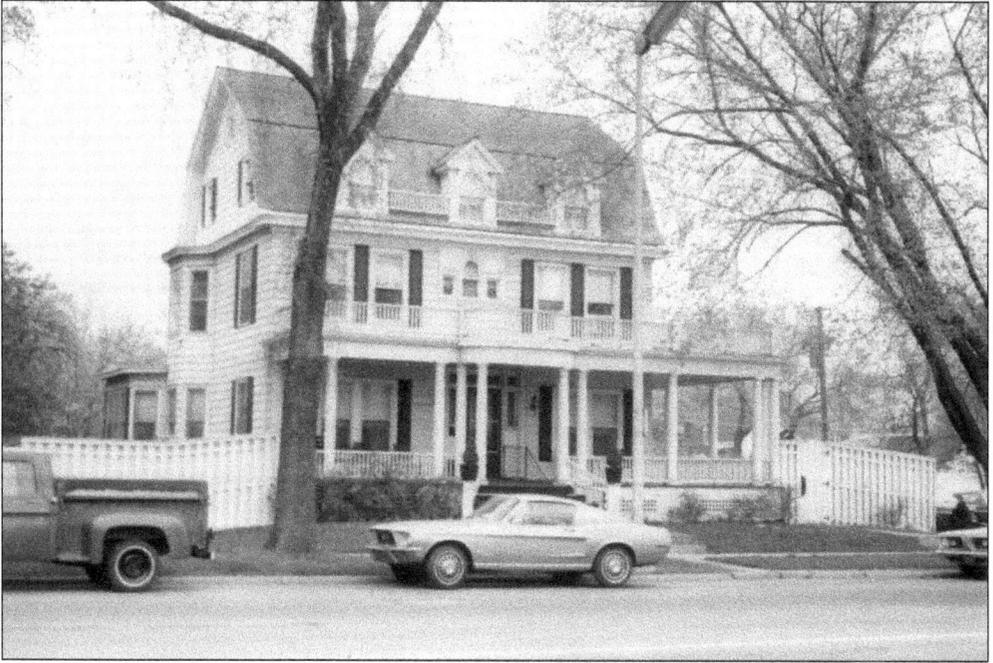

Austin Church's first home was built in 1898 and was located on Washington Avenue (West Jefferson) between George and Truax Streets. When John Foley became superintendent of the Church Quarry, he moved into the home. The house is presently the location of Savannah's Restaurant.

Hattie Smith Church, of Biddle Avenue in Wyandotte, was the wife of Austin Church. This photograph was taken around 1890. (Courtesy of John Yost.)

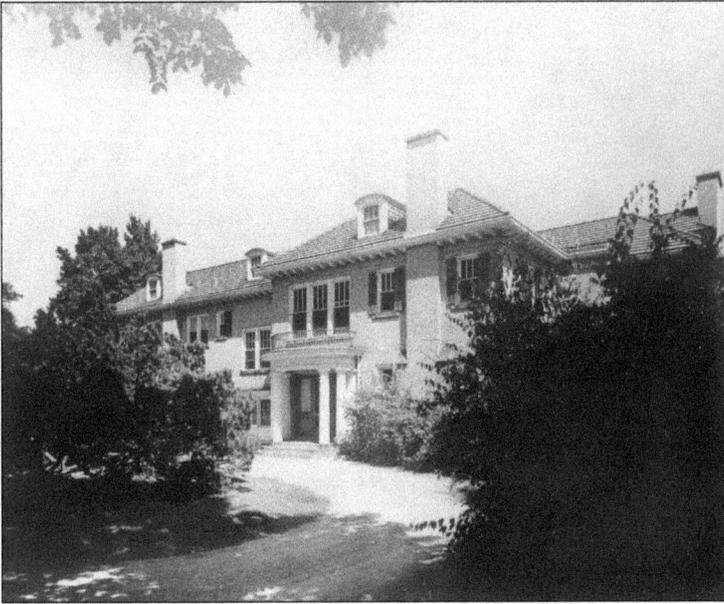

Austin Church's second home was built for his bride, Hattie Smith Church, and was located on three acres of riverfront. In 1943, the home became the first unit of the Riverside Osteopathic Hospital.

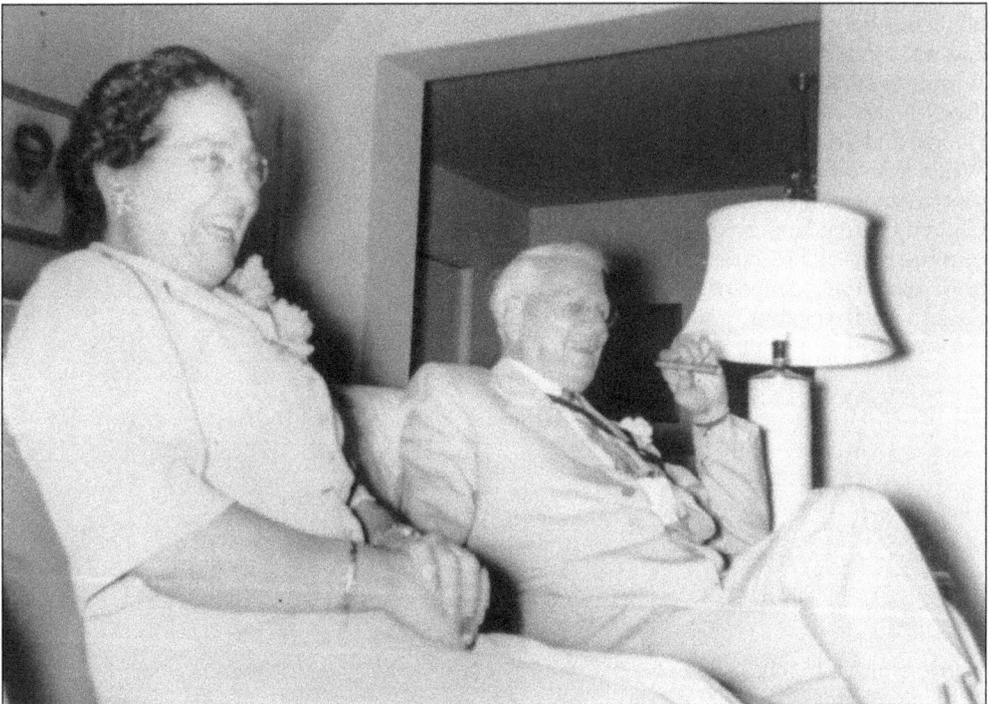

Austin Church (pictured with Hattie Smith) and his brother Fred came to Michigan in the late 1800s. In 1896, they purchased the Sibley Quarry for its limestone, used to make baking soda sold under the family's nameplate Arm & Hammer. From 1910 to 1917, Church built "day boats" in a plant at the foot of Truax Street and Front Street (Riverside Drive). In 1912, he established the Church-Field Motor Company. (Courtesy of the Lucy Shirmer collection.)

Anna Mans Bridge and her husband, William Sychelmoore Bridge, bought land on West Road on November 26, 1901, from the Michigan Alkali Company for $5,000. They named it the Blue Jacket Farm. William operated Trenton's first milk wagon before 1900.

William and Anna Bridge had one daughter, Emily Elizabeth Bridge. This photograph was taken when she was five years old. Emily graduated from Trenton High School and attended Michigan Normal College (now Eastern Michigan University). She taught in the Detroit school system and retired from teaching in 1932. When Emily died in 1972, she left her estate to the City of Trenton to be used as a "cultural center, museum, or similar facility." (Courtesy of the Trenton Historical Commission.)

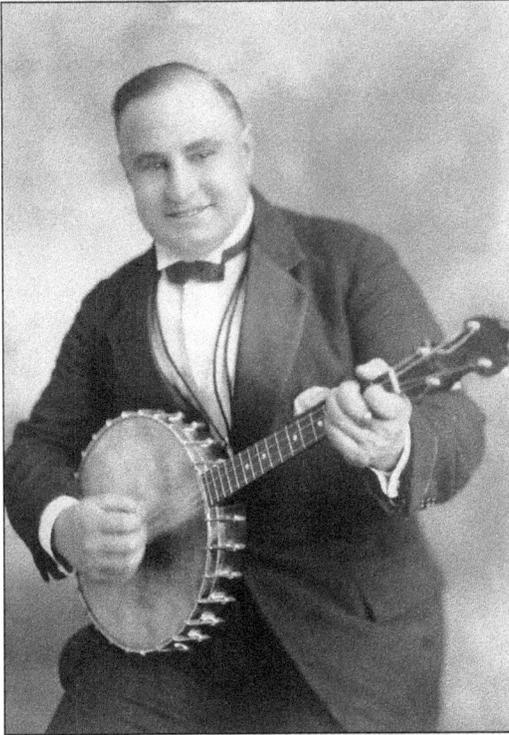

Paul Teifer Sr. was known as the "Silver Tenor and Banjoist." He performed on Radio Station WWJ and played in many theaters, including the Broadway Strand, Fox, Washington, National, Rivola Strand, Majestic, and the Trenton Opera House. He was also employed for 13 years by the Trenton Water Department. In 1943, Paul was appointed postmaster of Trenton.

Paul also was a member of the Spanish Serenaders, the Eight Jazz Landers, and the Toreadors and the Spanish Maidens. Paul and his vocal abilities definitely stood out. One story goes that in the Roaring Twenties a lieutenant in Al Capone's Chicago Mob heard Paul's crooning and took him "for a ride" in his black limousine. It seems he appreciated Paul's stage rendition of "O Sole Mio" so much that he wanted, for an unknown reason, to take him out to a sumptuous dinner. What a relief! (Courtesy of Patricia Teifer Gearhart.)

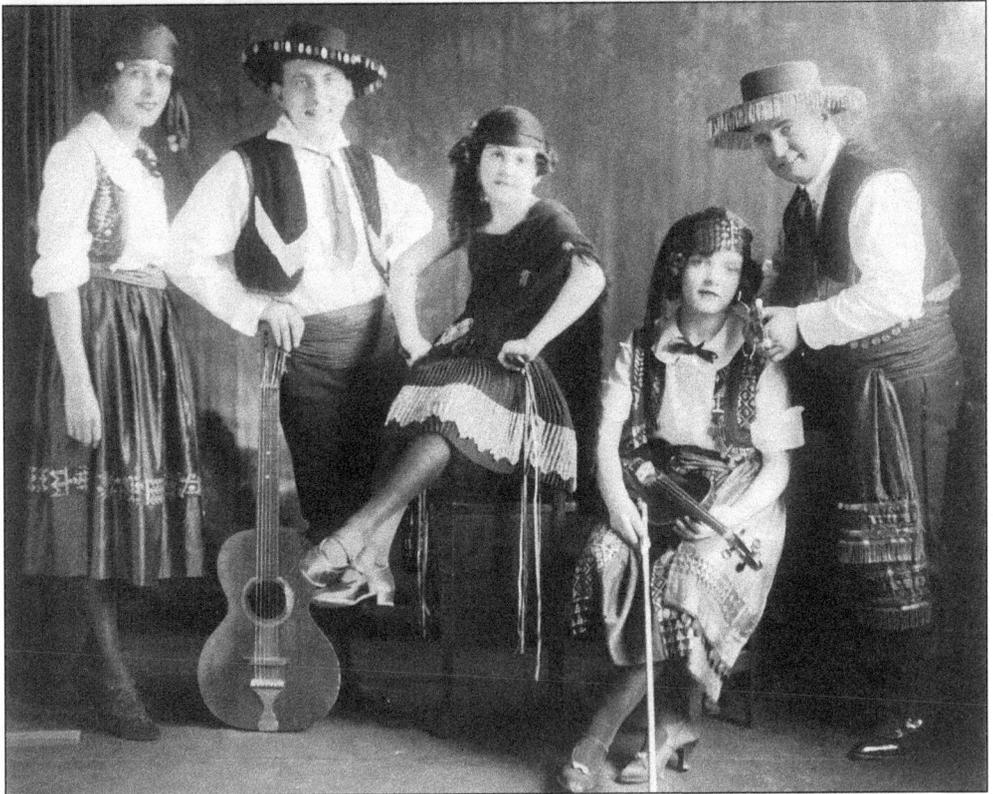

Paul Teifer Jr. was born and raised in the city of Trenton. He was elected city assessor and city treasurer. Paul directed the Trenton Sharpshooters BB Gun program, sponsored by the Trenton Parks and Recreation, for over 30 years, winning 16 consecutive Michigan State Championships and the Daisy International Air Rifle Championship. This photograph shows Paul in 1974. (Courtesy of Patricia Teifer Gearhart.)

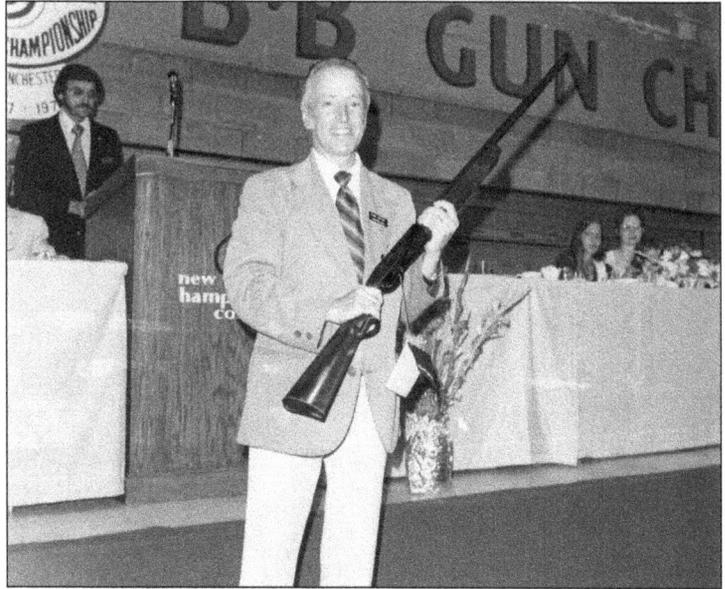

In the 1880s, John Moore, a tavern keeper, and his wife, Sarah, purchased this property situated at the northwest corner of St. Joseph Avenue to build their home. There are no photographs of John, as after his death his wife cut out his likeness from all images and burned them. The Moore house is now the home of the Trenton Historical Commission and Museum. It has been placed in Michigan's Register of Historic Homes. (Courtesy of the Trenton Historical Commission.)

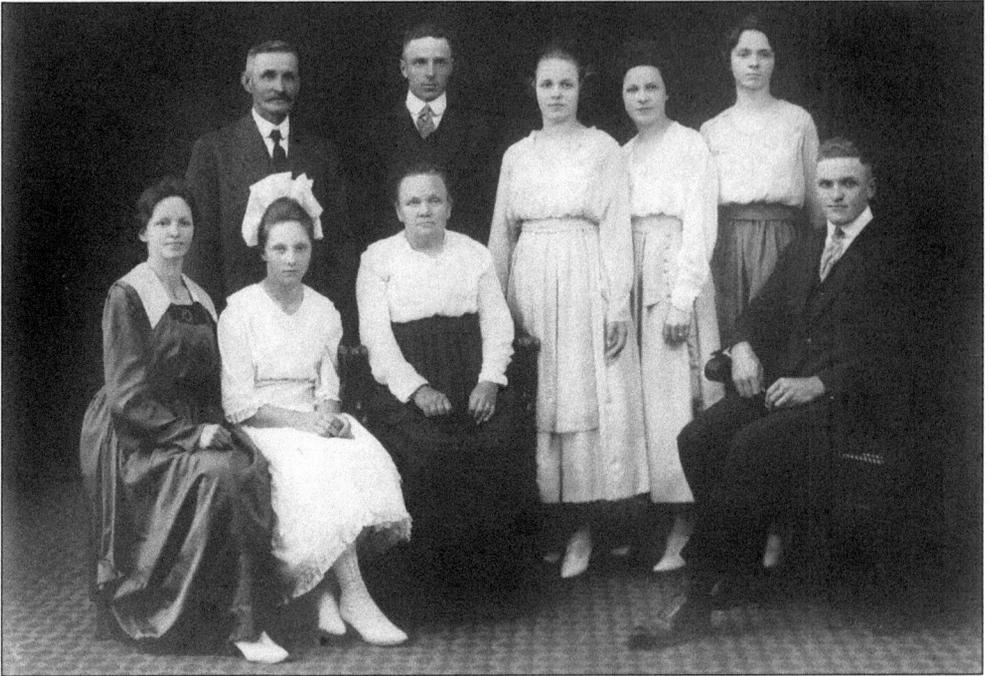

In 1919, Nellis Moore, John and Sarah's grandson, sold the house to Fred Boelter. Boelter was born in Germany and married Lissetta Upplegger. Pictured in 1919, the family members are, from left to right, (first row) Harriet "Hattie," Dorothy Minnie, mother Lissetta, and Frederick C. Boelter Jr.; (second row) father Fred, Arthur Boelter, Martha Boelter, Minnie Boelter, and Emma Boelter. In 1928, Emma, who never married, converted a portion of the front parlor into a beauty shop, where she worked until she retired in 1957.

Nicholas A. Mans came to Trenton in the late 1800s and built a potash refinery on Riverside Drive at the foot of Harrison Street. Now called Rotary Park, it was the location of the Ashery, where wood ashes were collected into potash and shipped to various industries. Mans also became successful in the coal and lumber industries. In 1865, Nicholas married and built a home on Washington Street (now West Jefferson Avenue). The family home still stands today and is the home of George Mans, a descendant of Nicholas.

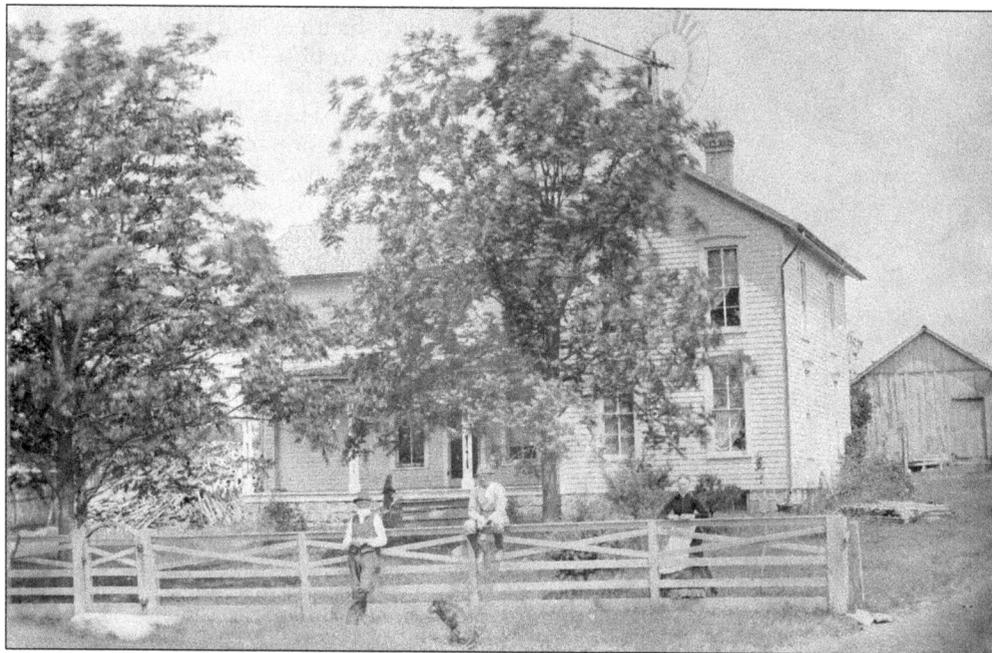

In 1858, Montgomery Lathrop bought 55 acres from Nathaniel and Lucy Alvord on the southeast corner of Fort Street and Van Horn Road; however, the Detroit Toledo Railway lines took one slice from the farm. Later, another piece went to the construction of Fort Street, and by the time Detroit Edison Company needed more space, the original farm had shrunk to just 20 acres. The farm was designated a "centennial farm" in 1962.

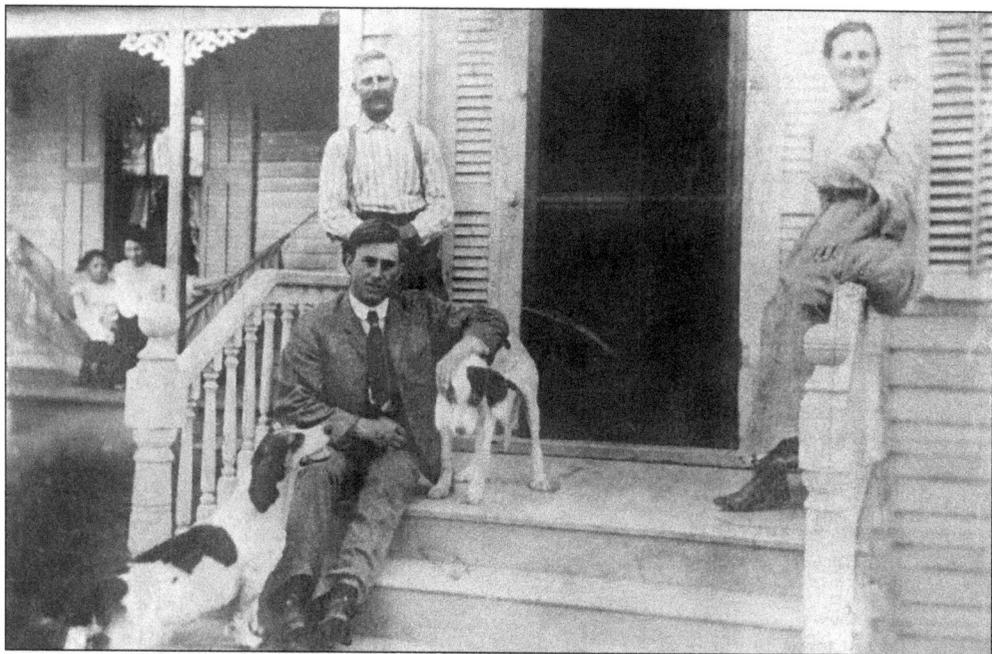

The centennial farm was the home of the Lathrop family. Seated on the porch of the house are Hosmer Lathrop (on the steps), his father Eljah Lathrop (behind Hosmer), and his mother Eliza Lathrop (right). (Courtesy of the Trenton Historical Commission.)

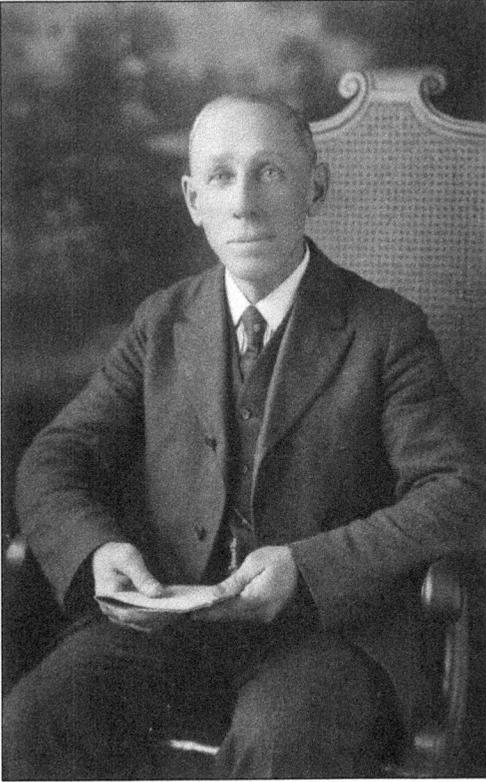

Arthur B. Smith opened the first drugstore in Trenton in 1876. He supplied patent medicines, bandages, and filled prescriptions for Trenton residents. In 1885, the village's first telephone switchboard was installed in the rear of the Smith Drugstore. Later, C.O. Owen purchased the store. It was a great blow when, in September 1917, Smith died while waiting in line at the bank. Although Dr. Hiram Holden came immediately from his office across the street, it was too late to revive Smith.

Dr. Howard Blythe Kinyon was the village health officer for 35 years. Dr. Kinyon put his medical practice on hold to enter military service during World War I. He spent two years in Russia with the Expeditionary Forces. He later became the health officer for the township, following Dr. Hiram H. Holden in the position. (Courtesy of the Trenton Historical Commission.)

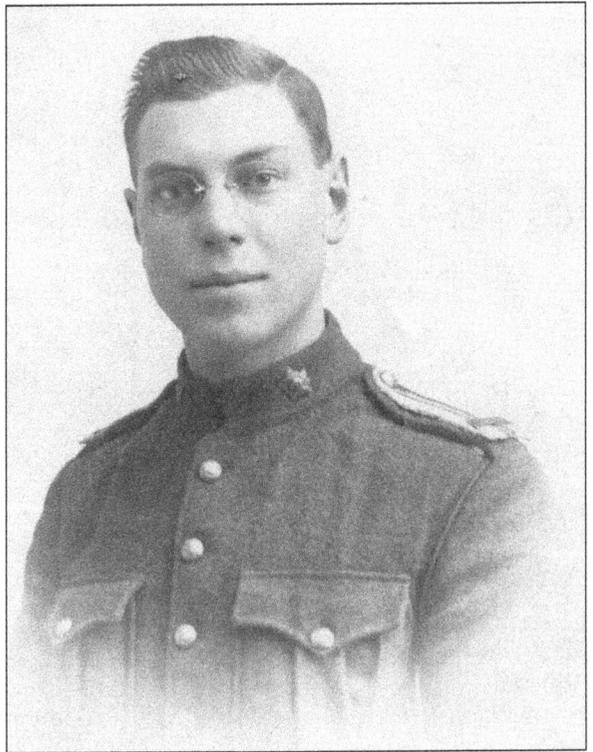

38

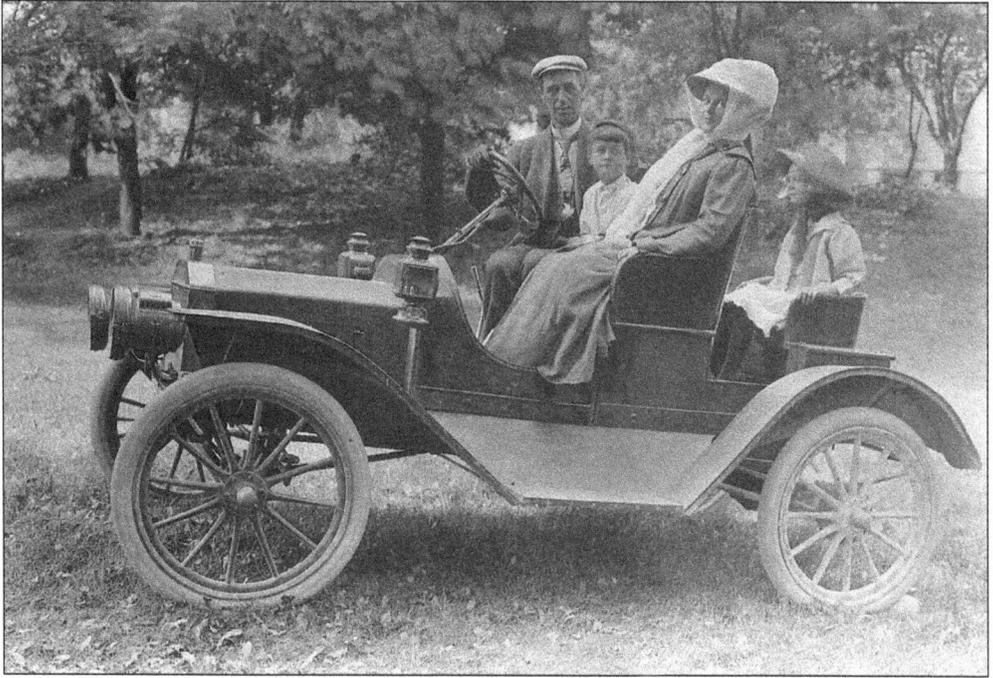

Dr. Hiram H. Holden came from Stratford, Ontario, where he attended the Collegiate Institute. He then taught school for a while and later became a druggist. He left the drug business and entered the Michigan College of Medicine in Detroit, graduating in 1883. In 1911, Dr. Holden took his family for a ride in his new car. They are, from left to right, Hiram, LaTisha, James H., and Dorothy Holden. (Courtesy of Judi and James Holden.)

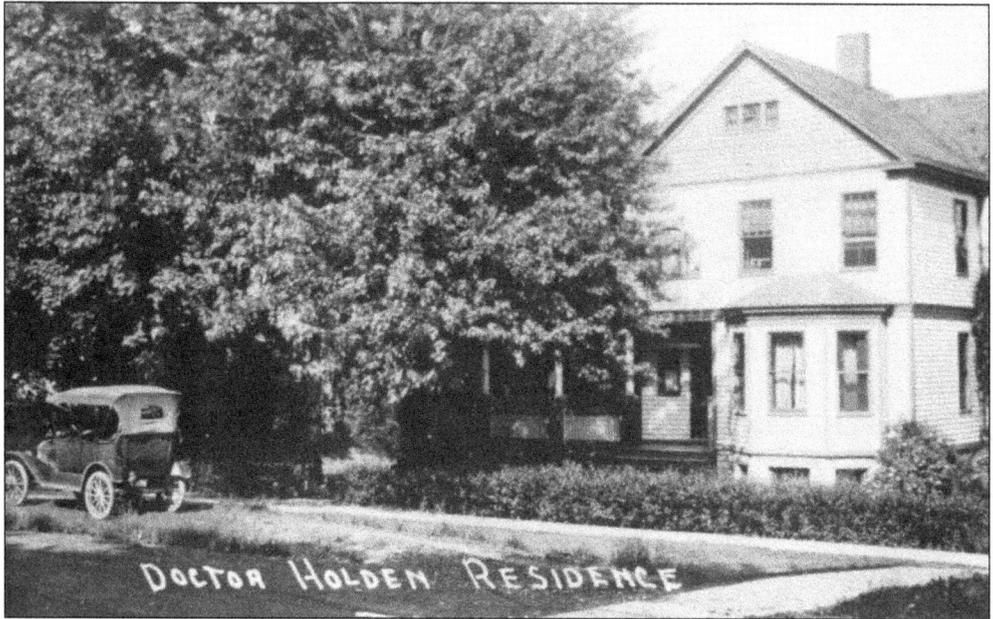

Trenton was Dr. Hiram Holden's first place of practice, and he and his family moved into this home, built in 1886. He later became the first health officer for the township and was followed by Dr. Howard Blythe Kinyon.

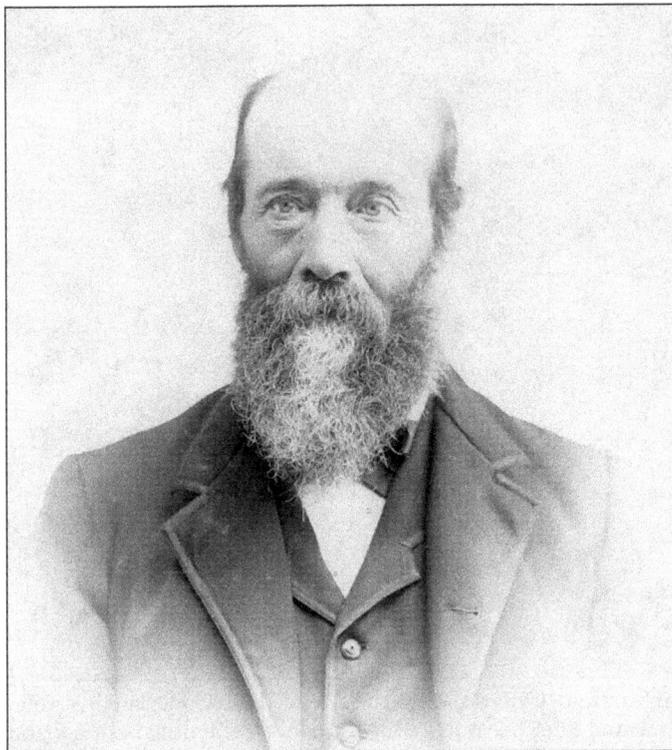

James Bailey Sr. (left) was born in 1832 in England. He married Margaret Wolcott (below), who was born in 1934 in Dublin, Ireland. They arrived in the United States in 1854. James's son Alfred "Alf" Bailey was born in 1861. James Sr. ran a neighborhood store near the northern end of town. He carried a regular line of groceries, and his wife baked bread for customers. (Courtesy of Margery and David Reaume.)

James Bailey Jr. (right) was born in 1863 on Grosse Ile and married Anna Dyke (below) in 1892. In 1898, James was elected village president and served as justice of the peace. He was employed by the Canada Southern Railroad as an agent and by the Michigan Central Railroad. James and Anna ran a boardinghouse for teachers at their home on the southeast corner of Third Street and St. Joseph Avenue. James died in 1917, and 60 automobiles formed the procession to Woodmere Cemetery for his burial. (Courtesy of Margery and David Reaume.)

Alf Bailey, owner of a dry goods store, was in business in Trenton for 36 years before selling the store to his brother Leonard in 1911. He semiretired but still continued to work in various departments of the large store.

The residence of Alf Bailey sat on the southeast corner of Riverside Drive and Elm Street. (Courtesy of the Trenton Historical Commission.)

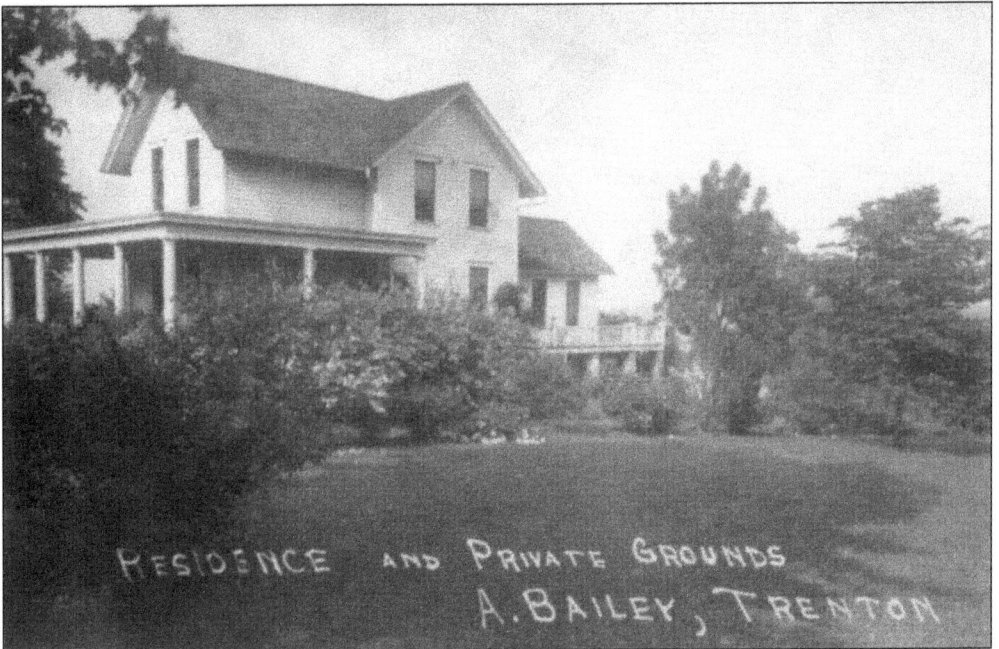

RESIDENCE AND PRIVATE GROUNDS
A. BAILEY, TRENTON

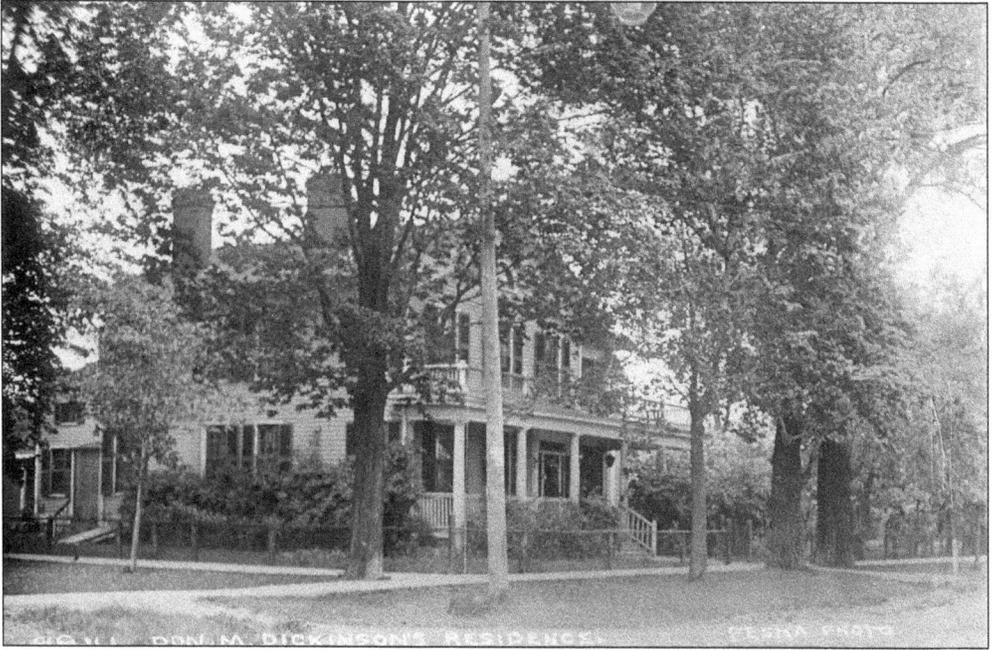

Donald M. Dickinson attended the University of Michigan and established a law practice in Detroit. In 1887, Pres. Grover Cleveland appointed Dickinson as US postmaster from January 6, 1888, until March 4, 1889. In 1896, Dickinson became senior counsel for the United States before the international commission on the Bering Sea claims. He died in October 1917, and between 11:00 a.m. and noon all business places in Trenton closed and all church and school bells tolled. The home of Hon. Donald M. Dickinson was torn down to make way for new homes.

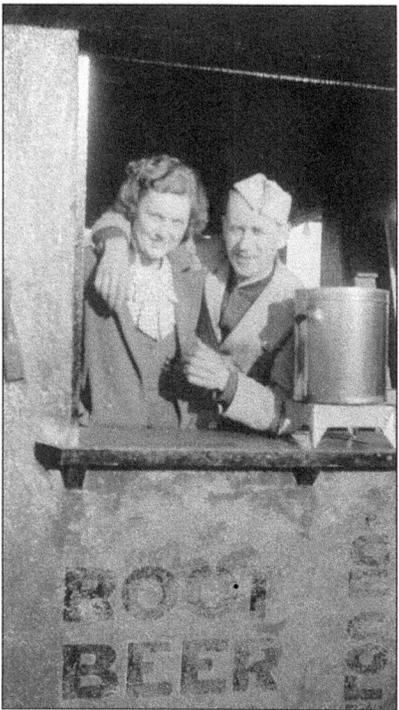

Taken in 1936, this is a photograph of Peter and Hattie A. Duich, who owned a root-beer stand on Jefferson Avenue. Later, the stand became the first A&W Root Beer franchise in Michigan.

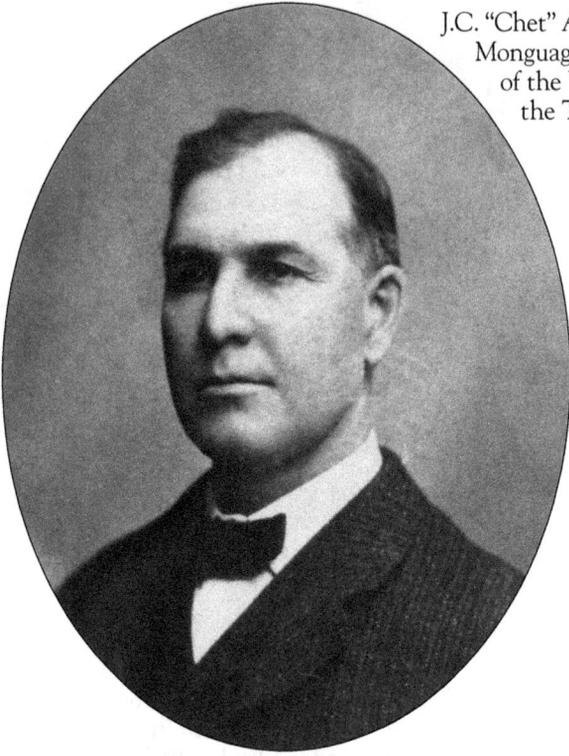

J.C. "Chet" Armstrong, pictured in 1900, became the
Monguagon Township treasurer and the president
of the Village of Trenton and was a member of
the Trenton Board of Education for 20 years.

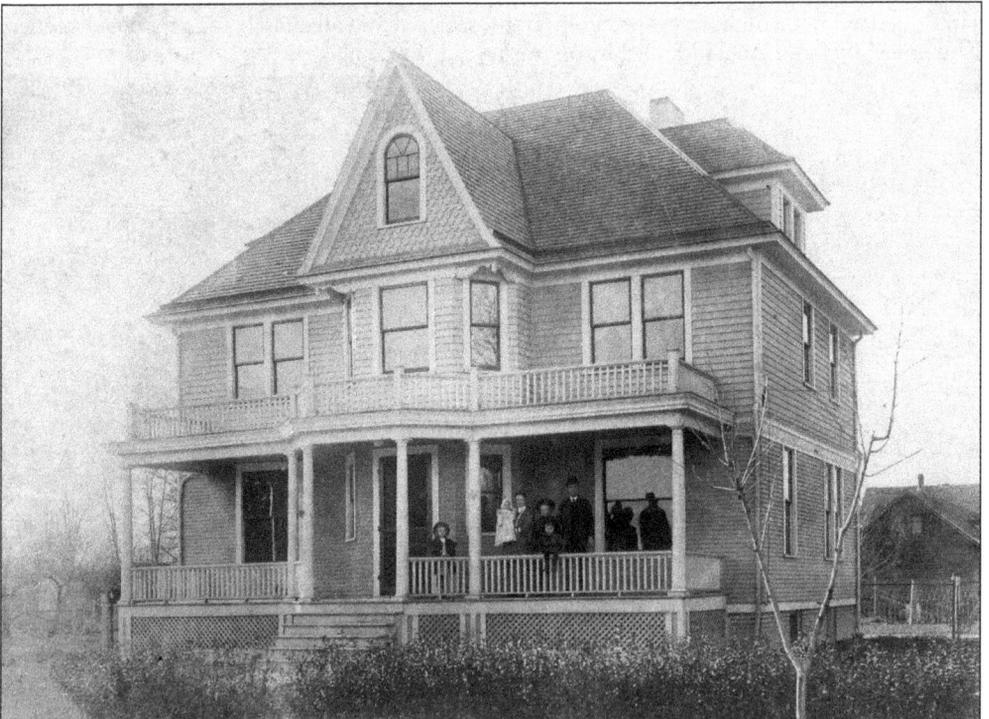

Chet Armstrong and his family are gathered on the veranda of their new home, built in 1905 at
the corner of Pine and Front Streets. Armstrong was born in Cleveland, Ohio.

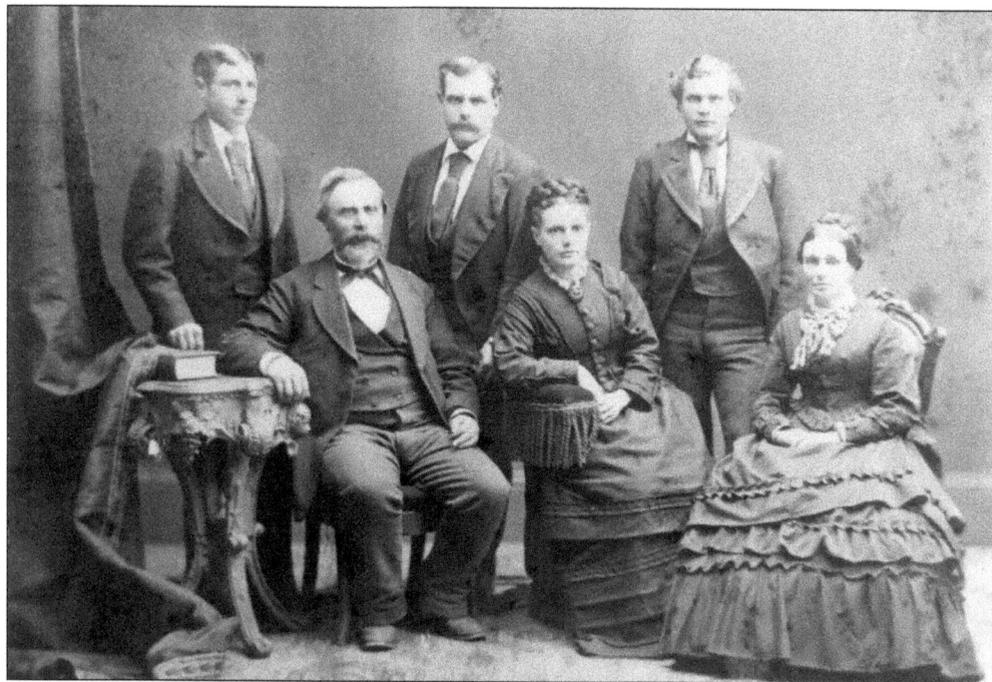

Col. James I. David of Trenton served in the Civil War as quartermaster in the 1st Michigan Cavalry and as a colonel in the 9th Michigan Calvary. The 9th consisted of 2,057 men and would later be added to William Tecumseh Sherman's forces, which began its famous march from Chattanooga to the sea on May 6, 1864. Pictured are, from left to right, (standing) Orin David and two unidentified people; (sitting) Col. James David, Mrs. David, and Mrs. Emma Hartrick Reaume. Colonel David was part owner of the Davis and David Mill, specializing in pinewood and later hardwoods.

During the Civil War, Col. Arthur Edwards was appointed to the US Quartermaster's Department and had 350 to 400 carpenters and shipbuilders from Michigan working to build boats for the Union. The first boat constructed under his supervision was a small stern-wheeler named the *Chattanooga*, but it was nicknamed the "Cracker Box" because she carried large quantities of hard tack. The *Chattanooga* once successfully ran a blockade of rebels from Chattanooga to Knoxville under instructions from Gen. Ulysses S. Grant.

This photograph is of John Todd and his wife, Sarah Hosmer Todd. John was the first funeral director and street commissioner in Trenton. (Courtesy of the Trenton Historical Commission.)

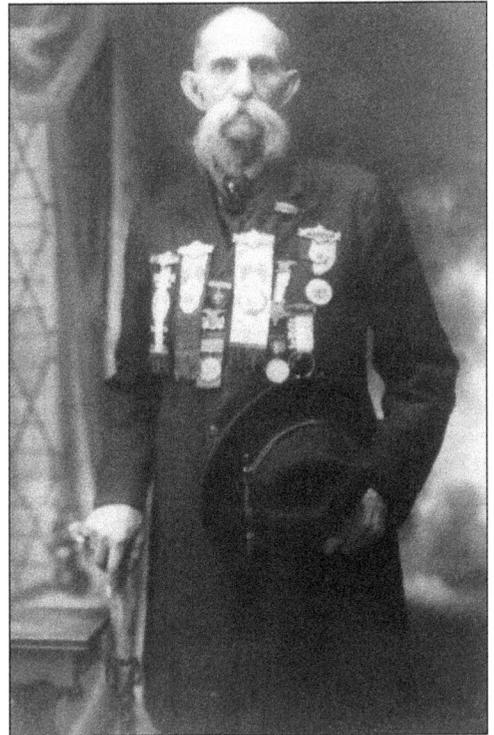

John Todd also fought in the Civil War, and this photograph of him was taken on April 4, 1916, with his Grand Army of the Republic (GAR) ribbons.

Mary Phelps Pringle was born in 1855. She was a widow when she married Archie McIlhinny. The couple had a son named Douglas (pictured here with Mary). Mary Pringle McIlhinny's father-in-law, James Pringle, bought the Exchange Tavern home (originally built by Abram Truax) from the estate of Alvord Phelps. The McIlhinny home was located on the northeast corner of Riverside Drive and St. Joseph Avenue.

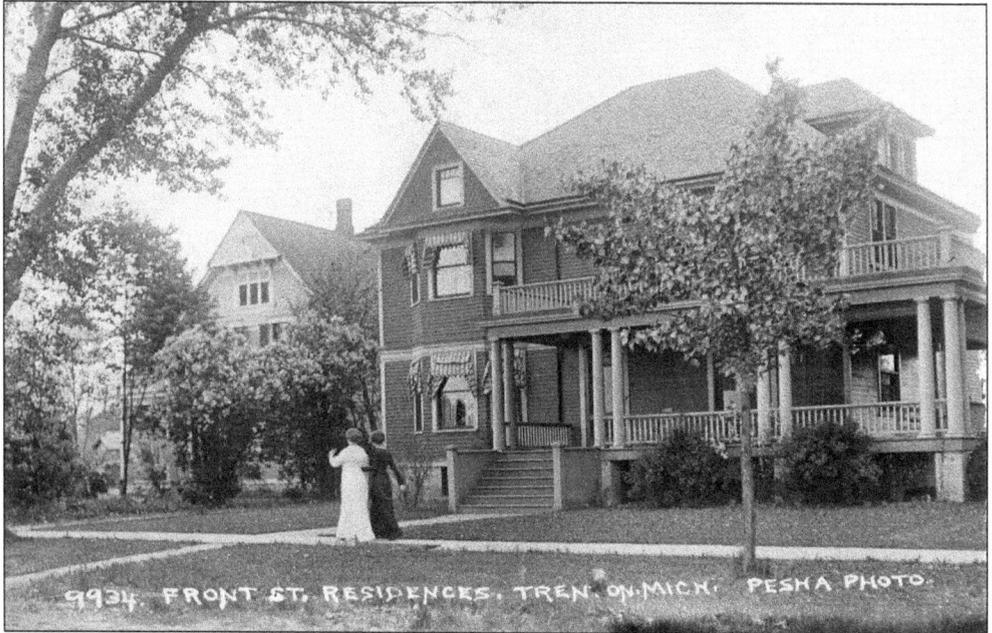

Dr. A.O. Osborn's home was on Front Street in Trenton. Unfortunately, there is little to no information beyond his name and home. Dr. Ralph Ridge bought this house from Dr. Osborn for his son Ralph Ridge Jr. and his wife, Sally, to be used as a funeral home.

Dr. Ralph Ridge was the first chief of staff at Riverside Osteopathic Hospital.

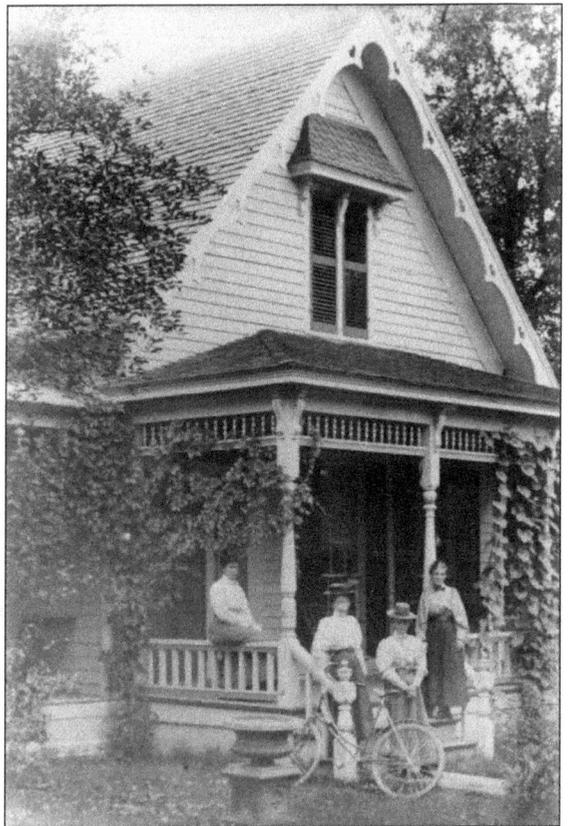

The Park residence was located on the southwest corner of Front (now Riverside Drive) and Elm Streets. The house is still standing and is currently occupied by Mr. and Mrs. W. Dan Gillespie. These ladies posing on the porch of the Park residence are, from left to right, Mabel Park, Letitia Park, Elizabeth Sundstrom, and Katherine Alvord.

At age 30, Thomas Limbocker was a 2nd lieutenant in the 1st Michigan Light Artillery, Battery I and fought in the Civil War. He and a partner, Nathanial Willard, started a business making yeast. It closed with the death of Willard, then reopened, but finally closed again when Limbocker's building was destroyed by fire. The Limbockers had one daughter, Mary Elizabeth. Thomas was the township treasurer and also ran the post office. At the time of his death in 1877, he was the county auditor. This image is of the Limbocker home.

Capt. Robert Wagstaff was captain of the *Julia Palmer* that delivered supplies to Fort Mackinac in northern Michigan one winter, which did not have enough supplies to last the season. In 1834, Wagstaff married Catherine Walker, and in the early 1840s they moved to Truago. He contracted with Abram Truax, who fought in the War of 1812 and was at Fort Detroit when Gen. William Hull surrendered, to build a frame house on the northwest corner of Front and Elm Streets for $200.

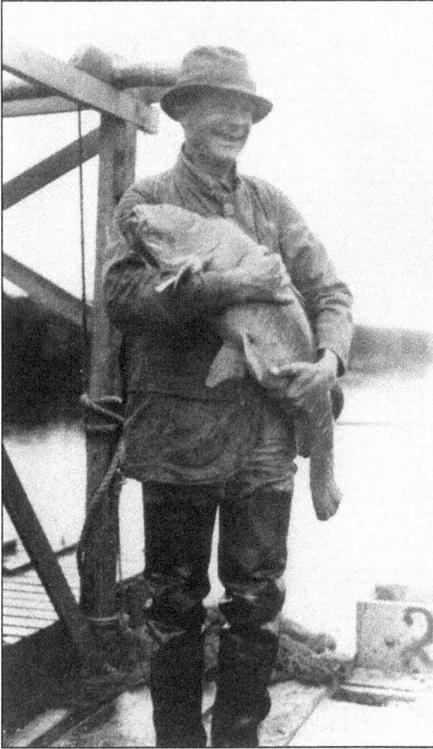

This photograph is of a young Claud Owen around 1917. Claud owned Owen Drugstore. When he was not working, one of his many pastimes was fishing. Claud enjoyed it so much that he and about six other Trenton residents purchased and leased a small island in the Georgian Bay in Canadian waters. There, they had a small lodge complete with built-in bunks where the men and their families could enjoy some downtime.

James Henry Vreeland was a Monguagon Township supervisor and president of the Farmers Mutual Fire Insurance Company. He married Alwilda Hendricks on March 10, 1864.

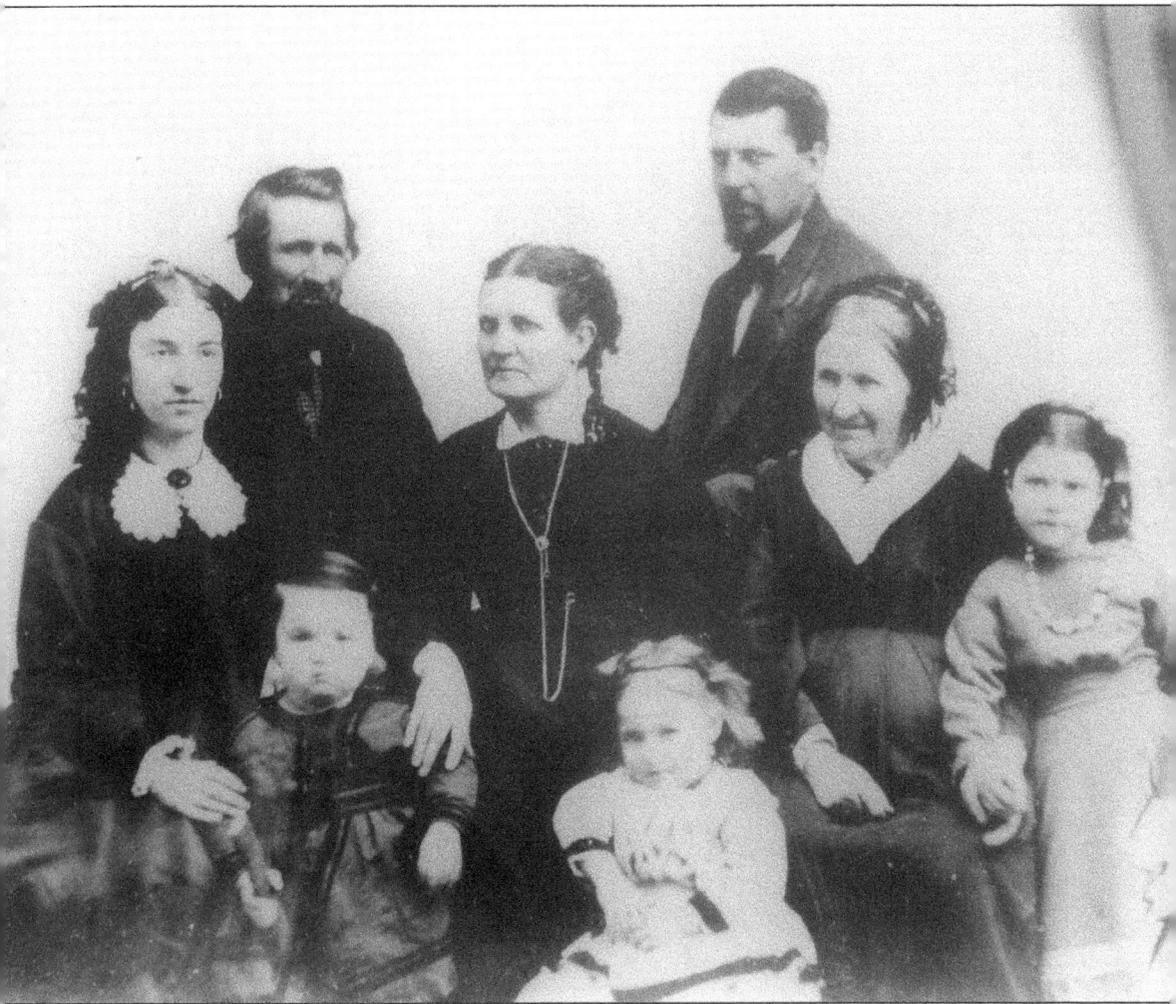

This photograph is of the Vreeland family. The adults in back are, from left to right, Alwilda Hendricks Vreeland; Jacob Reese Vreeland, brother of James Henry Vreeland; Kithura Harriman Vreeland, Jacob's wife; James Henry Vreeland; and Nancy Stoflet Vreeland, wife of Elias and mother to James and Jacob. The young girls are unidentified, but one is probably Mary (or Ann Mary), daughter of Jacob and Kithura; Sam Vreeland is the young boy.

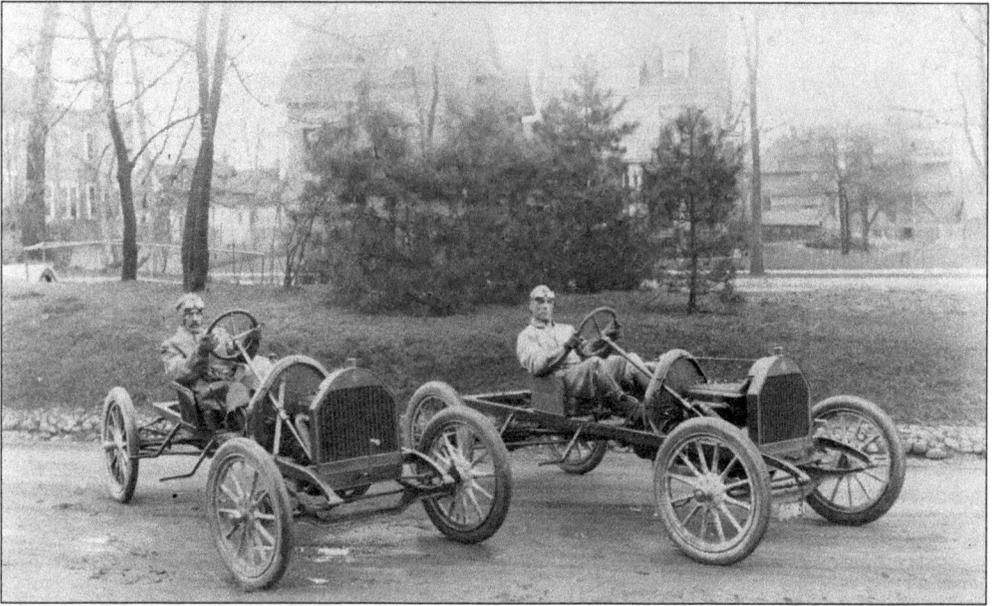

This photograph, taken either in 1911 or 1912, shows two early Indy 500 drivers and their race cars. The drivers came to Trenton because of their friendship with Trenton policeman Fred Teska and city administrator Lloyd Curry, who were both Indy 500–certified mechanics. Teska and Curry worked on the cars while they were in town.

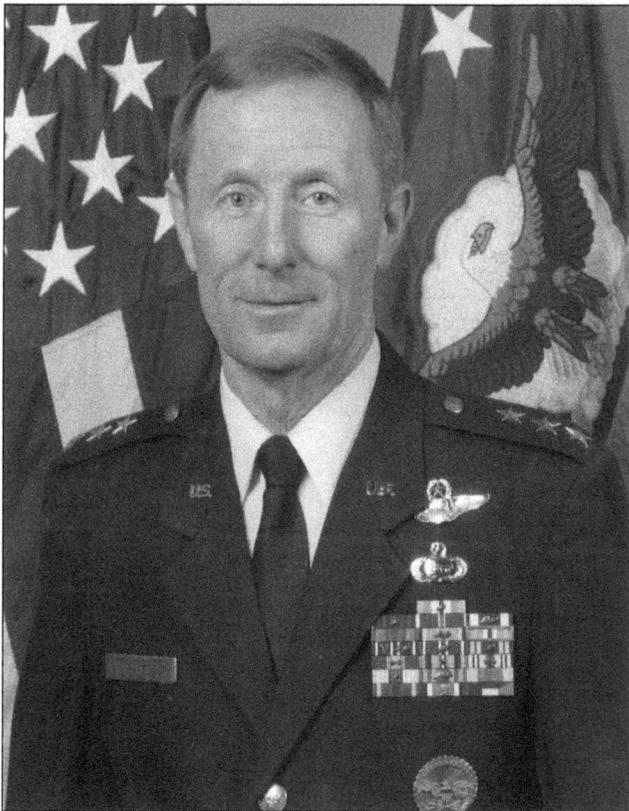

Lt. Gen. Ronald Sams, a retired inspector general in the US Air Force, and his family moved to Trenton in 1951. At school, Ron was a drum major for the Trenton High School band, editor-in-chief for the *Trojan Trumpet*, and a leader for student and church organizations. He graduated in 1967 and recalls that his home on Stella Court and his neighborhood "came to represent everything that was good . . . and right about my hometown."

Four

SHIPBUILDING

The village of Trenton was an ideal place to house a shipyard. The area for miles around was heavily forested with lumber used to make wooden boat hulls. By 1825, steam engine–driven vessels were becoming common, but two-masted schooners were still preferred. Water routes were vital, as roads were so poor. Goods took a full day to transport from Trenton to Detroit by road but only two to three hours by ship, which also carried larger loads.

After the launch of the *Amelia G. Ireland*, John Craig had further requests for his services, which led to profits and the need to expand his business. In 1882, Craig moved his company to Trenton, Michigan, but by 1887 a larger facility was needed, and a new yard was purchased in Toledo.

Austin Church, who had tried his hand at building automobiles and experimenting with a dairy farm, became interested in producing a superior pleasure craft. Tracks ran from the inside of the building into the slip, or channel, at the inner edge of the marsh, making the launching of boats uncomplicated. The boats were constructed of mahogany and other fine woods. Unfortunately, there is no photograph of the Church Boat Works; however, other ship builders used that same prime location and were documented.

The shipyard moved through various owners, and the Davis brothers moved into the vacant shipyard in 1927 and formed the Corsair Boat Co. Corsair intended to specialize in fast 30- to 32-foot cruisers built primarily for the Florida market. The Depression changed that aspiration, and in 1932 Corsair was in financial trouble. Davis Boat Yard built several 40-foot boats for the Coast Guard before the yard was sold to A.J. Liggett in the early 1940s.

For over 100 years, there was some form of shipbuilding in town, and it sadly ended when the Liggett Boat Works closed in the mid-1960s.

466/500 *Alvin Clark* J Clary

In 1847, the *Alvin Clark* was the first documented ship to be built and launched at Trenton. Constructed by Pearson Clark and named for his son, the *Alvin Clark* was a two-masted schooner, weighing 218 tons with a length of 105 feet, eight inches. Most of her 18 years were spent shipping illegal lumber from forests to Chicago. On June 19, 1864, she was headed to Wisconsin to pick up a load of lumber when a sudden storm capsized and sank the ship. The *Alvin Clark* rested in 110 feet of water at the bottom of Lake Michigan off Green Bay, Wisconsin. She was discovered in 1967 and raised in 1969. Due to the cold water of Lake Michigan, the ship was in perfect condition. Some of the mechanical systems still worked, and it contained a number of preserved artifacts; however, no plans were made for preservation when she was raised. Free from the cold waters of the lake, she began to deteriorate and was finally destroyed in 1994. (Drawing by James Clary.)

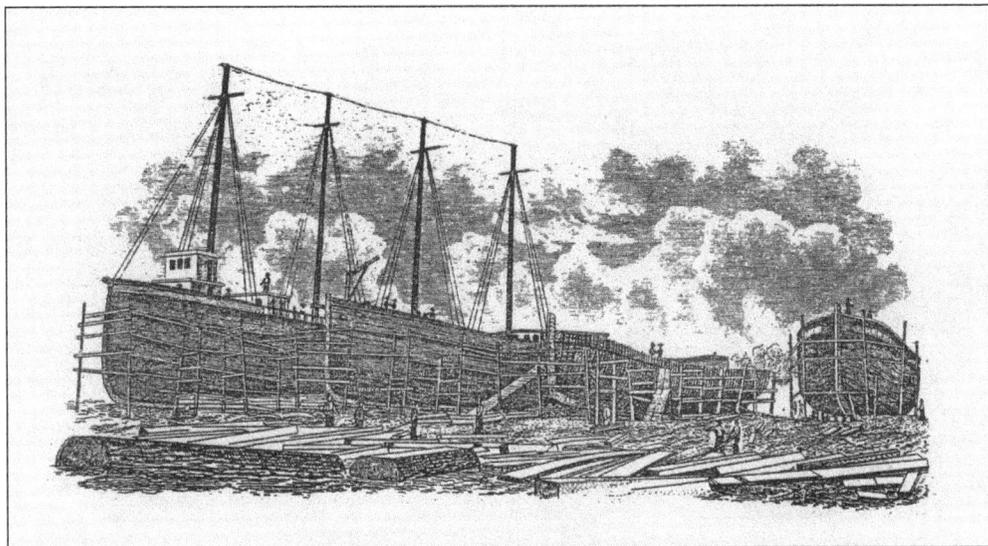

The A.A. Turner Shipyard operated from 1866 to 1873 and built 36 ships in total. In 1862, Turner built the *Morning Star* for the Detroit and Cleveland Steam Navigation Company. It was a wooden side-wheel steamer that carried both passengers and freight.

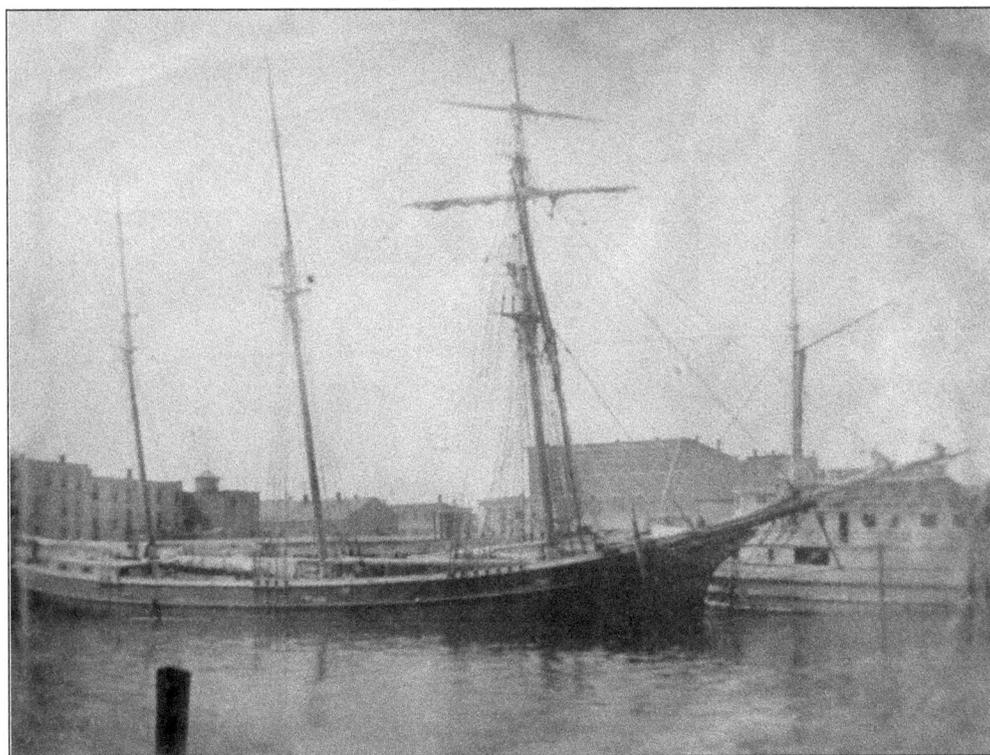

John Craig was born in New York. He pursued carpentry and studied drafting in order to learn vessel-design techniques. He worked for his brother-in-law Alex Linn in Gibraltar, Michigan. John later left and started his own shipyard there in 1882. The *Amelia G. Ireland* became Craig's first vessel on his own. James Chase captained *The Lark* (pictured), built by the Craig Shipyard that operated from 1882 to 1886. The outfit moved from Gibraltar to Toledo, Ohio, due to labor shortages.

From 1910 to 1917, Austin Church built "day boats." Located on Front Street at the foot of Truax Street, he constructed a large yard for building vessels. To the far right in the distance is the Church Boat Company, and to the left is one Captain Sullivan's home. The Church Boat Works built the USS *Ionita* in 1914, which was commissioned by the US Navy, 9th Naval District, as a section patrol craft that same year. She spent World War I on patrol in the Detroit River. The Purdy brothers joined Church Boat Works and took over operation.

The Purdy brothers, Edward "Ned" and James "Gil," worked for entrepreneur Carl Graham Fisher. Fisher initially had them working out of a site at the Indianapolis Speedway. The outfit then moved to Miami Beach, which Fisher was developing. The location proved to be a challenge for building boats, so the Purdy Boat Company moved to Trenton, Michigan, in 1919, staying there until 1924. At that point, Seth Davis's operation moved into the structure until the mid-1950s, when he sold it to Louis Liggett. Pictured from left to right are Ned, Gil, and an unidentified captain of the *Sea Witch*.

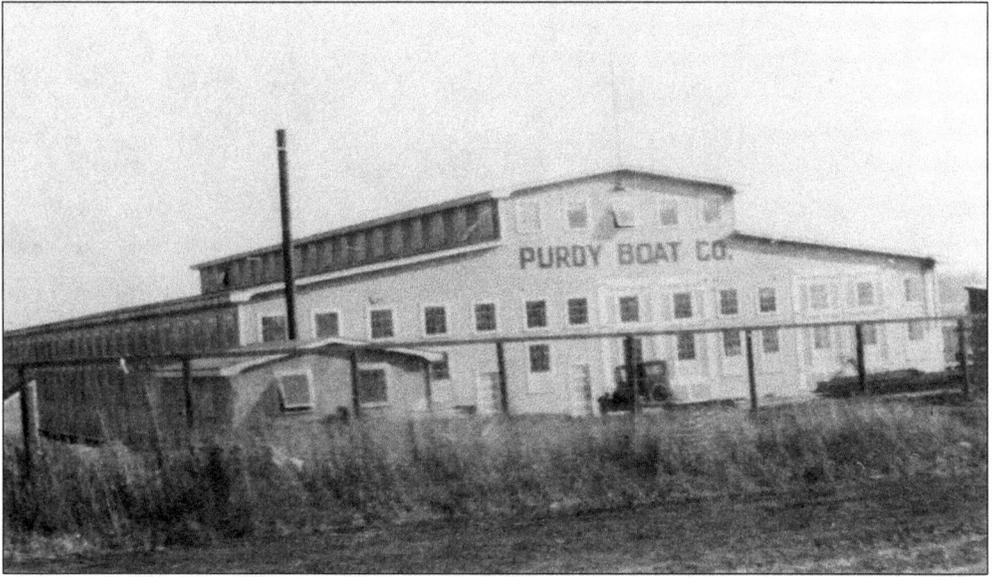

Initially, the Purdys took over the Church Boat Works facilities but soon realized that the shop was too small, so they bought land farther south on Riverside Drive at the foot of Walnut Street. On November 29, 1919, a fierce gale struck the almost-complete building, nearly demolishing it, causing over $7,000 in damages. Repairs were made, and by January 1920 it was nearly ready for occupancy. (Courtesy of the Trenton Historical Commission.)

The Purdy Boat Company moved from Miami, Florida to Trenton, Michigan in May 1919. The first boat designed and built by the Purdy's in Trenton was the *Shadow F*, completed in August 1922. In late 1924, the decision was made to move the company to New York State, and on April 1, 1925, the Purdy Boat Company opened for business in Port Washington, New York.

The Purdys were known for building big, beautiful yachts—complete down to the silverware, table linens, and china, marked with the company's monogram. One of the Purdys' best-known luxury yachts was the 74-foot *Aphrodite*, built for John Hay Whitney in the 1920s. (Courtesy of the Trenton Historical Commission.)

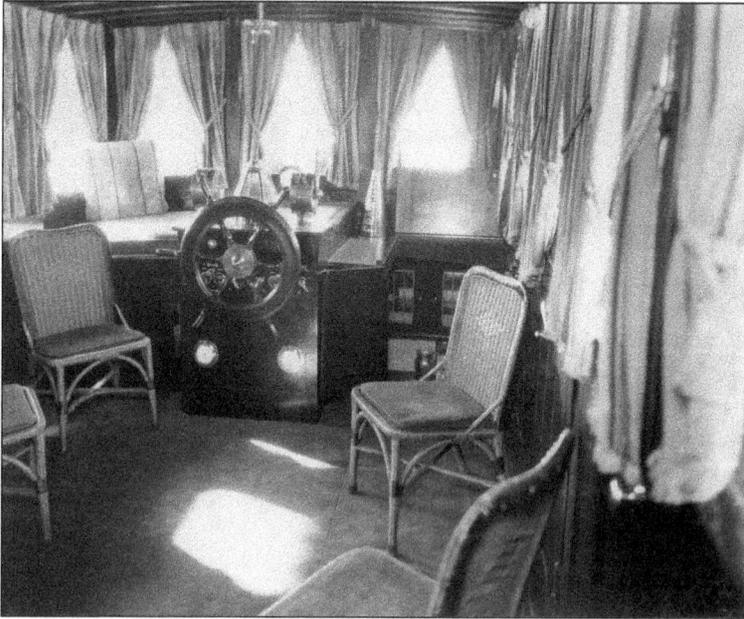

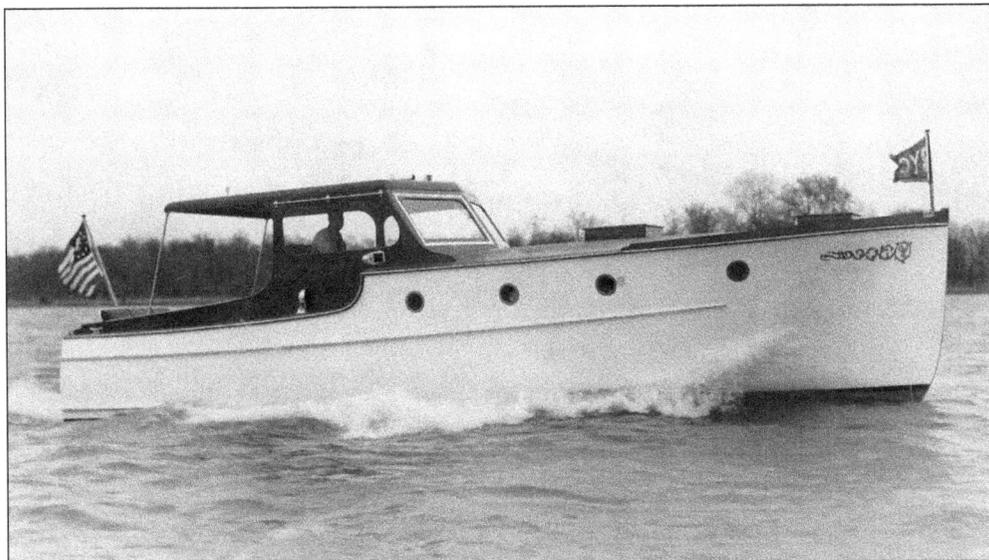

A.G. Liggett & Son Co. expanded its Detroit boat works in 1917 by building a new plant at the foot of Sibley Road and a creek. Cruisers from 30 to 50 feet were built there. Liggett designed and developed unique hulls, and that combined with craftsmanship in mahogany made the Liggett name a trademark of quality. (Courtesy of the Trenton Historical Commission.)

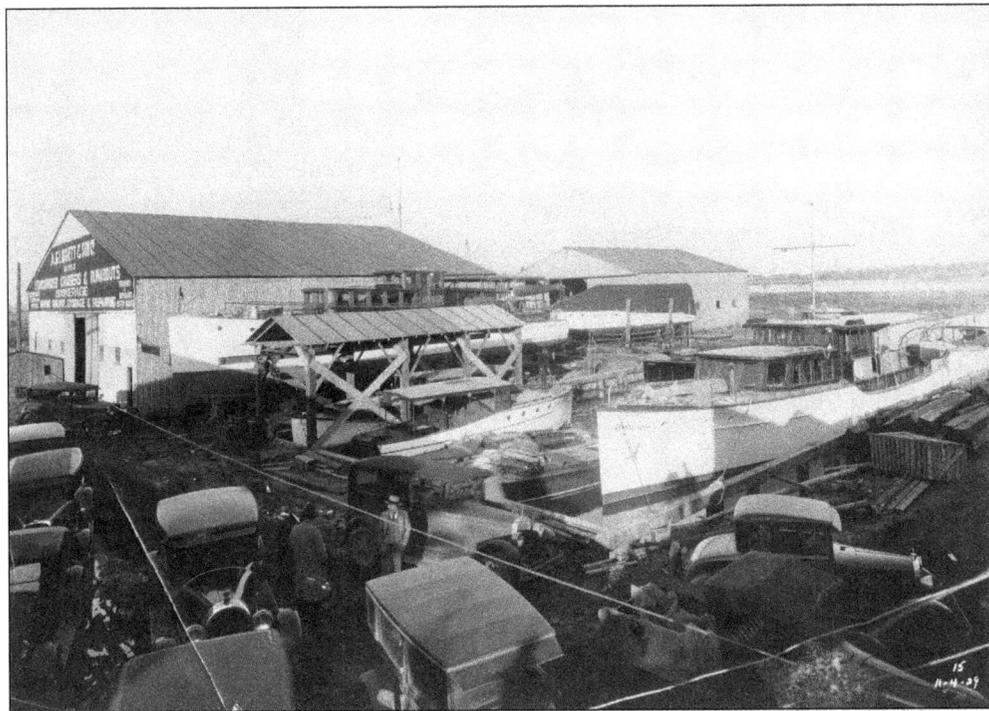

In 1943, Liggett moved into the old Purdy Boat Company's yards after having built a series of 75- to 110-foot "submarine chasers," with double-planked hulls, for the US Navy. The boat works employed 50 to 250 workers. In 1943, Louis Liggett moved his operation to Riverside Drive at the foot of Walnut Street. He did not continue boatbuilding but started selling Chris-Craft boats. (Courtesy of the Trenton Historical Commission.)

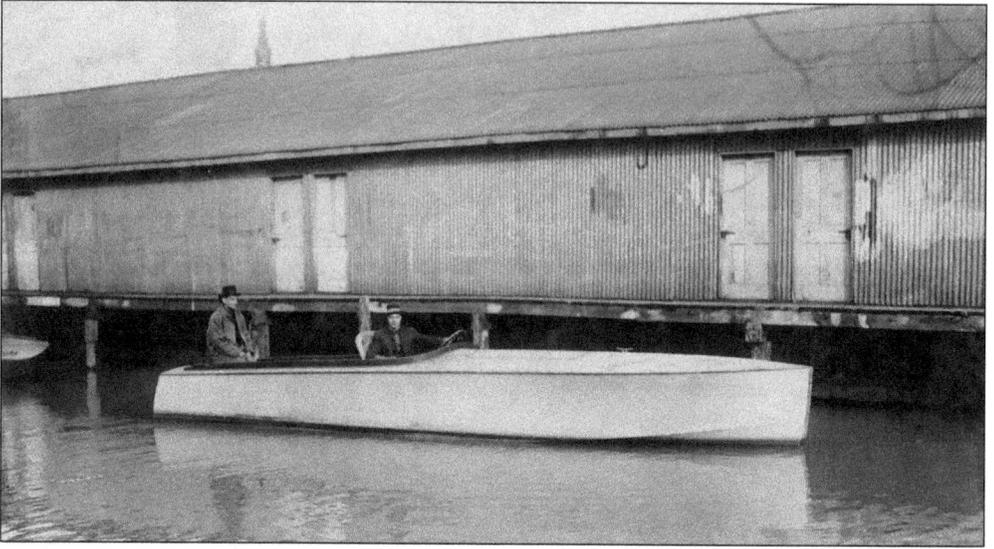

A.G. Liggett & Son Co. was also famous for its Bimini Baby, a high-speed cruiser up to 72 feet in length. The Biscayne Baby, driven by professional automobile drivers, was a speedboat that cost $2,800. It was 18 feet long and could turn around at 40 miles per hour.

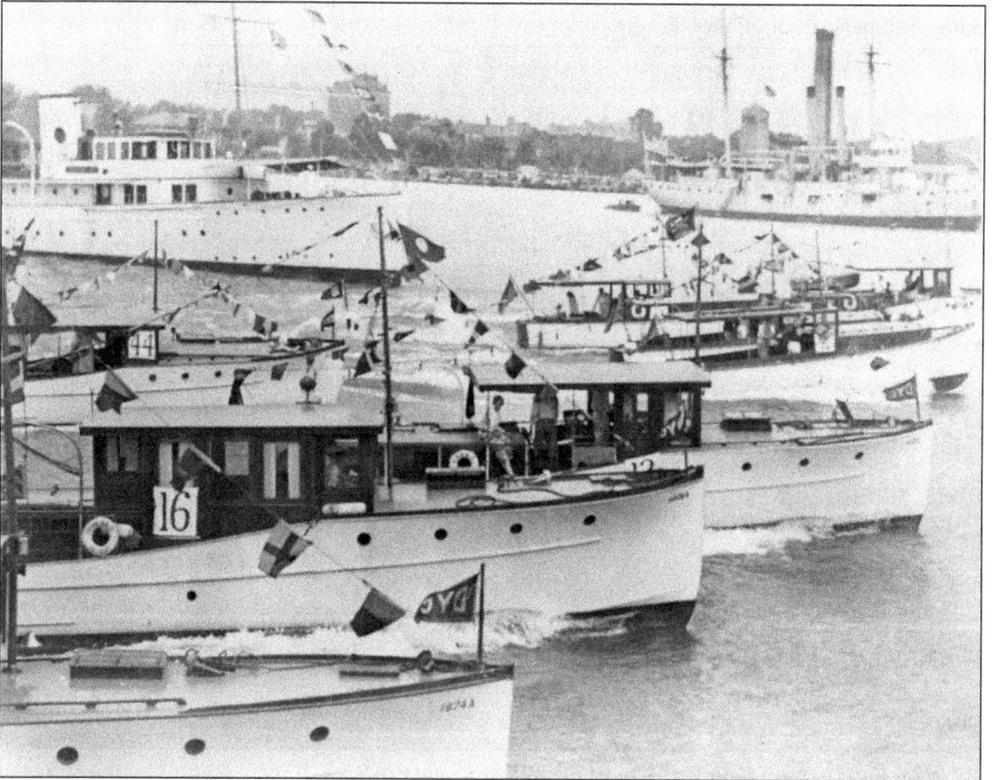

In the 1930s, a boat race was held at the Detroit Yacht Club and consisted of 30 Liggett cruisers. Louis Liggett Jr. became an authorized dealer for Chris-Craft pleasure boats, and in the early 1940s and 1950s the boat yard was mostly a repair facility. It was torn down after Louis Jr. retired in 1965.

Five

MAKING A LIVING

The first "businesses" in Trenton were probably the cash-and-barter saw mill and the Exchange Tavern. Giles Slocum built the first dock in 1834. Between 1825 and 1840, most of the settlers were engaged in farming and lumbering. For years, the town's activity centered on the river, and fishing became a profitable business.

With the coming of the railroads, the village began to expand west from the river's edge. New settlers came, and new houses began to spring up. By 1875, various enterprises had developed in Trenton. As discussed in the last chapter, there was a large shipyard. A second sawmill was built to create additional lumber for the stave mills and factories making plow handles. Cheese boxes, used for aging cheese and transporting it to a distributor or store, were also assembled by the D.H. Burrell Company in their stave mill. Roundhouses, foundries, car shops, and stations for the railroads were built, and taverns, stockyards, a quarry, and customs houses were opened. There was a sash, blind, and door manufacturer, a large flour mill, a dairy, a potash plant, and general agricultural works.

Many businesses have come and gone but their memory and history still lives on.

The area comprising the Sibley Quarry originated in the Devonian Period, an era spanning from 416 to 359.2 million years ago. Legend states that local Native Americans first operated the limestone quarry and used the stone for arrowheads. The French who came with Antoine Laumet de La Mothe, sieur de Cadillac may have quarried stone for foundations and chimneys for their homes in Detroit.

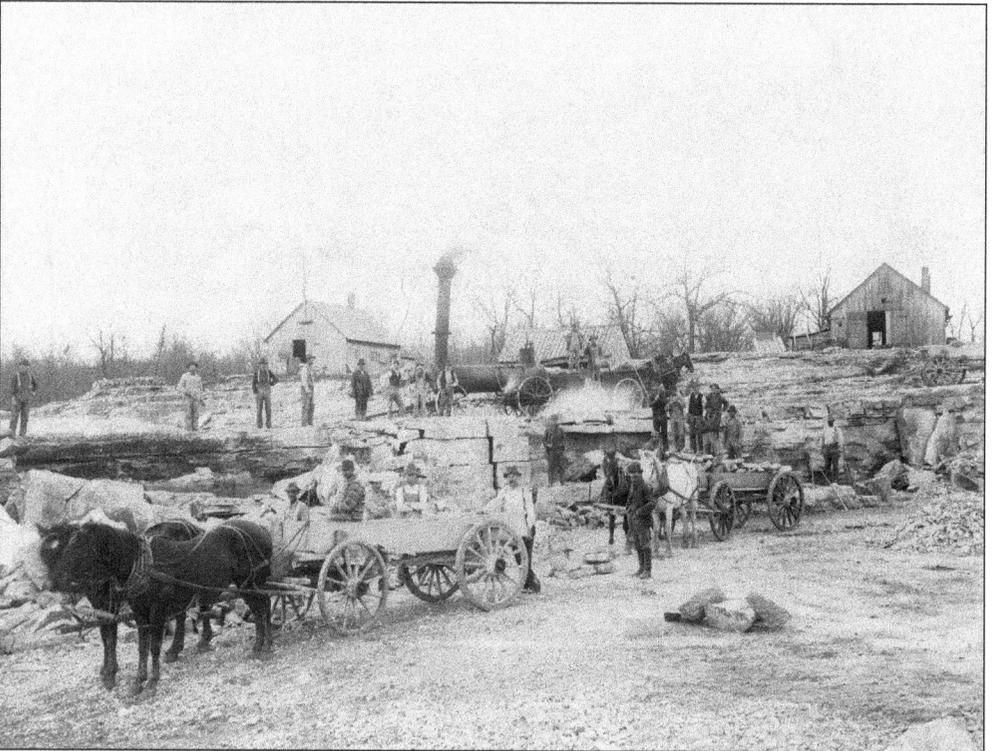

The Sibley Quarry was developed by Solomon Sibley and was excavated by hand by local Indians. Austin Church later bought it and used the limestone for the Church and Dwight Company, the manufacturer of Arm & Hammer baking soda. In 1819, township supervisor Artemus Hosmer was in charge of quarry operations for owner Solomon Sibley. During the cholera epidemic of 1832, Hosmer volunteered with three other quarry employees to take a load of lime to Detroit to be used as a disinfectant over bodies before the graves were closed.

This 1900 photograph shows William Duchene (standing) and Joseph Duchene coming home from the Sibley Quarry with their team of horses. (Courtesy of the Trenton Historical Commission.)

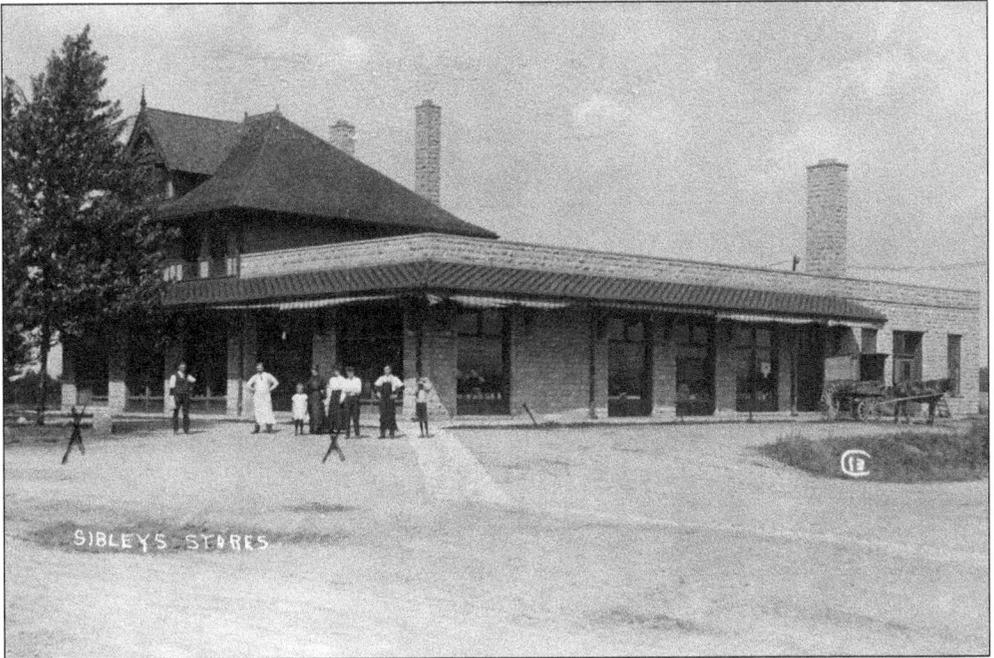

Quarry workers used the Sibley Company Store to purchase supplies. Employees and their families could buy goods on credit, and the amount would be deducted from their next paycheck. In 1900, Austin Church, who now owned the quarry, built an office and mechanized the operation. (Courtesy of Jeff Wagar.)

Cameron Hendricks acquired the Trenton Creamery about 1926. The horse-drawn milk wagons were retired in the early 1940s when Divco trucks, with the driver standing at the controls, replaced them. The glass bottles were carried in wire crates. Driver Harry Pomrenke remembered that Cam—and only Cam—taste tested every can of milk brought in from the farms using a ladle. Milk skimmed from the top of each bottle prior to placing the caps on went down the drain except for the amount Harry would save for his dogs. Hendricks eventually sold the business to Willie Quedneau.

The creamery also had its own baseball team. The players posing here around 1935 are, from left to right, (sitting) unidentified, Charles Lafayette, Cameron Hendricks, unidentified, Orville Walters, unidentified, and Russell Batten; (standing) ? Tromley, Jimmie ?, Frank Walters, Bill Batten, George Huff, and unidentified. (Carol Hendricks collection.)

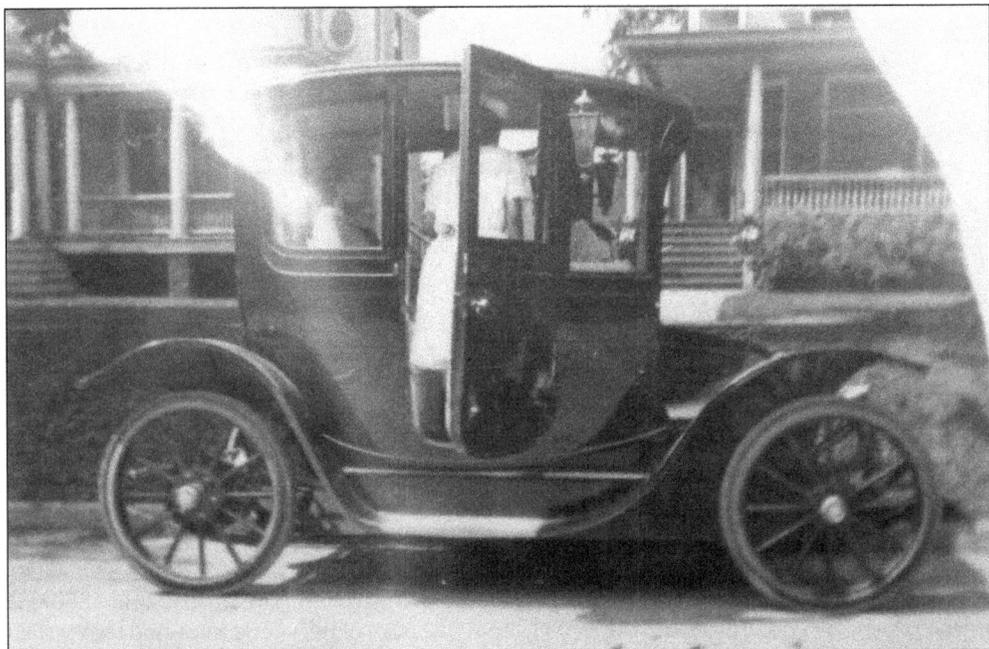

In 1912, Austin Church established the Church-Field Electric Motor Company. Fifty men were employed in building this groundbreaking electric automobile. The line had two body types: a four-door passenger coupe for $2,300 and a five-passenger coupe for $2,800. The plans for the Church-Field Electric were short lived. In August 1913, the company temporarily closed its plant and was never reopened. Eber W. and Jessie Vreeland Yost are showing their new car to their family in Wyandotte, Michigan. (Courtesy of John Yost.)

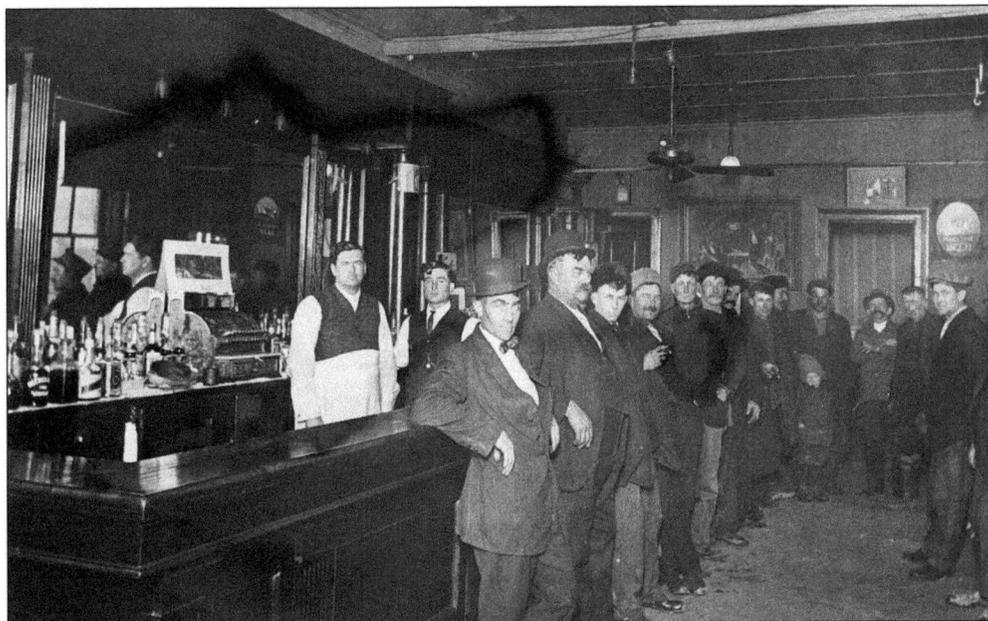

Located and the northwest corner of West Road and West Jefferson Avenue was another watering hole in Trenton, Singer's Bar, owned by Tony Singer. John Moore had previously owned the establishment. This photograph was taken in the early 1900s.

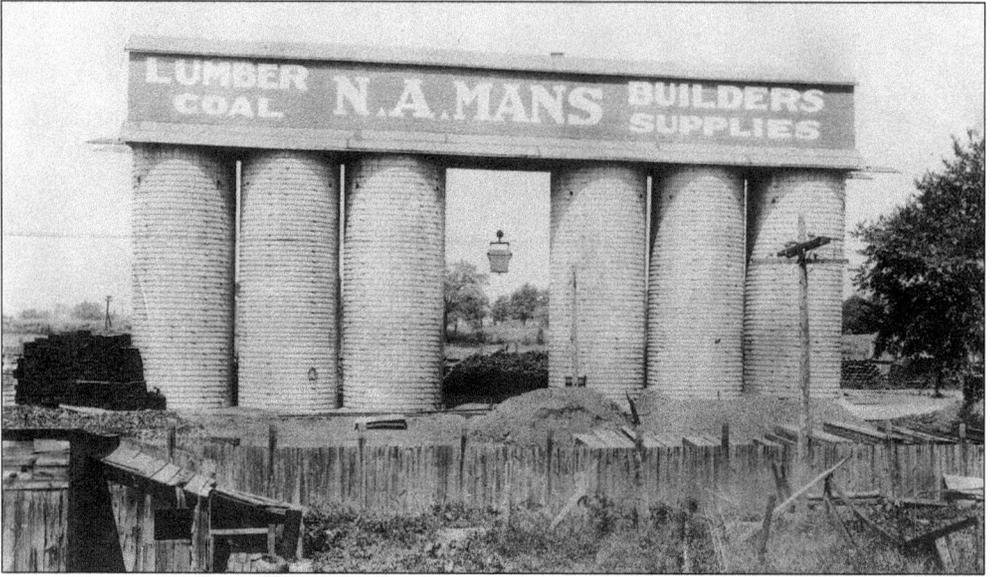

Nicholas Mans emigrated from Germany to Trenton sometime between 1850 and 1860. He learned the potash trade at age 19. Lye is made from the ashes of hardwood trees, and that is then either used to manufacture soap or boiled down to create potash. Later, Mans's sons expanded the business into coal and lumber; however, since there was no lumber office, orders were left at the local drugstore.

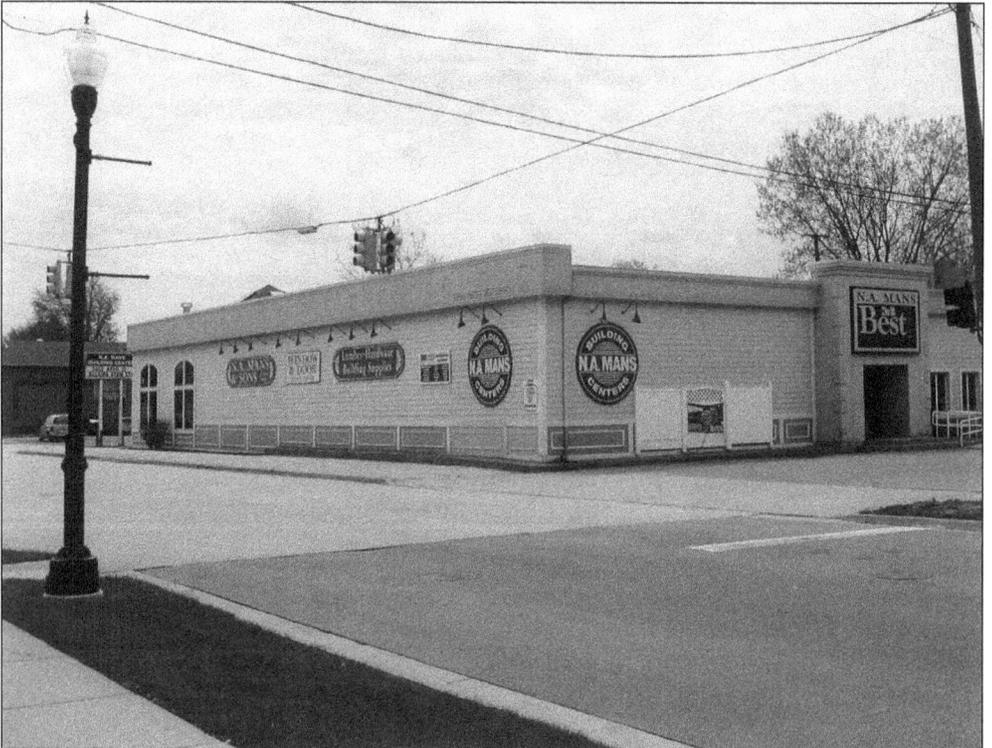

Today, Mans Lumber and Millwork is one of the oldest family-run lumberyards and is still owned and operated by the Mans family.

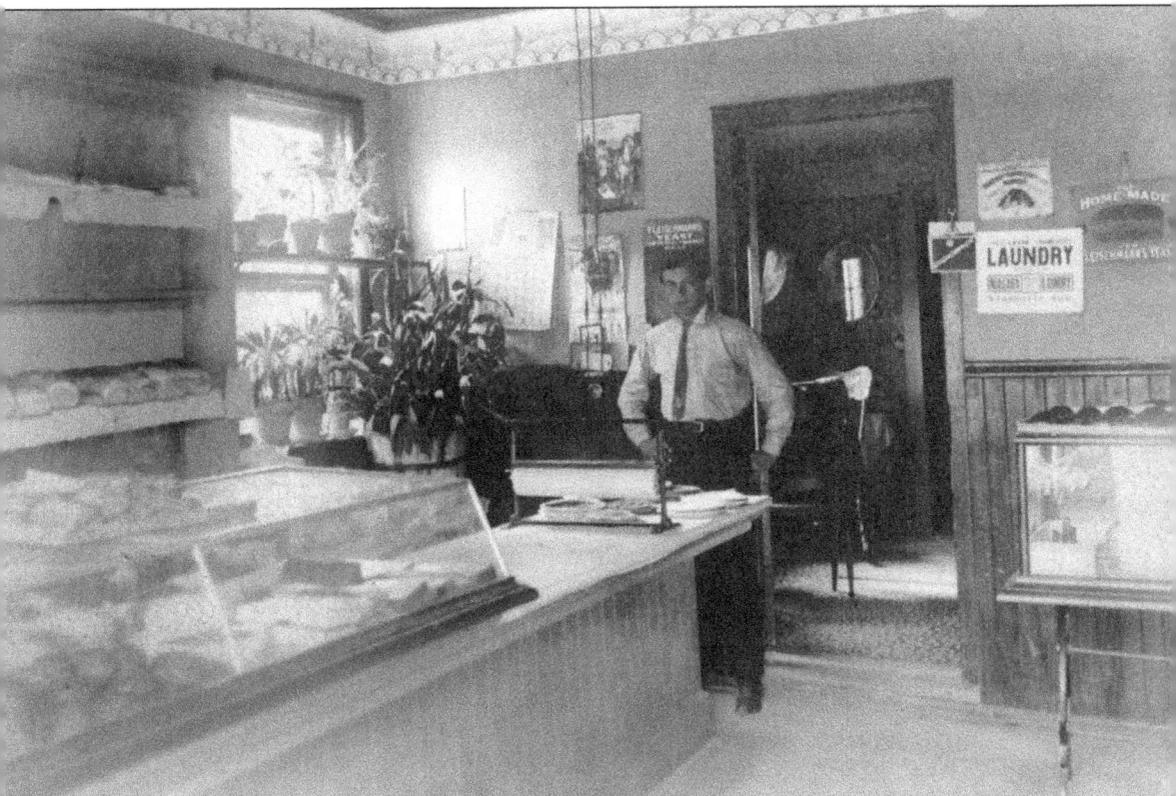

This bakery was owned and run by Louis Knaf, who came to Trenton and took over the bakery previously owned by Frederick Fedderkin and his wife, Marie. The ovens were out back, separated from the shop. Louis baked breads, doughnuts, and cream puffs filled with homemade whipped cream. The bakery also had a counter filled with penny candy for children, which included licorice sticks, mothballs, coconut strips, and rock candy. (Courtesy of the Lucy Shirmer collection.)

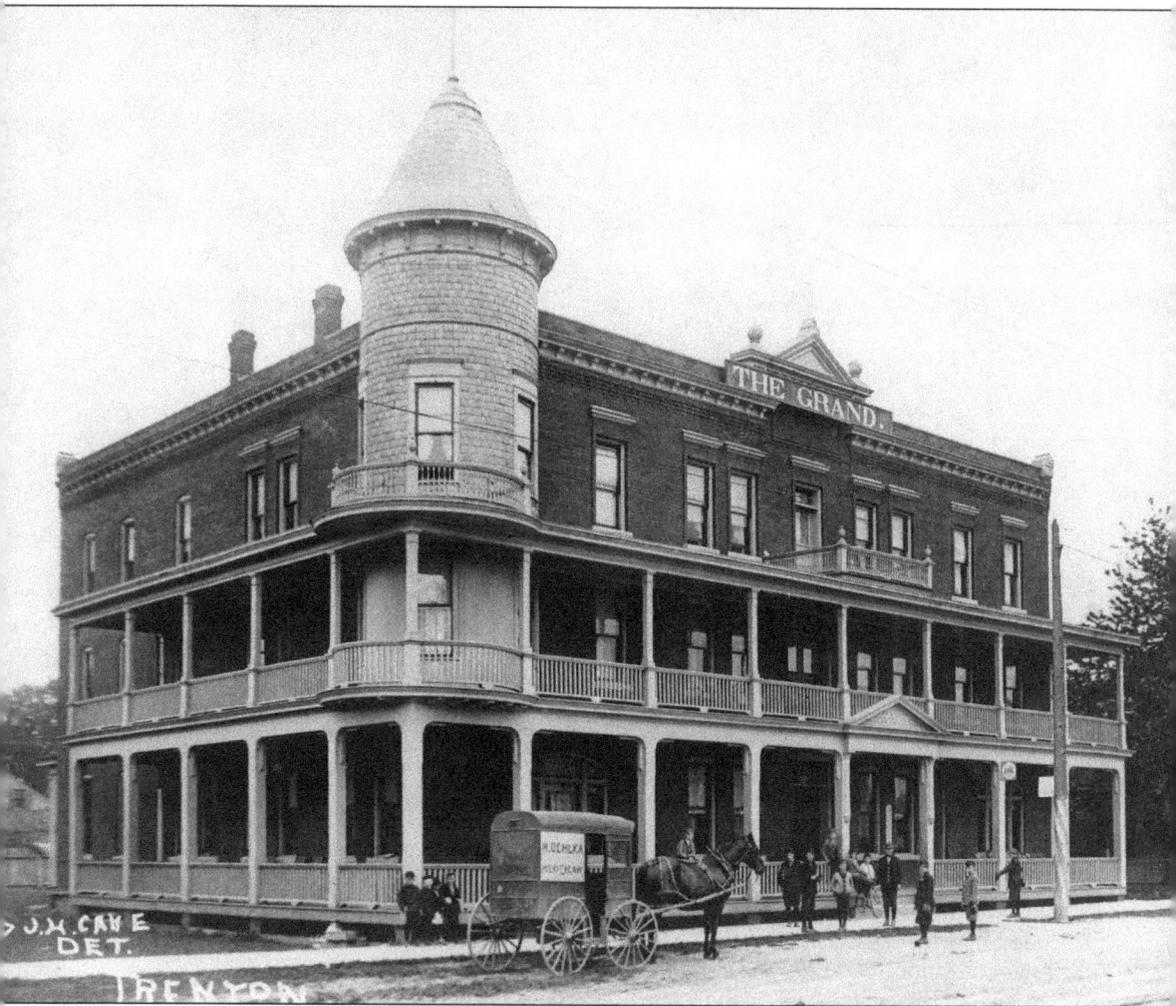

John Felder, born in Sandusky, Ohio, on March 25, 1845, came to Trenton on July 2, 1872. At the time of his retirement in 1905, he owned four different stores. His slogan was "If you can't find it elsewhere, you'll find it at Felders." His retirement lasted 27 years, and in 1932 he opened a store with his sons John and Fred in charge. In 1895, he and his wife, Anna, opened the Hotel Felder on Jefferson Avenue. The hotel is a classic Queen Ann–style structure with an 11,000-square-foot interior. It was large enough to hold 29 rooms, a honeymoon suite, an office, and a dining room and had two bathrooms on each floor. The building was the first in Trenton to feature electric lights. Running water was supplied by a special pump and pipeline direct to the river. The hotel's grand opening included an open-air concert performed by the village band. On November 13, 1896, according to the *Wyandotte Herald*, "The Felder House menu was printed in French Sunday. Result, a strike by the waitresses." In 1901, due to competition from the Commercial Hotel, the Hotel Felder reduced its rates to $1.25 per day and offered dinners for 25¢. At one point when the hotel changed owners it received the name The Grand, which stuck even after the property exchanged hands a few more times. Presently, it is called TV's Grand Event. (Courtesy of the Lucy Shirmer collection.)

A bar was also located in the hotel. From left to right are Ronald Schenavar, Sam Hendricks and his dog Teddy, Ed Hartrick, Alex LeFluer, and Pete Sanger. Saloons at the time paid $500 for their licenses. The original bar is still being used in the hotel today. Note the spittoons on the floor.

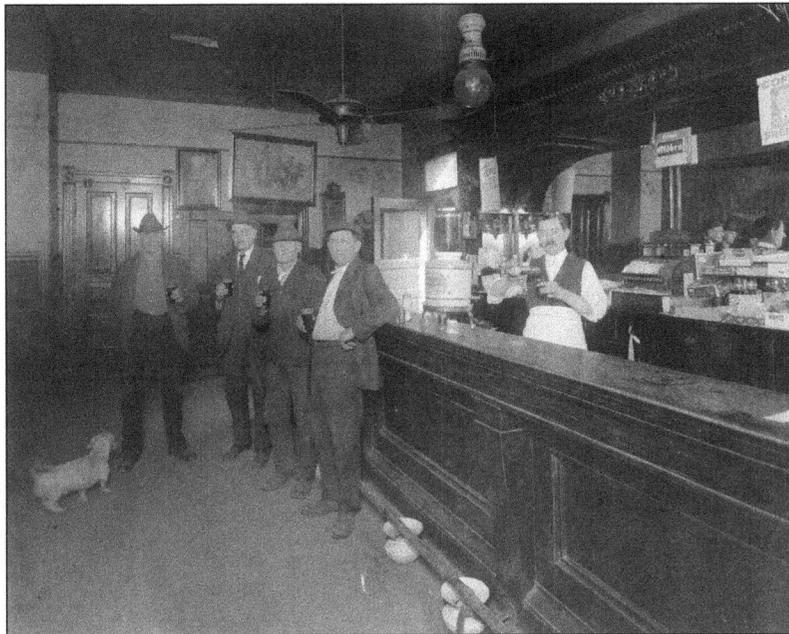

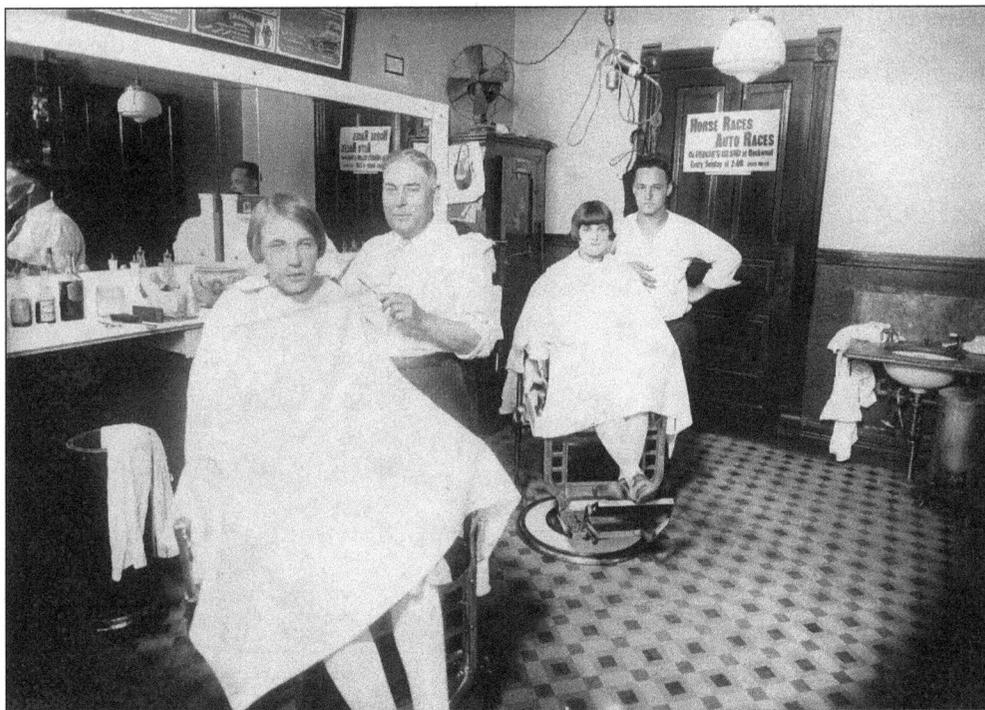

The Kaemlein Barbershop opened on December 3, 1887, and was also located inside the Hotel Felder. Customers included Jean Sutherby (seated left), Edna Labadie (seated right), and barbers Adam Kaemlein (left) and Ben Steiner. (Courtesy of the Trenton Historical Commission.)

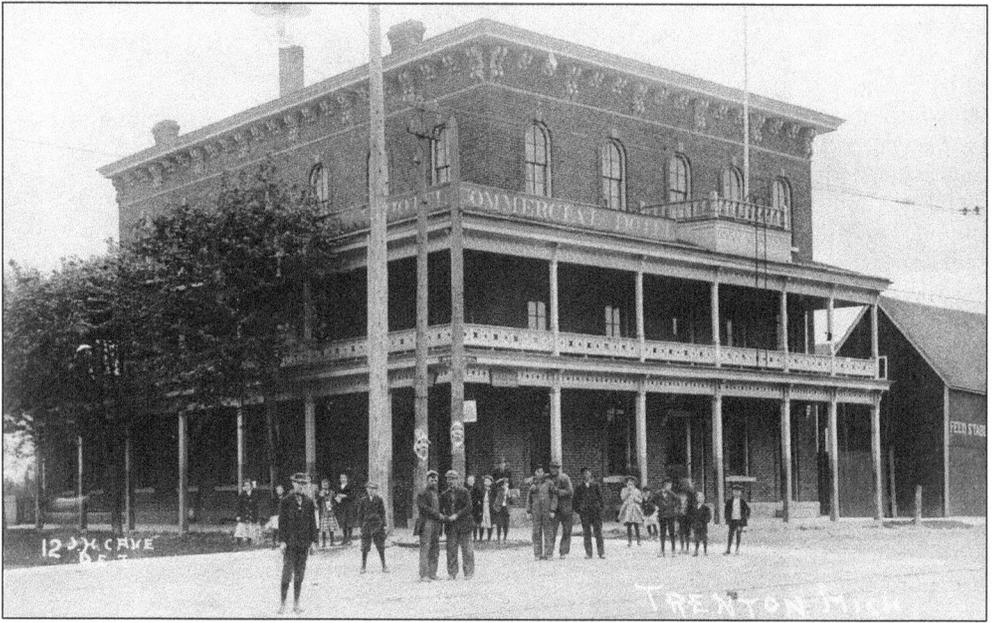

The Dion House, a hotel, was built in the 1880s under an unknown name. Chris Radeau had been shot by a transient named Fritz Bereay and died of his wounds, so Mrs. Radeau ran the hotel alone—one of the few women in business in Trenton at that time. A few years later, she married Adolph Dion, and the hotel name was changed to the Dion House. In 1890, it was redecorated and renamed the Commercial Hotel when Ed Janke became the new proprietor. Later, it became the home of the Trenton Masonic Lodge No. 8, which pulled off the porches and raised the ceilings.

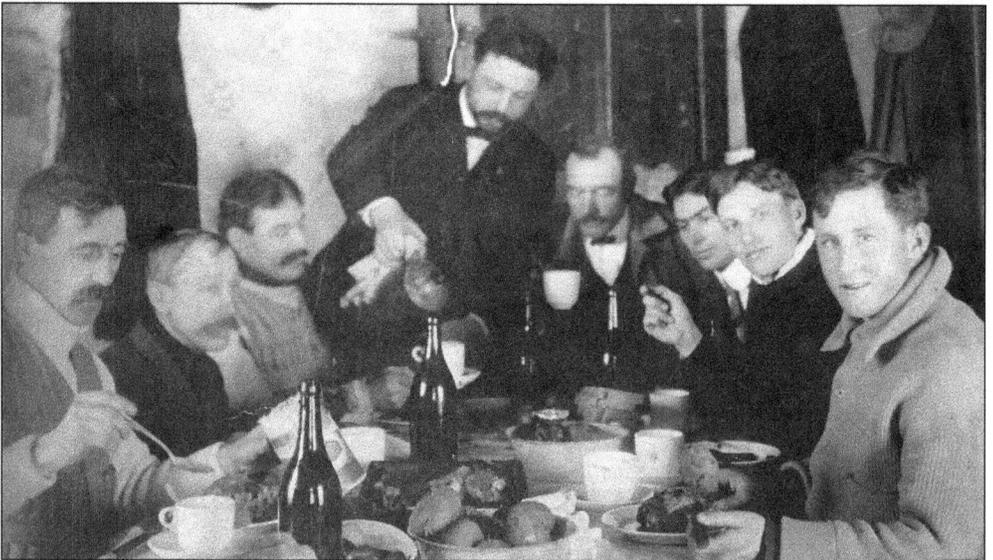

The Dion House advertised rooms for 40 regular borders, and it was sometimes necessary to double up in order to accommodate transient guests. The hotel also included fine dining. From left to right, Dr. Holden, A.B. Smith, John Reed, Dr. Osborn (pouring drinks), Sam Hendricks, Dr. Thompson, Mr. Losee, and Mr. Teifer are seen meeting for dinner at the Commercial Hotel in 1905, dining on a duck dinner with mussels.

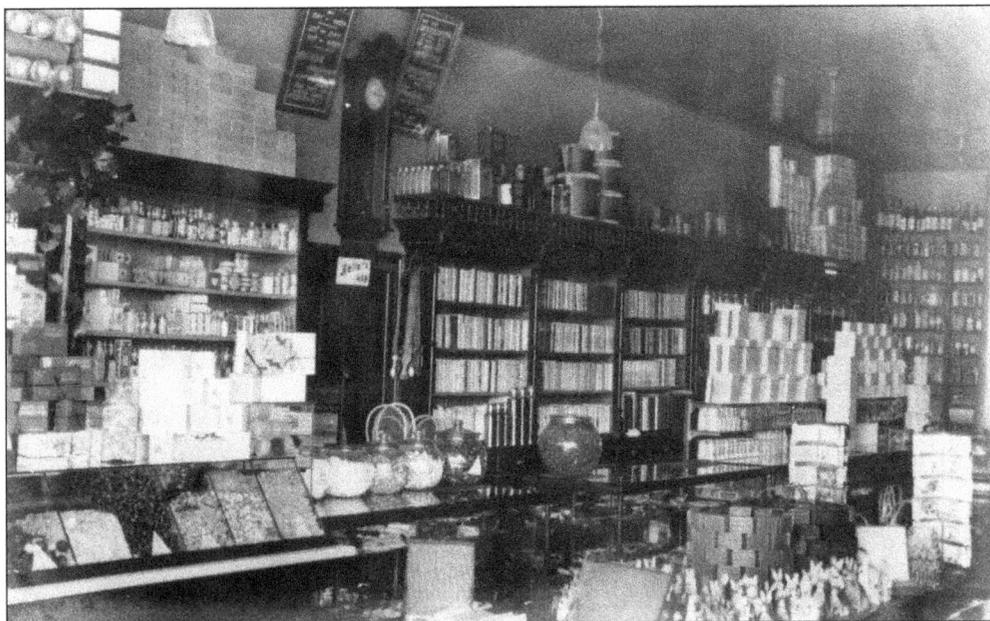

In 1907, the Dorrance & Garrison Drugstore was located on West Jefferson Avenue in Trenton. Claud O. Owen was the manager and bought it when the previous owners retired. At that time, the name was changed to Owen Pharmacy. There were also two Dorrance & Garrison stores in Wyandotte. (Courtesy of Claud Owen.)

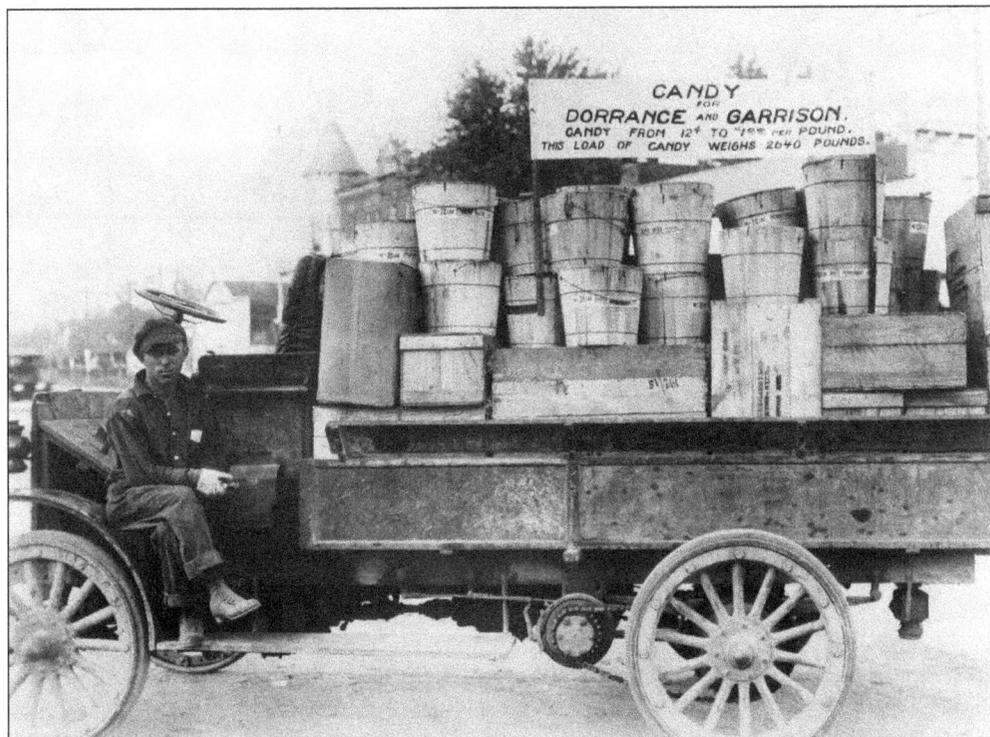

Driving the candy truck for Dorrance & Garrison in 1917 is Fred Dusablon. In 1966, the business became Zemke Drugs and in 1975 the Ego Eye (a clothing store). (Courtesy of Claud Owen.)

Trenton's D&C Stores, Inc., was a place where one could buy anything from 5¢ to $1. In 1945, it became C.F. Smith Co. In 1950, the location changed to Stamps Home and Auto Supply. In 1970, it became the Trenton Flower Shop.

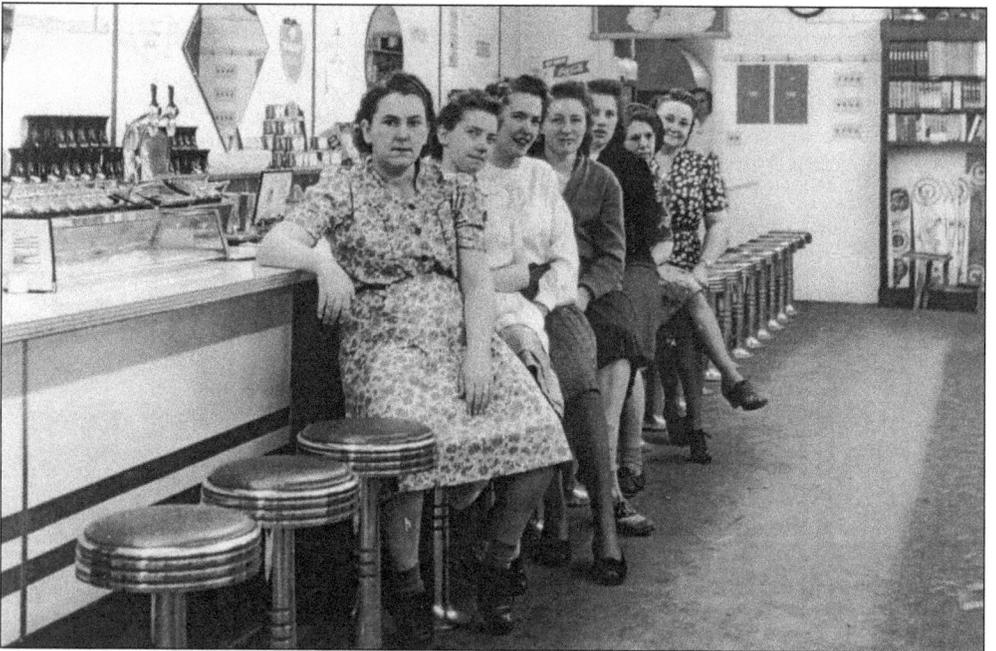

D&C Stores moved one block north on Jefferson Avenue and became C.F. Smith. The store had a soda bar, serving sundaes for 15¢; soda, lemonade, and silver fizz for 10¢; and an Angel Wing Sundae, which was cream covered with fruit, surrounded by slices of banana, topped with marshmallow, and served with wafers. This World War II–era photograph shows Helen Blossom (fifth from the left) and other unidentified ladies at the bar. (Courtesy of the Trenton Historical Commission.)

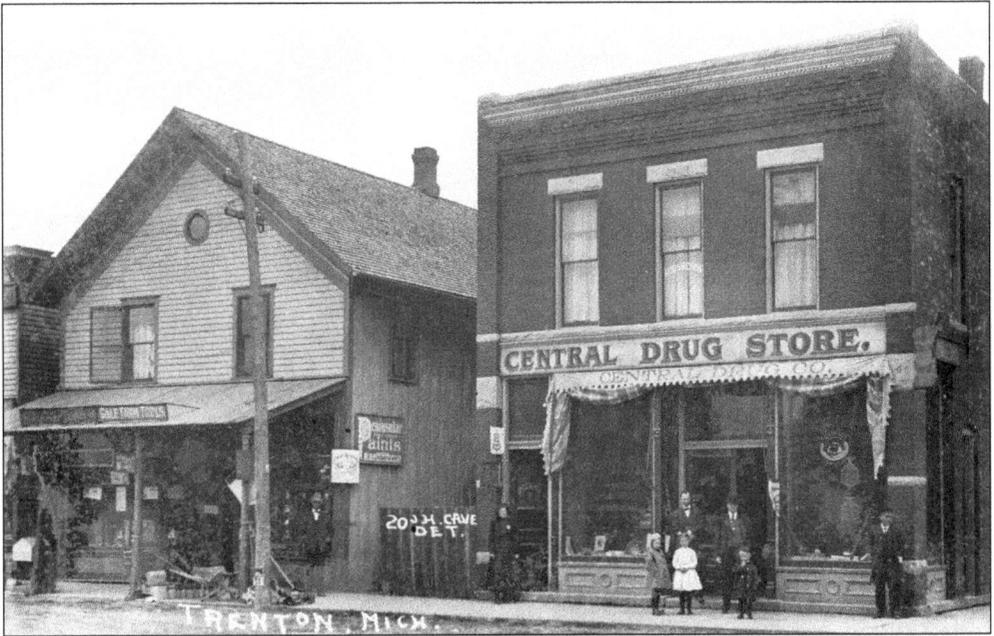

The Central Drugstore was located on the southwest corner of Jefferson and St. Joseph Avenues. It was later purchased by Claud Owen and became Owen Pharmacy.

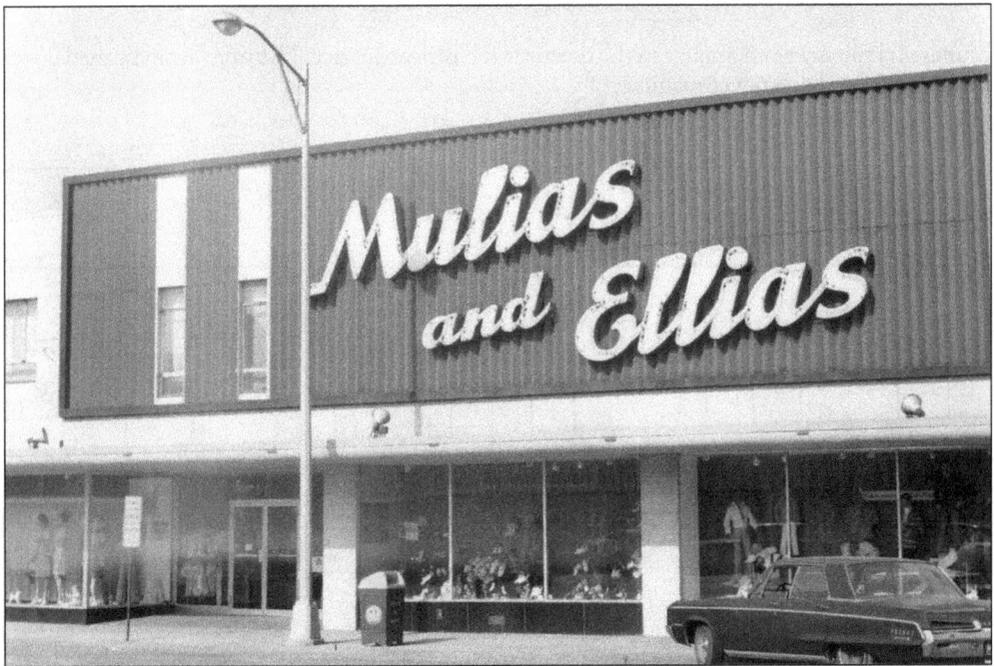

In 1908, Meyer Mulias emigrated from Lithuania to Bad Axe, Michigan, and later bought out Alf Bailey's General Store in 1914. Mulias and his cousin Ben Ellias sold groceries, hardware, and dry goods. Stanley Ellias, the son of Meyer Ellias, expanded the business to a large, modern department store covering almost a whole block on West Jefferson Avenue. There was a huge setback in 1926 when fire destroyed several stores on the block. It reopened for business in a tent the next day, although much of the stock had been lost in the fire.

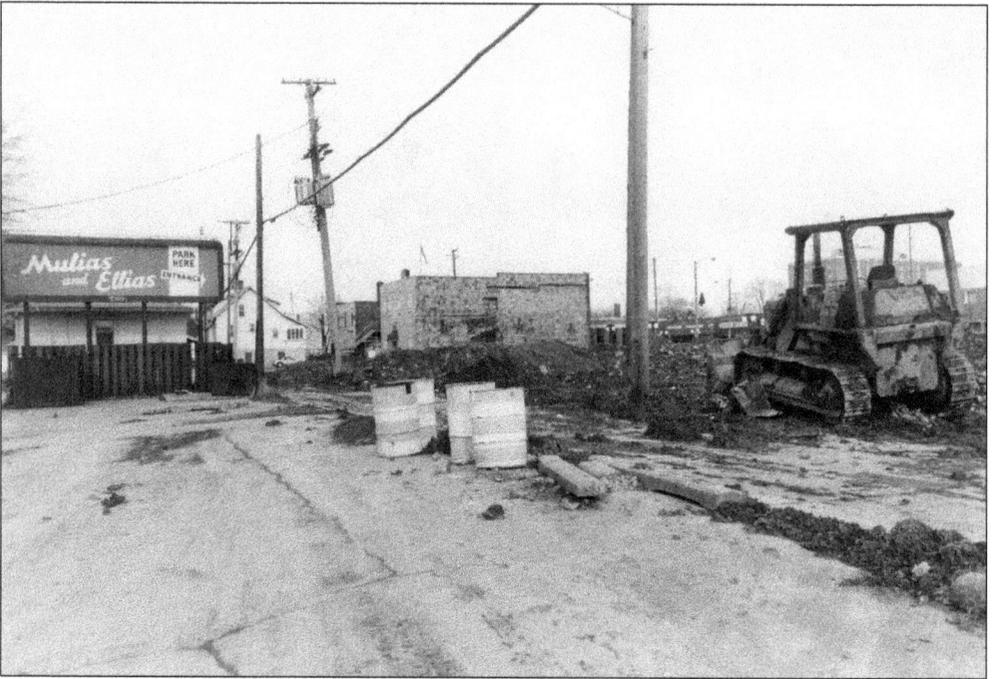

Mulias and Ellias was an anchor in the downtown business district. The store again burned down in the 1980s and was never rebuilt.

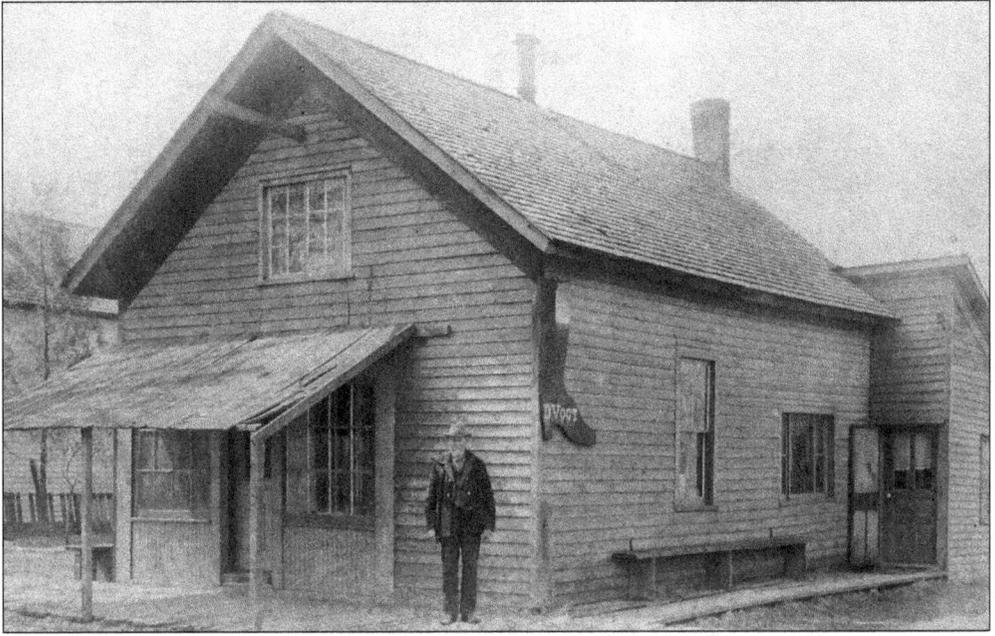

David Vogt was born in Erie, Pennsylvania, in 1834. His father, Gotfreg Vogt, was from Germany, and his mother was from Pennsylvania. Vogt was a shoemaker and made ginger ale in the back of his store. (Courtesy of the Trenton Historical Commission.)

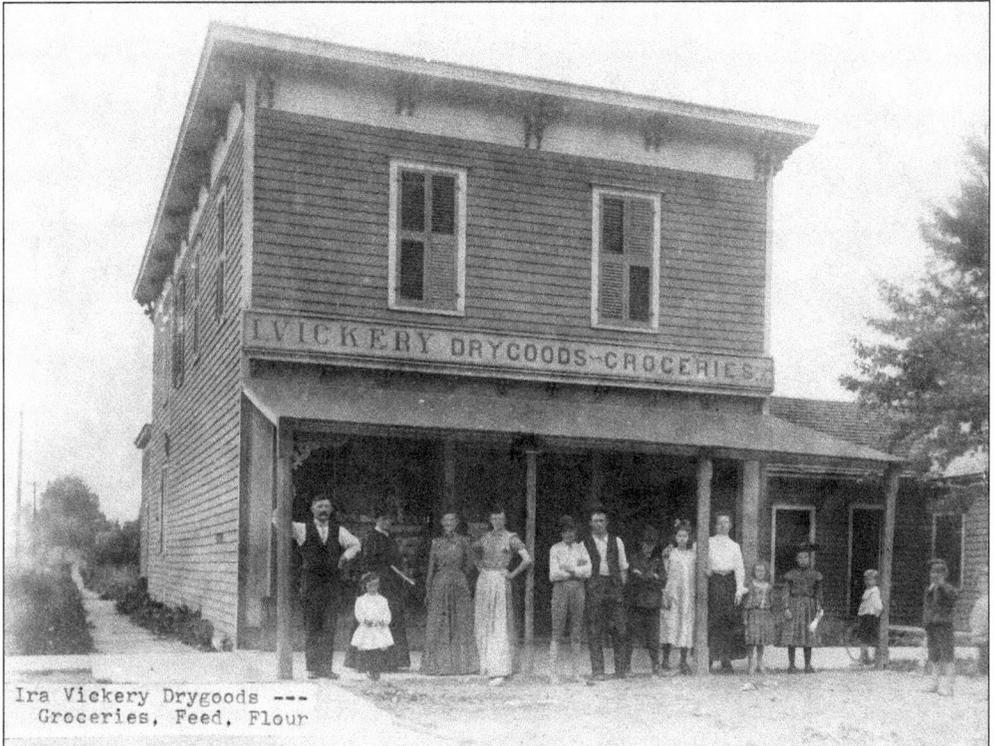

Ira Vickery owned a dry goods store, selling groceries, feed, and flour. In 1877, he became a village trustee. (Courtesy of the Trenton Historical Commission.)

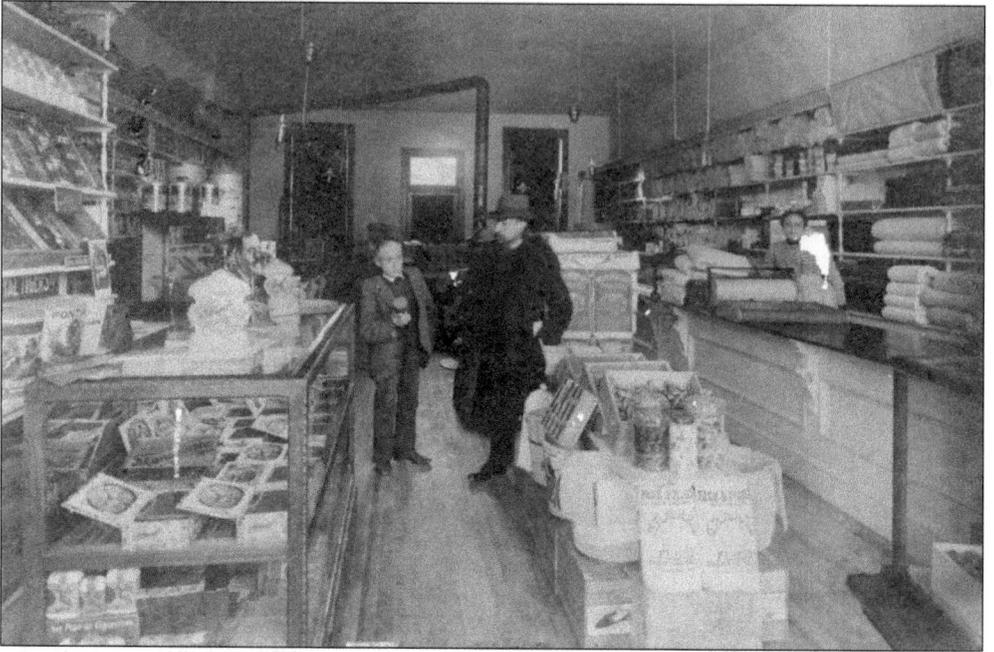

Charles Kimberk owned the general store on Jefferson Avenue. From left to right are Kimberk, an unidentified customer, and store clerk Grace Rice. The store later became Affholter Market and then Harry Davis Hardware. (Courtesy of the Trenton Historical Commission.)

In 1936, in a house given to them by his father, Ralph ridge Jr. and Sally Ridge opened the Ridge Funeral Home. Ralph Jr. graduated from the Cincinnati College of Embalming. During World War II, he joined the Army, and Sally went back to school to obtain her mortuary license, becoming the first female funeral director in the state of Michigan. In 1966, a new funeral home was built, and the old house was torn down. Today, it is part of the Martenson Family of Funeral Homes. (Courtesy of the Trenton Historical Commission.)

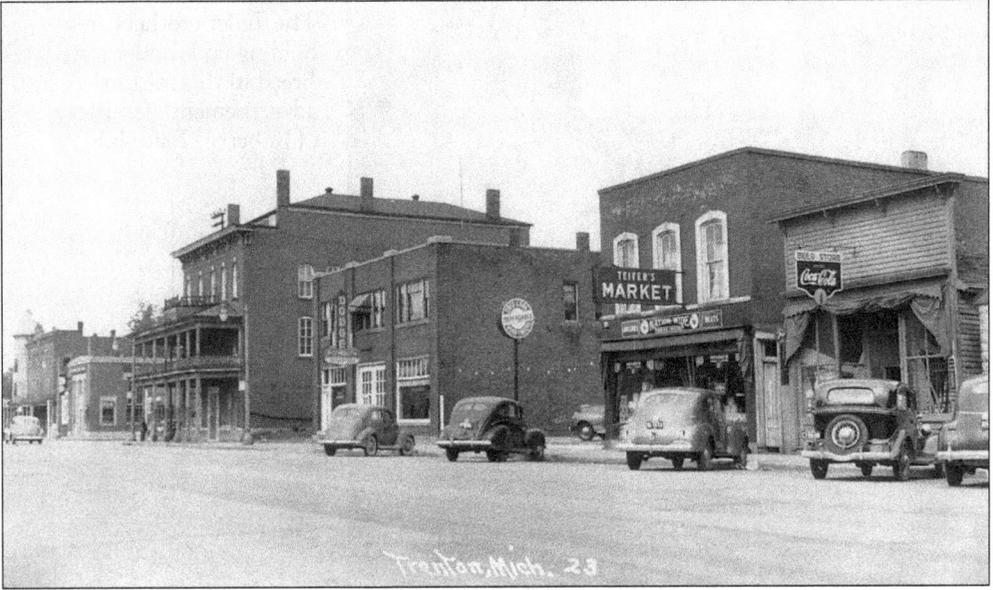

Robert Teifer opened his meat market and butcher shop on Jefferson Avenue around 1924. He would ride around to farms around Carleton, Maybee, Dundee, and Flat Rock buying cattle and then drive them back, cowboy style, to his Trenton slaughterhouse. (Courtesy of Robert J. Teifer Jr.)

Robert Teifer (right) and his brother James (left) also opened a grocery store in Trenton. (Courtesy of Robert J. Teifer Jr.)

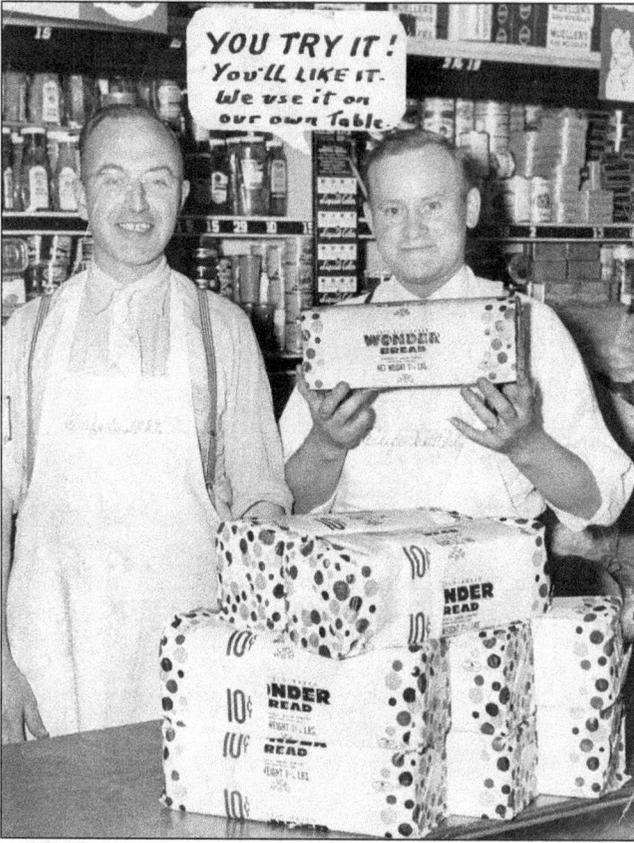

The Teifer brothers are holding up Wonder Bread in this in-store advertisement. (Courtesy of Robert J. Teifer Jr.)

This photograph is of William Jenkinson, on the right, in 1914 working in his barbershop located on West Jefferson Avenue. Jenkinson was the famed tightrope walker who performed at the Trenton Street Fairs (see page 22). Walter Hoffman is on the left.

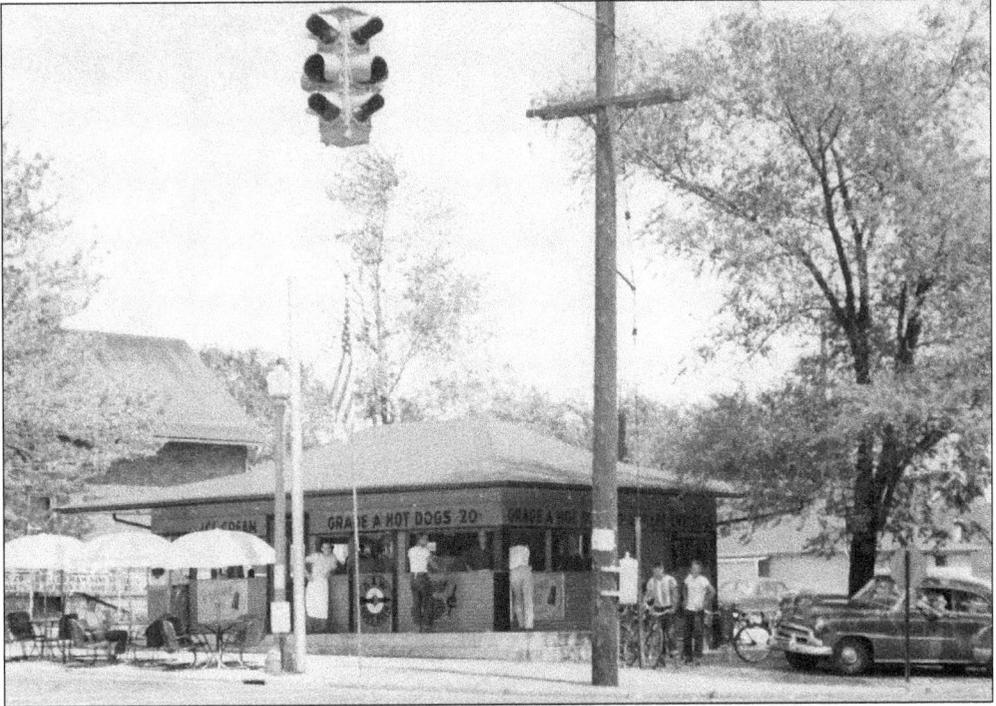

Trenton had a root-beer stand located on the corner of Jefferson Avenue and Maple Street. Owner Pete Duich opened it in approximately 1935. It later became the first A&W Root Beer franchise in Michigan. This photograph was taken in 1952.

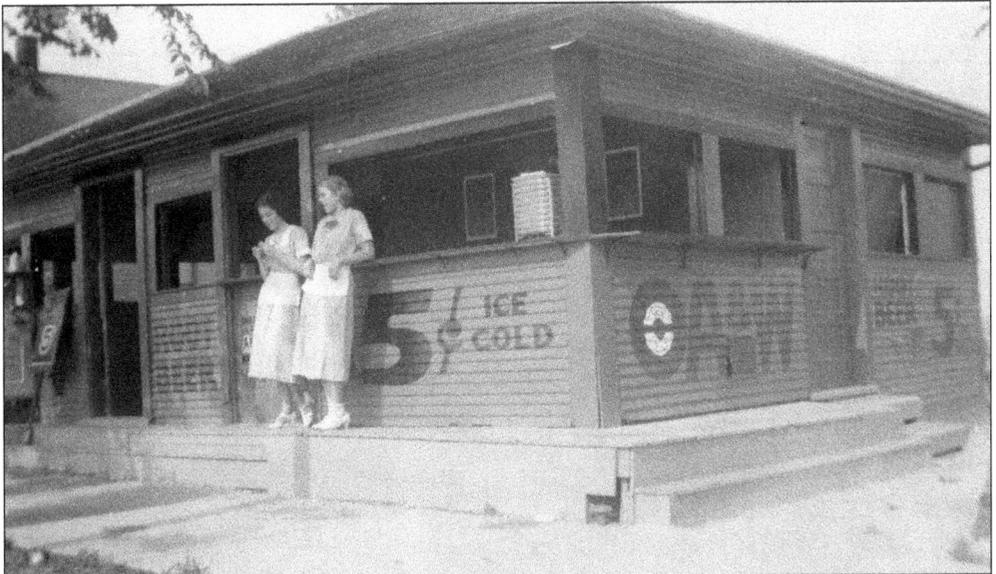

In 1946, Mrs. Hattie Duich (left) and her sister Marie Bradshaw (right) served as waitresses at the Trenton A&W root-beer stand.

The property located at 2447 West Jefferson Avenue, between Cherry and Atwood Streets, has had quite a few businesses, including Hartrick's Garage. The fire department rented space in the garage for its fire truck before a fire station was built.

October 25, 1933, 8 P. M.

Free Talking Pictures!

Three Big Reels

at the New Home of the

DODGE and PLYMOUTH

WITHAM & BALLINGER

DIRECT DEALERS

Phone 579 2447 West Jefferson Ave. Trenton, Michigan

Our Service Department

will more than please you—because of the low cost, ample facilities and experienced mechanics. Let us inspect your car, at no cost to you.

TIGER PRESS, Trenton Michigan

Later, the location changed to William & Ballinger Dodge and Plymouth, Truby Ford, and Howard Chevrolet. Taking the place of car dealerships was the Trenton Theater.

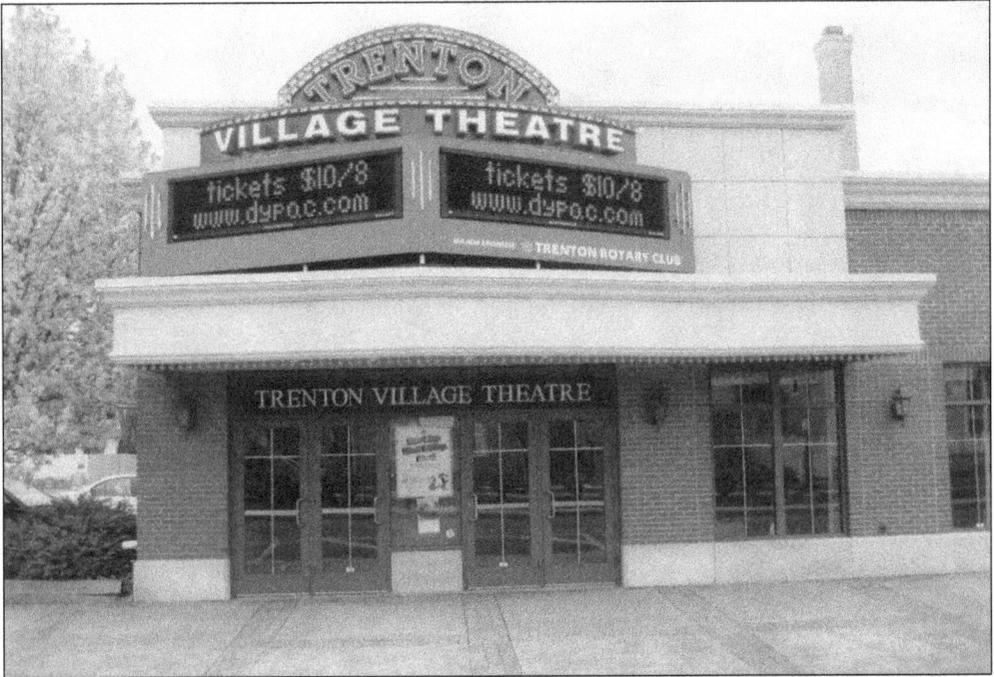

The Trenton Theater opened in 1919 and could seat 600 people. The theater was renovated, reducing the seating to 375, and reopened on July 31, 1936, showing *Mr. Deeds Goes to Town*, starring Gary Cooper. The Village Theater is now owned by the City of Trenton in cooperation with the Downriver Youth Performing Arts Center (DYPAC), who manages it.

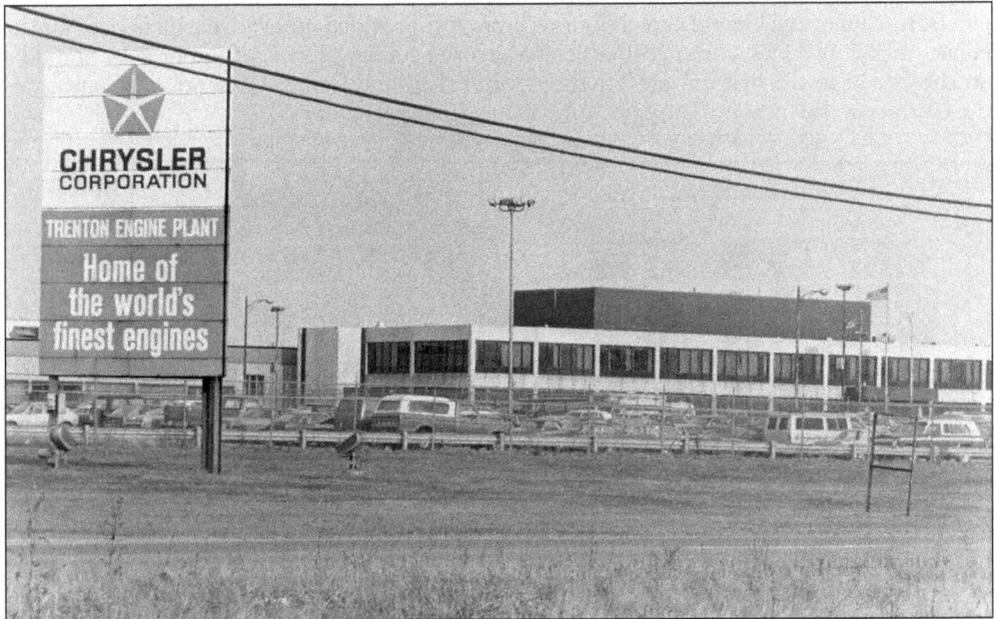

The Chrysler Corporation Trenton Engine Plant is located at 2300 Van Horn Road. The complex encompasses 822,000 square feet and sits on 136 acres. Previously, the plant made the fuel-efficient V-6 engine. On May 20, 2011, Chrysler wrapped up six decades of production, and the plant will now produce core components for the Pentastar engine.

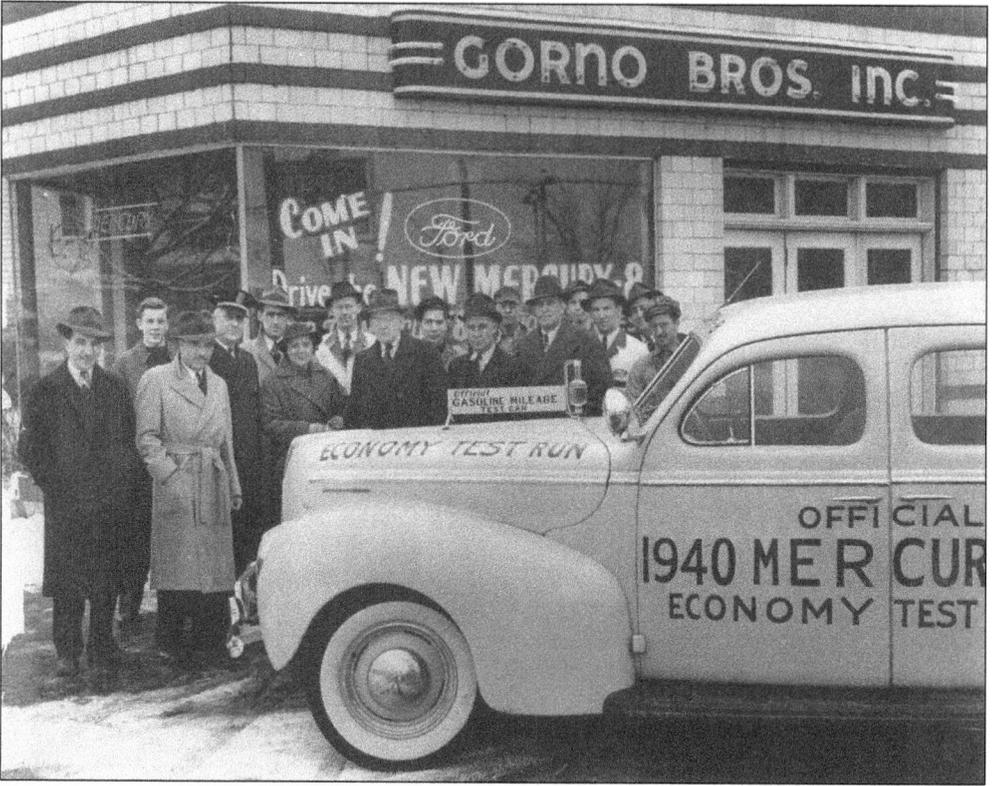

Opened in 1939, the first dealership and used-car lot of the Gorno brothers was located on West Jefferson Avenue and George Street. Gorno Bros., Inc. provided innovative experiences for the public, including a look at the 1940 official Mercury Economy Test Run automobile. Standing on the far left in the first row are Michael Gorno (left) and Dominic Gorno Sr. (Courtesy of the Gorno family.)

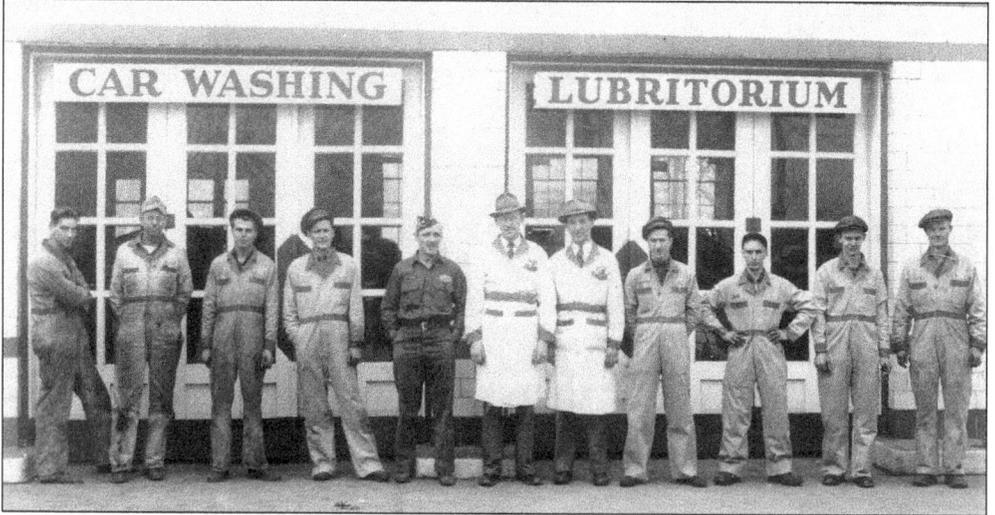

The automobile dealership also provided up-to-date services for their customers, such as car washing and a lubritorium, a place where the car's oil was changed. The dealership is now located on Allen Road in Woodhaven. (Courtesy of the Gorno family.)

Sibley Gardens Cafe
Trenton, Michigan
1950

Sibley Gardens is an independent, family-owned restaurant that has been open since 1935 and owned by the Piunti family since 1944. First located at 835 West Jefferson Avenue, it later moved to 916 West Jefferson Avenue, where it has been to this day. The restaurant employed Italian immigrant chefs to teach the owners how to make homemade ravioli. Sibley's is currently in its 71st year of operation.

Complete Dinners

INCLUDING

Assorted Relishes Minestrone Soup Juices

Steaks and Chops

BREADED VEAL CUTLET, Tomato Sauce	1.75
FRIED PORK CHOPS	1.75
CALVES LIVER and BACON or ONIONS	2.25
BROILED LAMB CHOPS	2.25
HALF BROILED CHICKEN	2.00
SIRLOIN STEAK	2.50
BROILED BEEF TENDERLOIN	2.50
T-BONE STEAK	3.00
CLUB STEAK	2.00

Italian Dinners

RIGATONI, SPECIAL SAUCE	1.85
SPAGHETTI, MEAT SAUCE	1.50
SPAGHETTI, SPECIAL SAUCE	1.85
SPAGHETTI, MUSHROOMS	1.85
RAVIOLI, MUSHROOM SAUCE	1.50
VEAL SCALLOPINI, WINE SAUCE	1.85
CHICKEN CACCIATORIA	2.25
VEAL CACCIATORIA	1.85

Sea Food

FROG LEGS (Roadhouse Style)	2.25
STURGEON	2.25
SCALLOPS	1.75
FRIED OYSTERS (In Season)	1.75
FRENCH FRIED SHRIMP	2.25
BROILED LAKE TROUT, Tarter Sauce	1.75
FRIED FILET OF PERCH, Tarter Sauce	1.75

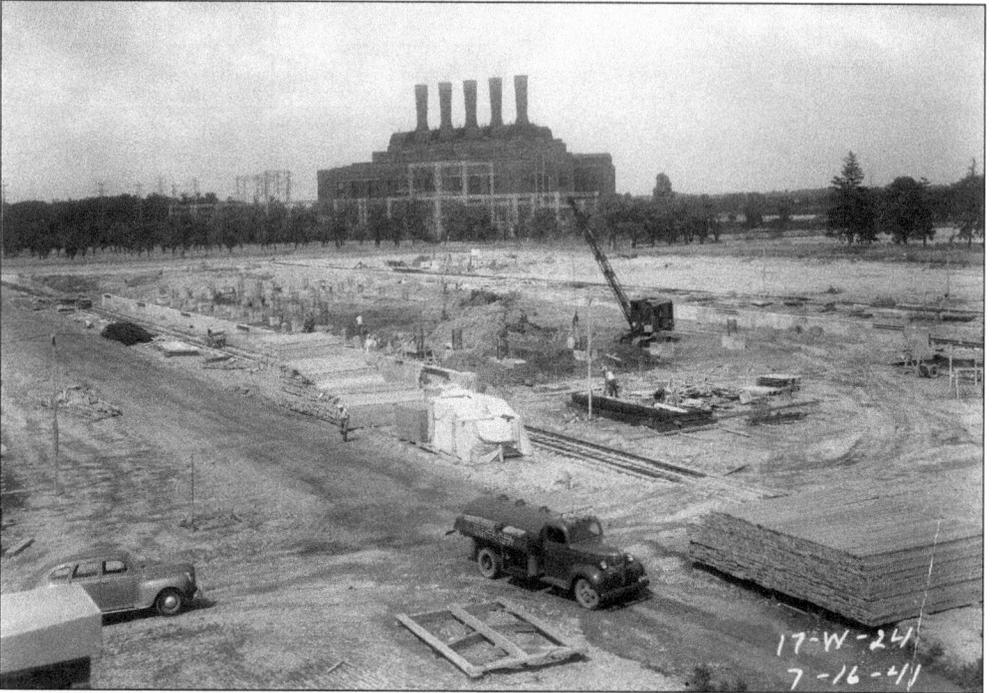

In 1942, the Monsanto Company purchased land on Jefferson Avenue for a plant. The company originally employed 178 people. Monsanto made three products in Trenton: phosphate sodium, Sterox wetting agents, and Saflex (plastic interlayer for safety glass).

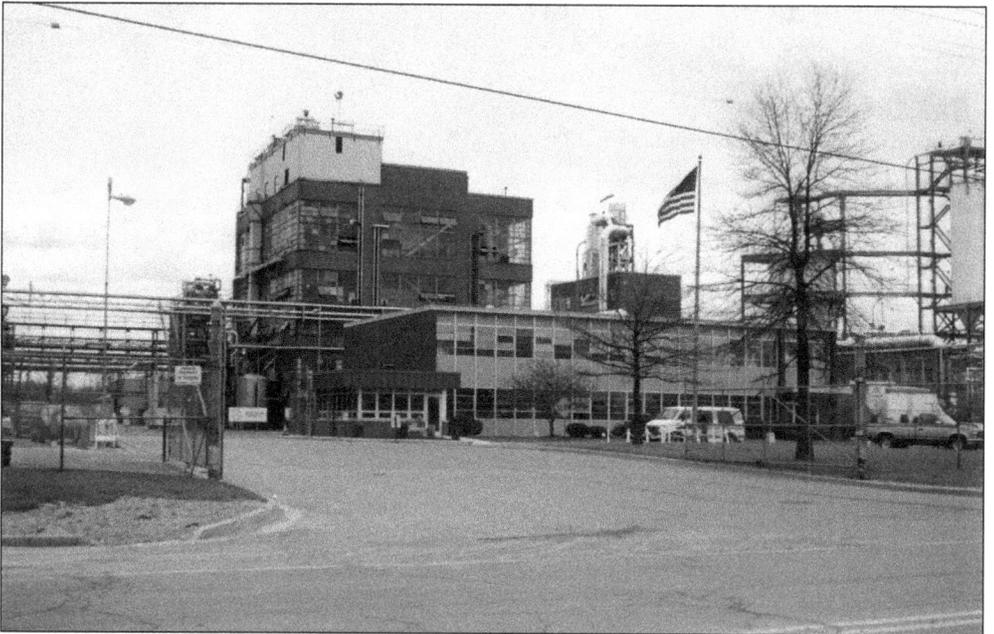

Prior to 1997, Solutia, Inc., was a wholly owned subsidiary of the Monsanto Company. A spin-off changed Solutia into an independent, publicly held company. The plant, located at 5045 West Jefferson Avenue, now produces a resin used to create the interlayers commonly used in automobile windshields and solar cells. Solutia employed a staff of approximately 250 to 499.

In March 2009, more than half of the employees at the plant lost their jobs due to a corporate decision to stop Saflex production in Trenton.

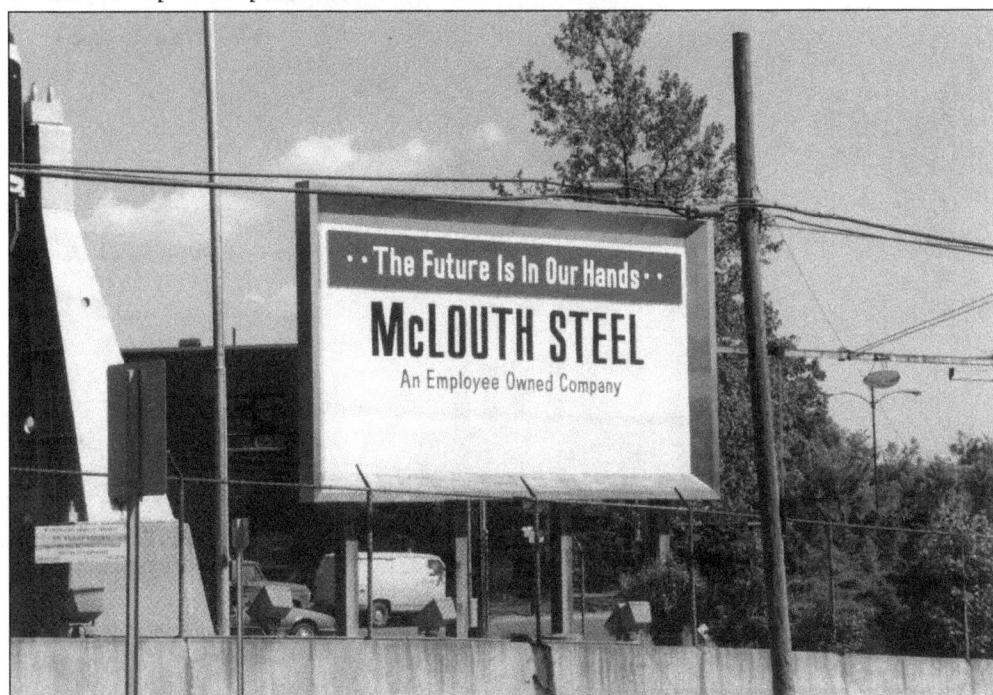

McLouth Steel Corporation began construction in 1948 of a new plant on a river site in Trenton. The *Trenton Times* on June 25, 1948, reported that the land "held under option by McLouth is 201.5 acres in the north Trenton area running from Sibley Road south along the river." The plant would house steelmaking facilities consisting of four 60-ton electric furnaces and a hot rolling facility.

McLouth became the first steel company to eventually produce 100 percent of its product by the continuous casting process, which added significantly to the efficiency of the operations and improved the quality of the finished product. The plant was sold in 1996 to the Detroit Steel Company. After several failed start-up attempts, the Trenton complex slowly disintegrated.

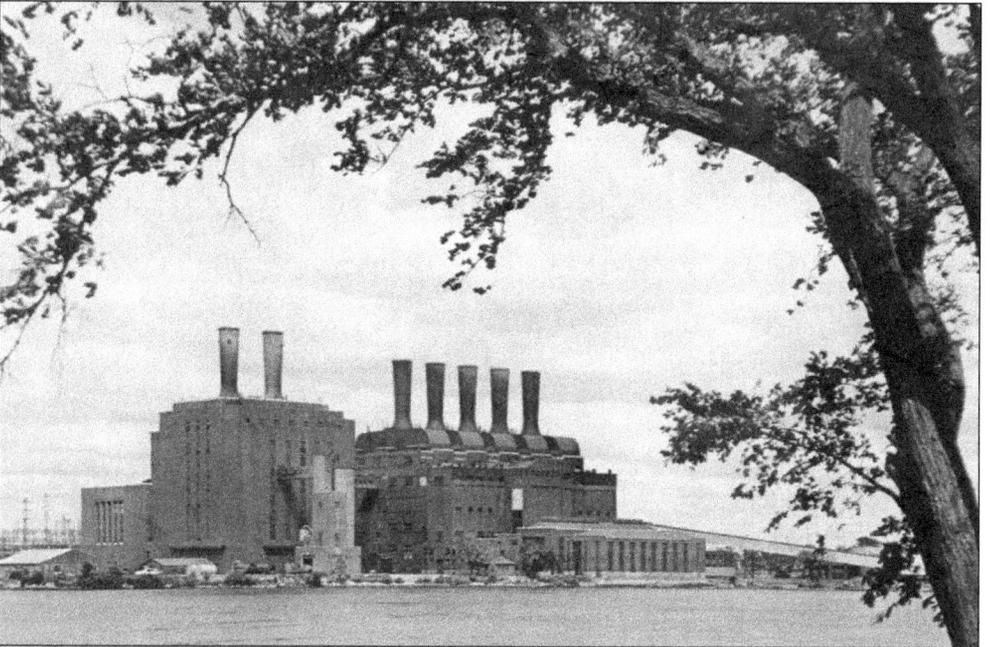

Known as the Trenton Stacks, this coal-burning power station is located in Trenton, Michigan. The first section was completed in 1922 and is owned and operated by Detroit Edison. The plant was the first of six electric generating units installed at the Trenton Channel to provide electric power to meet increasing electricity demands. The original plant consisted of 13 coal-fired boilers and six steam-driven turbine generators. Trenton residents were allowed to bring dead lightbulbs to the Edison office and receive new replacements. (Courtesy of Jeff Wagar.)

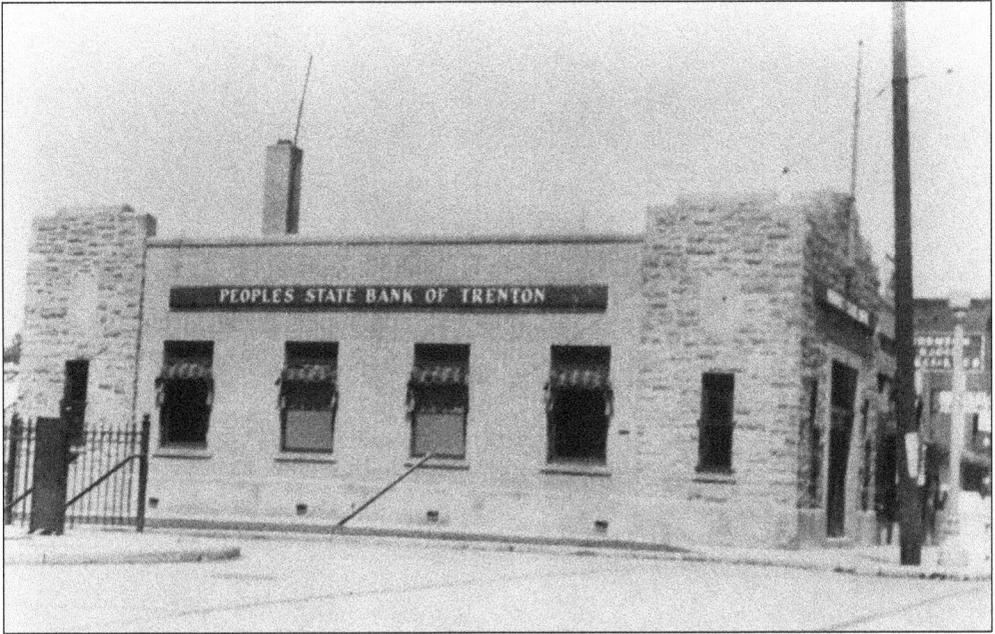

Peoples State Bank of Trenton was organized to help the community as a local bank. The *Trenton Times* on April 26, 1930, stated, "Good Banks and Good Towns are inseparable." By 1936, the bank's total resources were $604,090.33.

In 1950, the bank again expanded and had a grand opening. In 1960, the State Savings Bank of Flat Rock merged with Peoples State Bank of Trenton. In April 1976, the bank announced a change in the organization, and the name became Peoples Bank and Trust N.A. This photograph was taken in 1960.

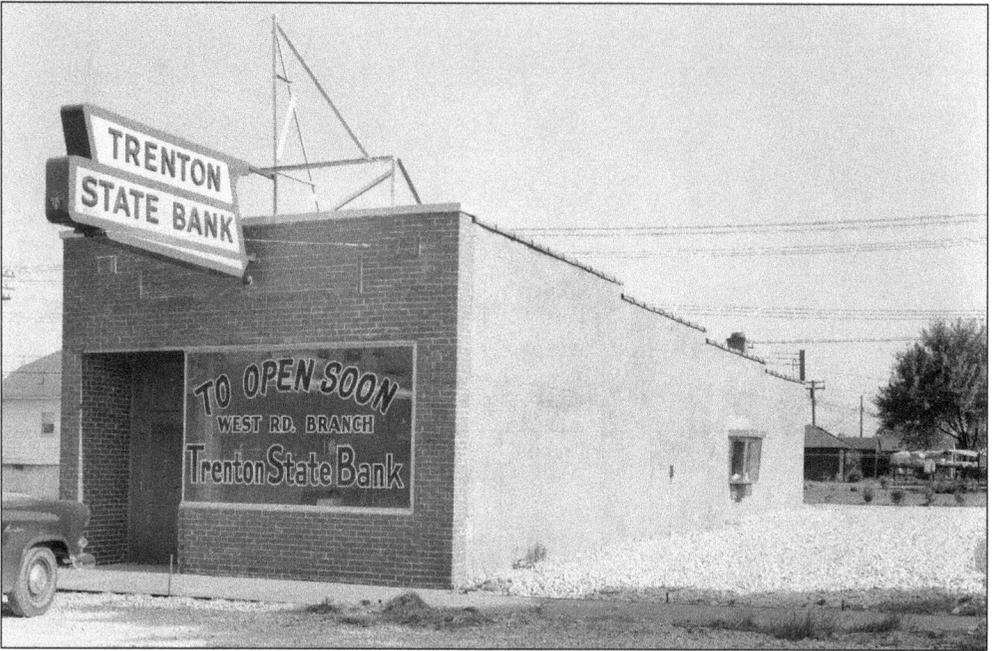

Trenton State Bank, located on West Jefferson Avenue at the corner of St. Joseph Avenue, was founded in 1912 under the name of Bank of Trenton. Its total resources in 1934 were $330,000, and in 1937 the bank became a member of the Federal Reserve System. The main office of the bank was robbed on January 12, 1925, when seven bandits entered the bank. A teller was shot and killed in the hold-up.

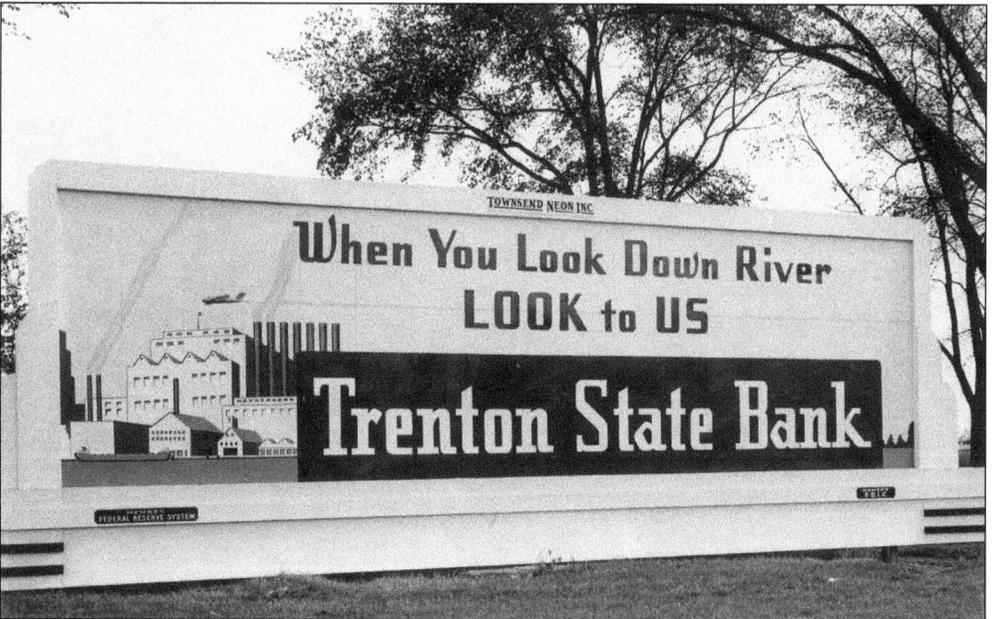

In 1929, Trenton State Bank was purchased by Detroit's second-largest bank, the Guardian Detroit Union Trust Group, and the local bank was known for a short while in 1931 as the Guardian Bank of Trenton. In 1933, all banks in Michigan were closed by Gov. William Comstock as per Pres. Franklin D. Roosevelt's order for all banks in the nation with the Emergency Banking Act.

Prior to 1976, the Trenton Beef House sat where city hall is now. It was built in the 1950s and owned by Bill Treadwell and was known as Treadwell's. It later changed hands and became Trenton Barbeque. Mollie Hoskins and Otto "Red" Clines took over in the early 1950s and renamed it the Trenton Beef House. The Trenton Beef House had a snack bar with revolving stools, a huge dining room, and also a banquet room. It was open 24 hours a day.

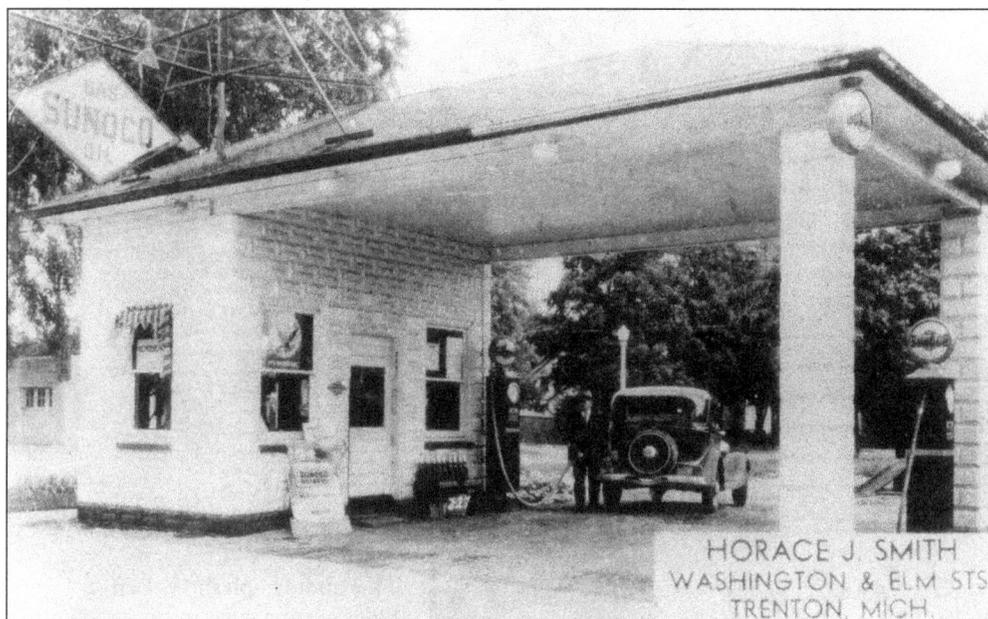

Horace J. Smith owned a Sunoco gas and oil station in 1939 located on Jefferson Avenue and Elm Street.

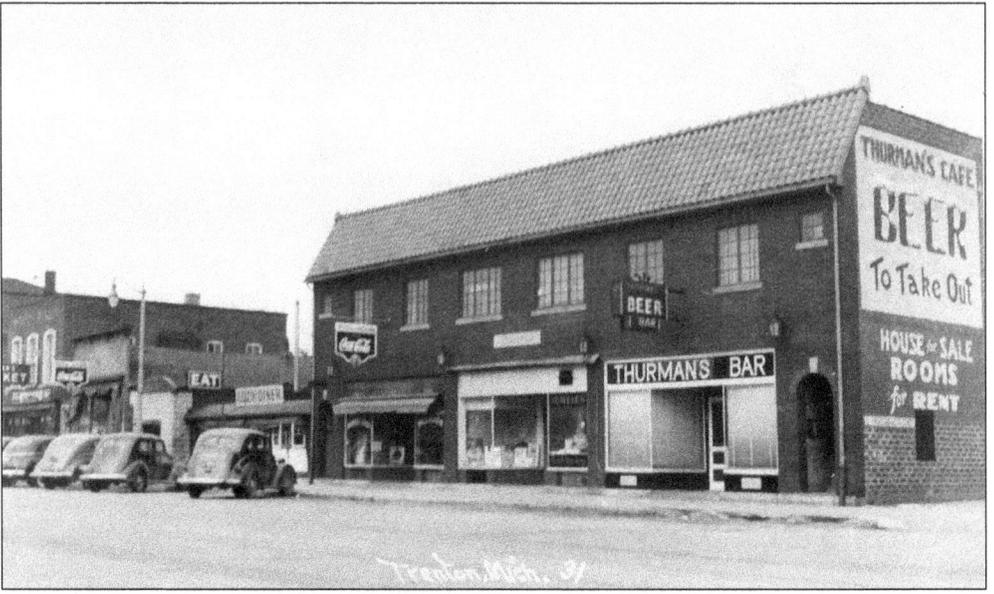

Thurman's Bar was owned by Harvey Labeau and was a "drink in or take out" beer distributor. It was located next to the pool hall. (Courtesy of Jeff Wagar.)

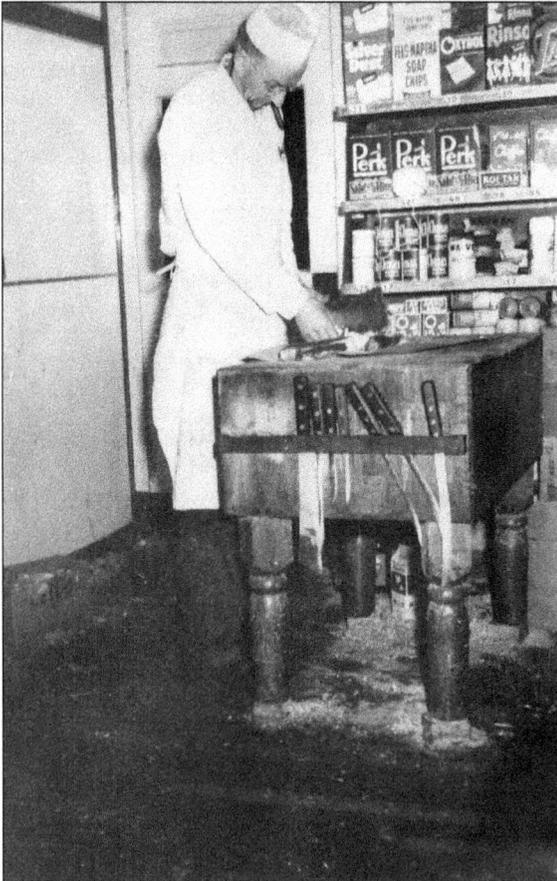

This photograph shows Ben Ellias cutting meat in his store located on the corner of Fourth and Atwood Streets.

Six

HOW TO GET FROM HERE TO THERE

When Antoine Laumet de La Mothe, sieur de Cadillac landed in 1701 in Detroit, roads were unknown. The first settlers of Trenton came by boat, having crossed the Great Lakes, landed in Detroit, and then struggled through the backwoods in order to arrive in the area.

From 1823 on, there was a gradual development of roads, and some were built into the interior. Stagecoach lines were established, and one of the first lines was along the River Road in Trenton that went to Ohio.

Local travel from the mainland to Grosse Ile depended largely upon ferries or privately owned boats. Large scows were propelled by ropes fastened to a horse, which walked around a cylinder. When the cylinder revolved, the power for turning the side paddle wheel was generated. Capt. Alexander Nicholson ran such a ferry. During the winter, when the river froze, crossing was done by sleigh, skates, or foot. During the 1870s, the gasoline engine replaced the horse-powered ferry, and Burley Keys & Kohler's ferry line was created.

Trenton sidewalks were wooden and were available in the business district, but they were a nuisance and always needed repair. The dirt streets were muddy, and cattle were sometimes seen roaming around. In the beginning of the 1890s, there was a minor confrontation between cow and non-cow owners, and by the end of July 1891 it was reported that about 40 cows were congregated at the corner of Jefferson and St. Joseph Avenues. Pres. Joseph Anderson held a Trenton Council meeting for the deciding vote: the non-cows owners won. In 1892, when the roads were still dirt and often muddy, people's other favorite means of transportation was the streetcar.

In the early 1890s, Trenton residents welcomed a new fashion: bicycling. Young ladies also wanted to enjoy this new rage, but men were slow to accept the idea. In 1896, the Village of Trenton passed an ordinance prohibiting bicyclists from riding on the wooden sidewalks more than five miles per hour on Jefferson Avenue between West Road and Elm Street. Also, bicyclists riding after dark had to carry a lamp as well and a bell or whistle.

Trenton also had access to the railroads. The Canada Southern Railway route ran from Essex and Amherstburg, Canada, across the Canadian Channel of the Detroit River to Stony Island, where a short-spanned bridge was built from there to Grosse Ile. The trains crossed the American Channel by bridge to Slocum's Island and continued on to the mainland.

By 1818, settlers had built homes on Grosse Ile across the Detroit River from Trenton. They could take in the view of other settlements across the river that could be a half mile to two and a half miles wide. Canoes, skiffs, and sailboats were used to transport people from Trenton to Grosse Ile.

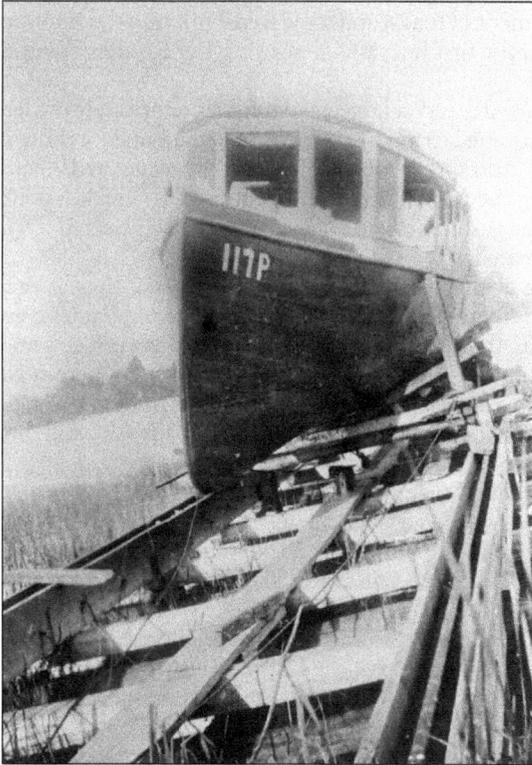

The ferries ceased to run when winter ice closed the channel, and the railroad bridge became the only dependable means of transportation of people, crops, and supplies between the mainland and Grosse Ile. When the channel was navigable, Burley Keys and B.H. Kohler operated a ferryboat, starting in the 1870s. Kohler bought out Keys and ran the ferry until about 1925, when it was discontinued. (Courtesy of the Trenton Historical Commission.)

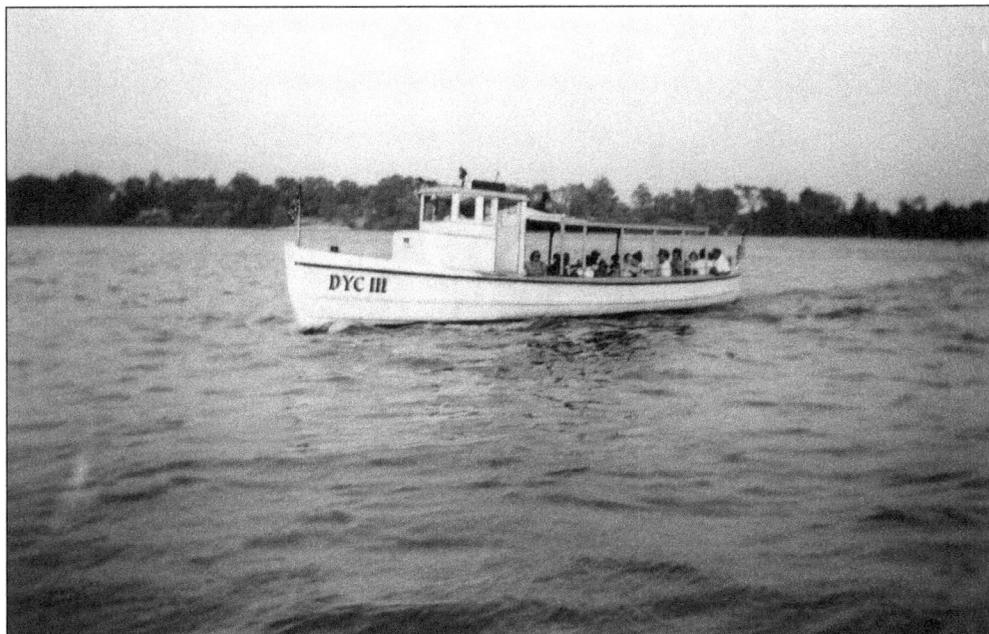

The *DYC III* day boat ran from the dock at Elizabeth Park up and down the Trenton Channel of the Detroit River from the late 1940s until about 1960. The boat, purchased by Dr. Hiram Holden from the Detroit Yacht Club, was operated by his son James Holden. The operation was a family affair, as Dr. Holden's grandson Jim sold the tickets. (Courtesy of Carol Hendricks.)

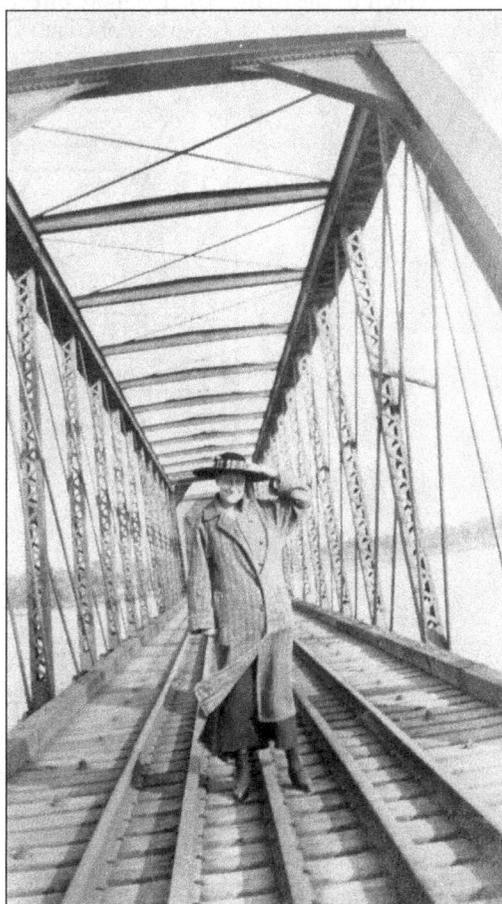

The Grosse Ile-to-Detroit railroad was the means of transportation for people and for goods and supplies, starting in 1880. This 1917 photograph shows the Michigan Central Train Bridge (later known as the Trenton-Grosse Ile Bridge) and a local resident daring a pose by having her photograph taken while standing on the tracks.

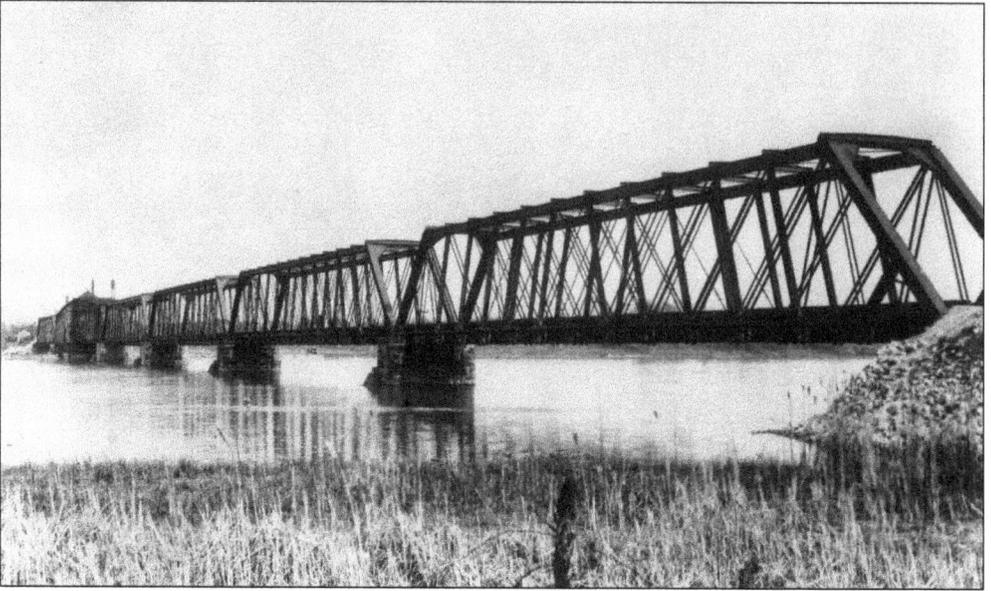

In 1879, the Canada Southern Railway secured the right-of-way on Grosse Ile and built a bridge from Trenton to the island. Later, a more direct route was established, and the Trenton-Grosse Ile Bridge was abandoned. (Courtesy of Claud Owen.)

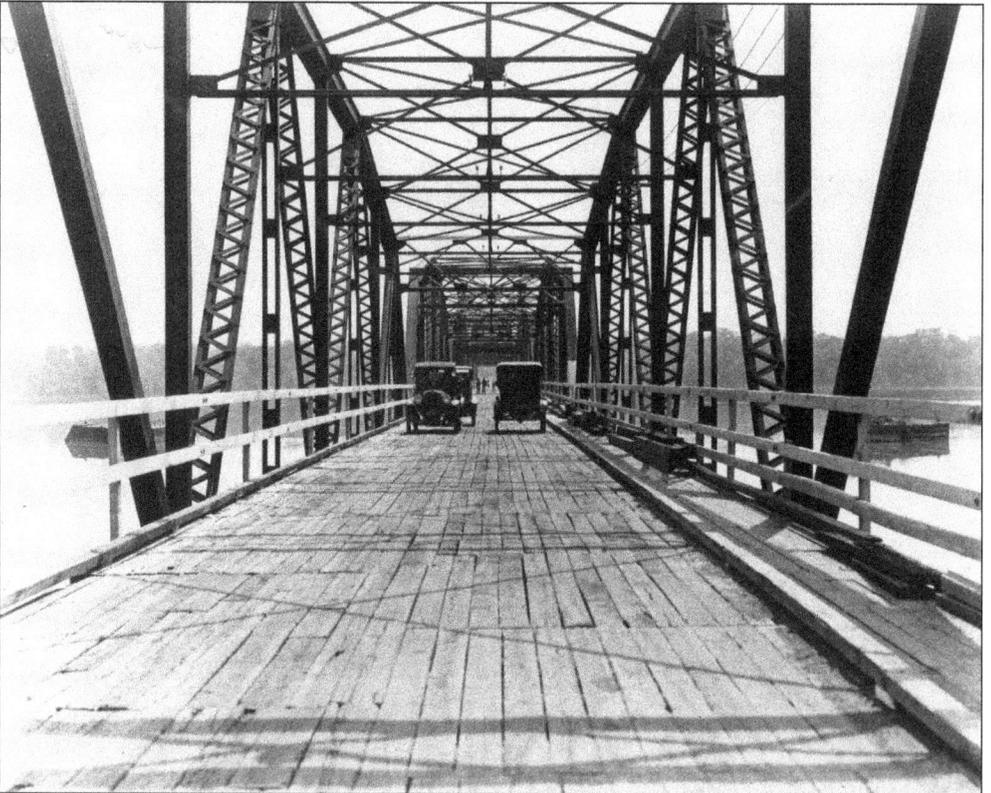

On September 3, 1930, the bridge connecting Grosse Ile to Trenton was reopened to foot and vehicular traffic only.

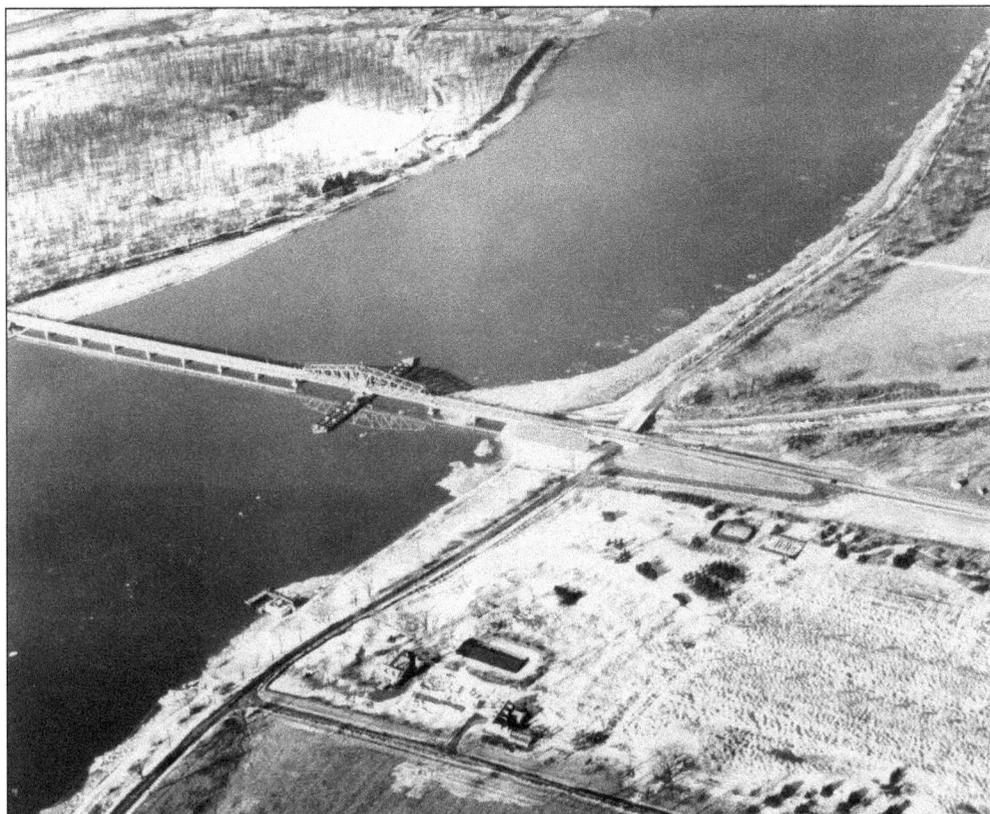

An aerial photograph shows the Grosse Ile Parkway County Bridge looking toward Elizabeth Park during the winter of 1938 or 1939.

In 1901, the village began a program of replacing sidewalks made of wood with cement. The plan was to lay 20,000 feet the first year, which encompassed about two blocks on both sides of the street. By 1921, automobile traffic was becoming a problem. The village announced that drivers of automobiles must conform to all traffic regulations and that they must drive on the right side of the street.

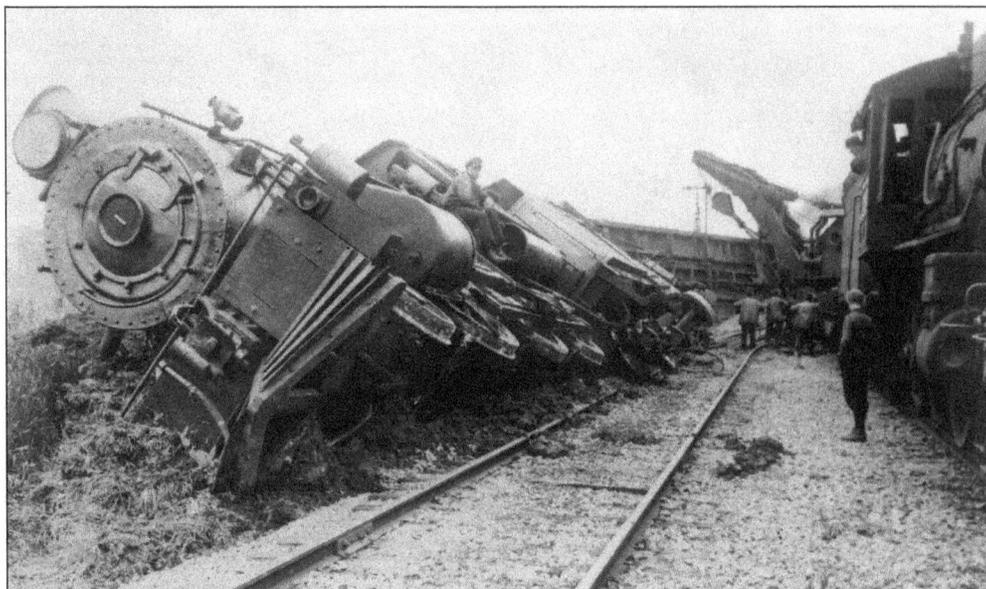

As for the railroad lines, during the summer there was always fear that flying sparks from trains might start a fire in the grass along the tracks. Occasionally, there were accidents. Sometimes a horse being ridden by a resident startled by engine noise became terrified and got out of control. At other times, heavy wagonloads got caught while crossing the railroad tracks. These photographs show that it could happen to the train as well with this wreck in Trenton that took place in the 1910s. (Courtesy of Claud Owen.)

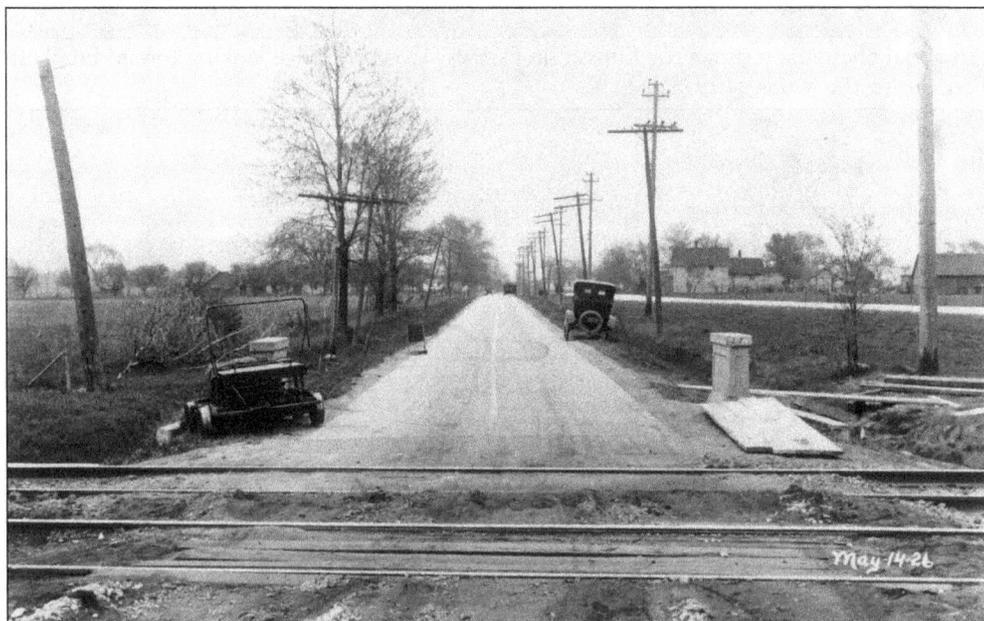

In 1915, the Delray Connecting Railroad (DCR) acquired track-usage rights over the Detroit, Toledo and Ironton Railroad (DT&I) to Trenton. The north end of the DT&I evolved into a heavy-duty railroad. As the Detroit automobile industry flourished, more industry was built, and soon Trenton became a heavily industrialized area. By 1926, trains crisscrossed Trenton. This photograph shows the West Road DT&I crossing.

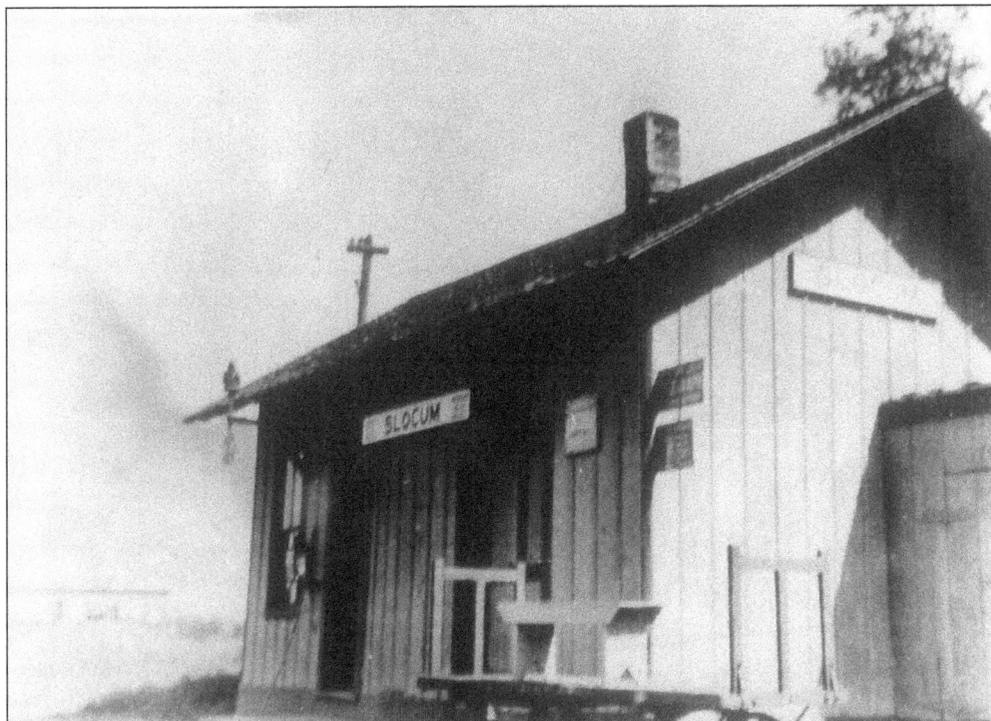
The Michigan Central Railroad engine in 1910 stopped at Slocum's Junction in Trenton.

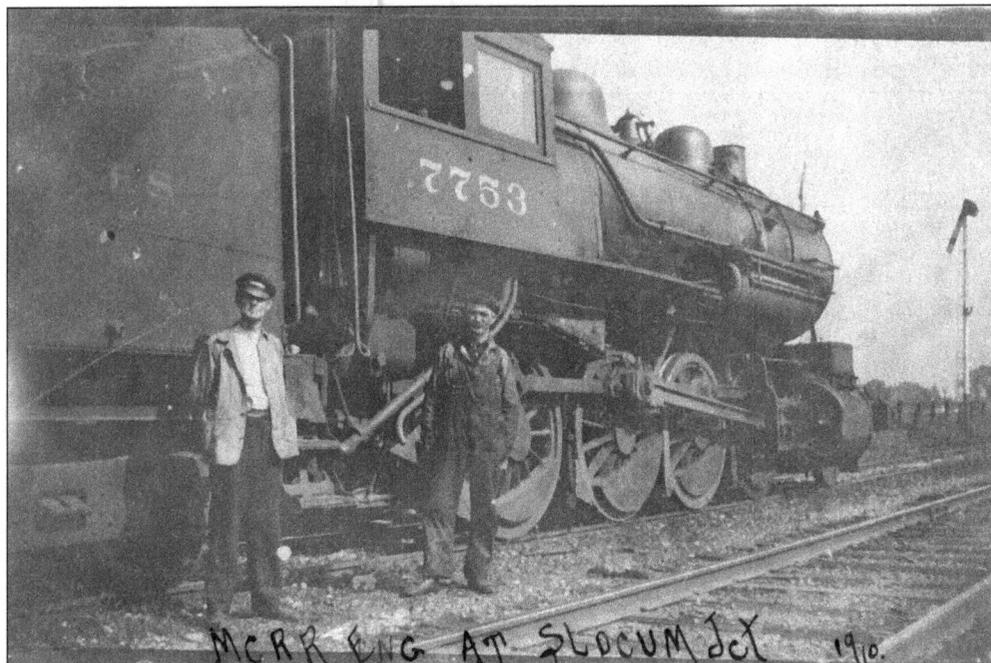
Slocum's Junction was located at the crossing of the Toledo and Fayette Divisions of the Chicago and Canada Southern Railroad. Five trains daily traveled from Slocum's Junction, across to Grosse Ile, and east across the old railroad bridge to Stony Island. There, travelers could connect to Amherstburg, Ontario, Canada, by ferry.

In 1938, Works Progress Administration (WPA) funds provided financing for a viaduct spanning the railroad tracks on West Road. The viaduct is a metal stringer (multi-beam) fixed bridge. The total length of the viaduct is 2,800 feet, and the main span is 51.8 feet long.

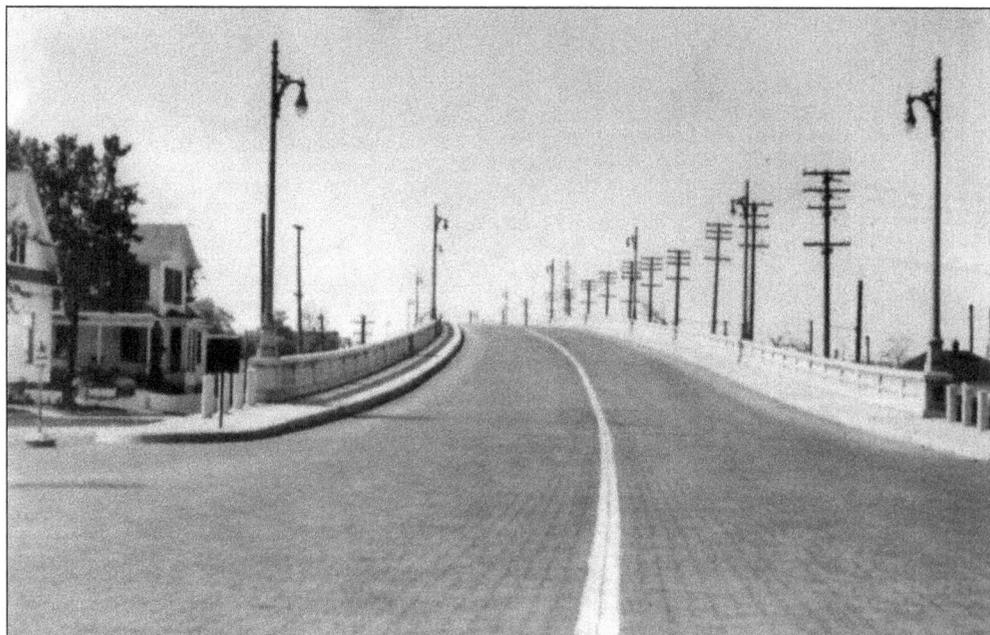

The completed viaduct was dedicated on August 11, 1939, at a cost of $496,000. It has a roadway width of 80 feet and has seven main spans. The bricks have since been paved over.

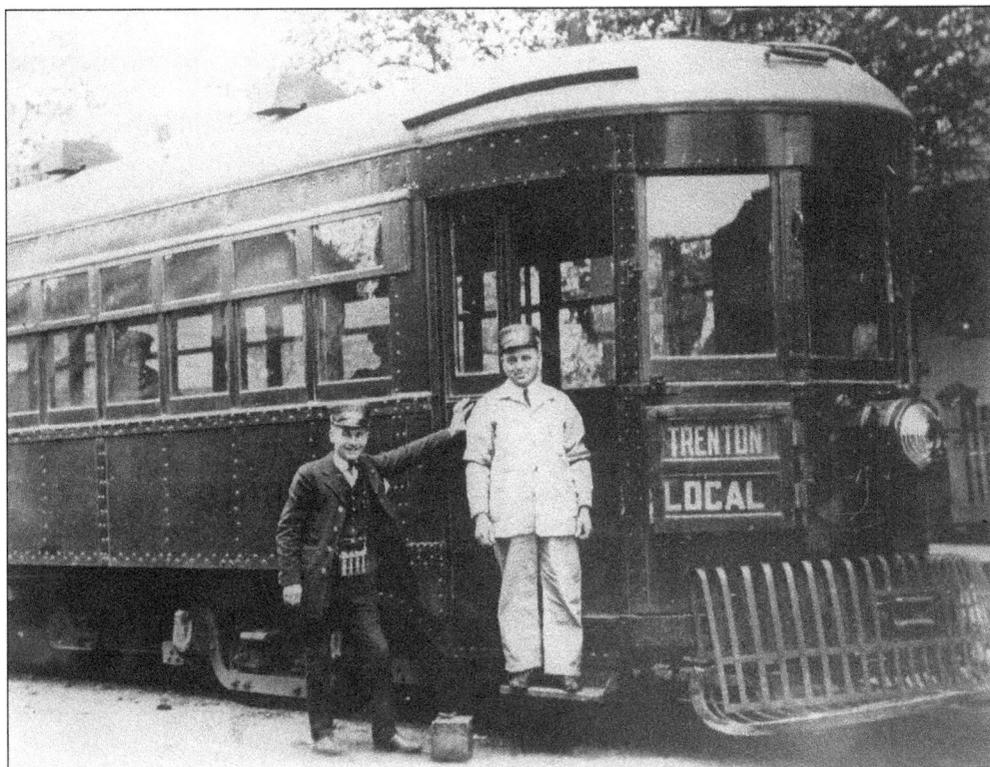

This local Trenton streetcar in 1923 shows conductor R.J. Watson Sr. on the left with his change belt. The streetcars running to Trenton were on a reliable 20-minute schedule. (Courtesy of the Trenton Historical Commission.)

By 1901, assets of the Detroit and the Detroit suburban systems and other outlying lines were incorporated into the Detroit United Railway (DUR). Car barns located on Fourth and Maple Streets housed trains used by the Detroit Urban Railway. (Courtesy of the Trenton Historical Commission.)

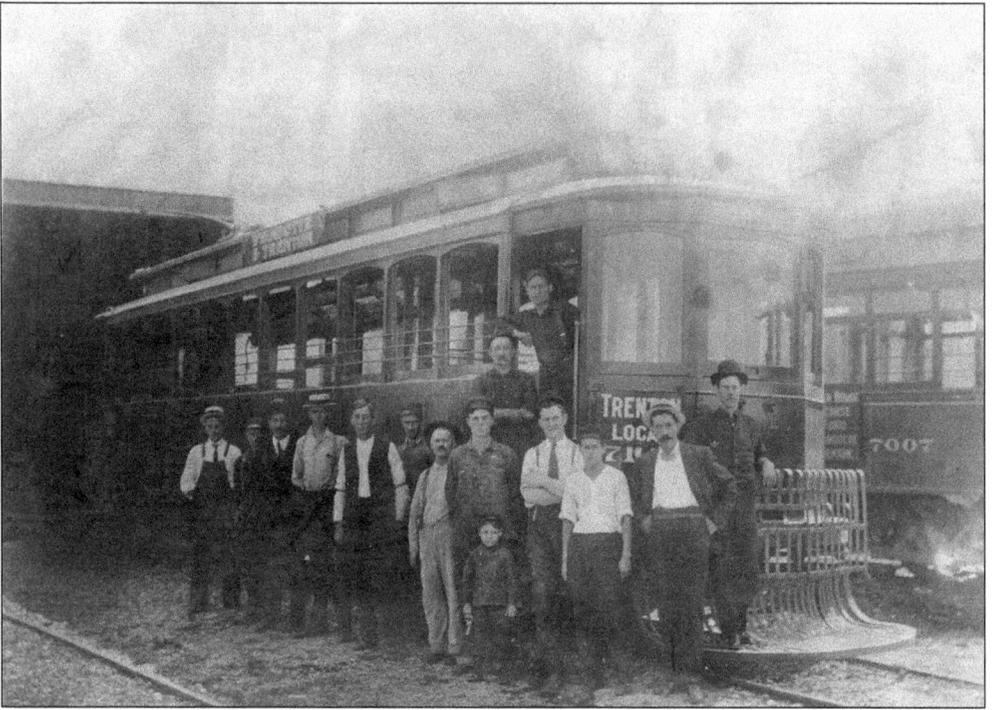

The Detroit Urban Railway had a stable of electric streetcars and buses in operation. The route ran from Detroit to Monroe and onto Toledo. Around 1879, the DUR began pulling away passengers, leaving the railroads with mostly freight shipping. Second from the right is supervisor William McFadden. (Courtesy of the Trenton Historical Commission.)

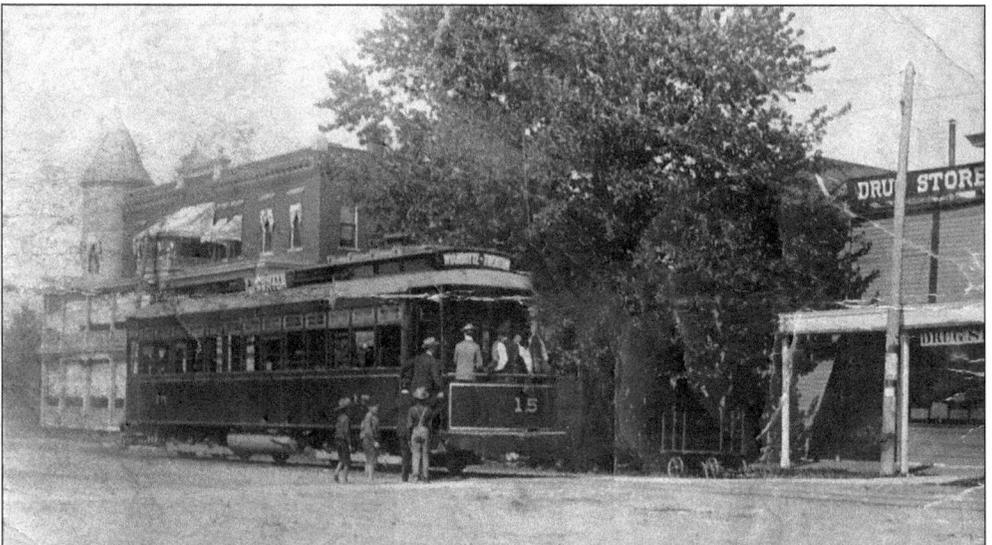

In the early 1900s, the streetcar was used for business, socializing, shopping trips to Detroit, and funeral trips to Woodmere and Woodlawn Cemeteries. In those instances, rental agreements were made for a special car to carry the casket and mourners. Another special car called the *Yolanda* was rented to take people to parties upriver. (Courtesy of the Trenton Historical Commission.)

Seven

THE GOOD LIFE

Trenton has always been known for its helping hand and cordial relations between its residents, local businesses, houses of worship, schools, police and fire departments, health-care organizations, and charitable causes. Times have changed, but the thoughtfulness of the people of Trenton has not.

Trenton had three hospitals. The old Trenton Hospital was primarily used for maternity cases and later a convalescent home. It was located in a house on Fourth and Elm Streets and was later torn down. Riverside Osteopathic Hospital (ROH) was built in and around the Austin Church home on three acres of river frontage. The residence was renovated, and the dedication was on July 8, 1944. To keep ROH afloat during its early days, doctors were assessed $5 a day for each patient they had in the hospital regardless of length of stay. The third is Seaway Hospital, a unit of the Peoples Community Hospital Authority (PCHA), that is now known as South Shore Hospital, built in 1961 by Oakwood Hospitals, Inc.

Churches have also served the residents of Trenton in good times and in bad. In 1836, Nathaniel Alvord began an Episcopal Sunday school in an empty store building on the northwest corner of Jefferson Avenue and Elm Street. St. Thomas Episcopal Church was organized December 10, 1842. The original church building was destroyed by fire on December 6, 1946. The First Presbyterian Church was founded on February 20, 1903, when a few friends met with the Rev. F.G. Ellet. Reverend Ellet gave his first sermon in the North Side Schoolhouse. St. Joseph Catholic Church was built due to the many French Canadian quarry workers who had to walk to Ecorse or Wyandotte to attend church. In 1849, Fr. C.L. DePreiter came one Sunday a month to hold Mass at a parishioner's home. Faith Methodist Episcopal Church has been a long-standing part of the community for over 165 years. Methodist class meetings were formed by early Trenton citizens in 1829 and met in various homes. In 1843, Methodist Episcopal Church was organized with 11 members. Finally, Beth Isaac Synagogue, serving downriver Jewish families, is one of the more recent additions to worship in Trenton.

Schools, police and fire departments, local town government, a library, a post office, newspapers, lodges, charitable organizations, and cemeteries have served Trenton from its beginning and are ever expanding.

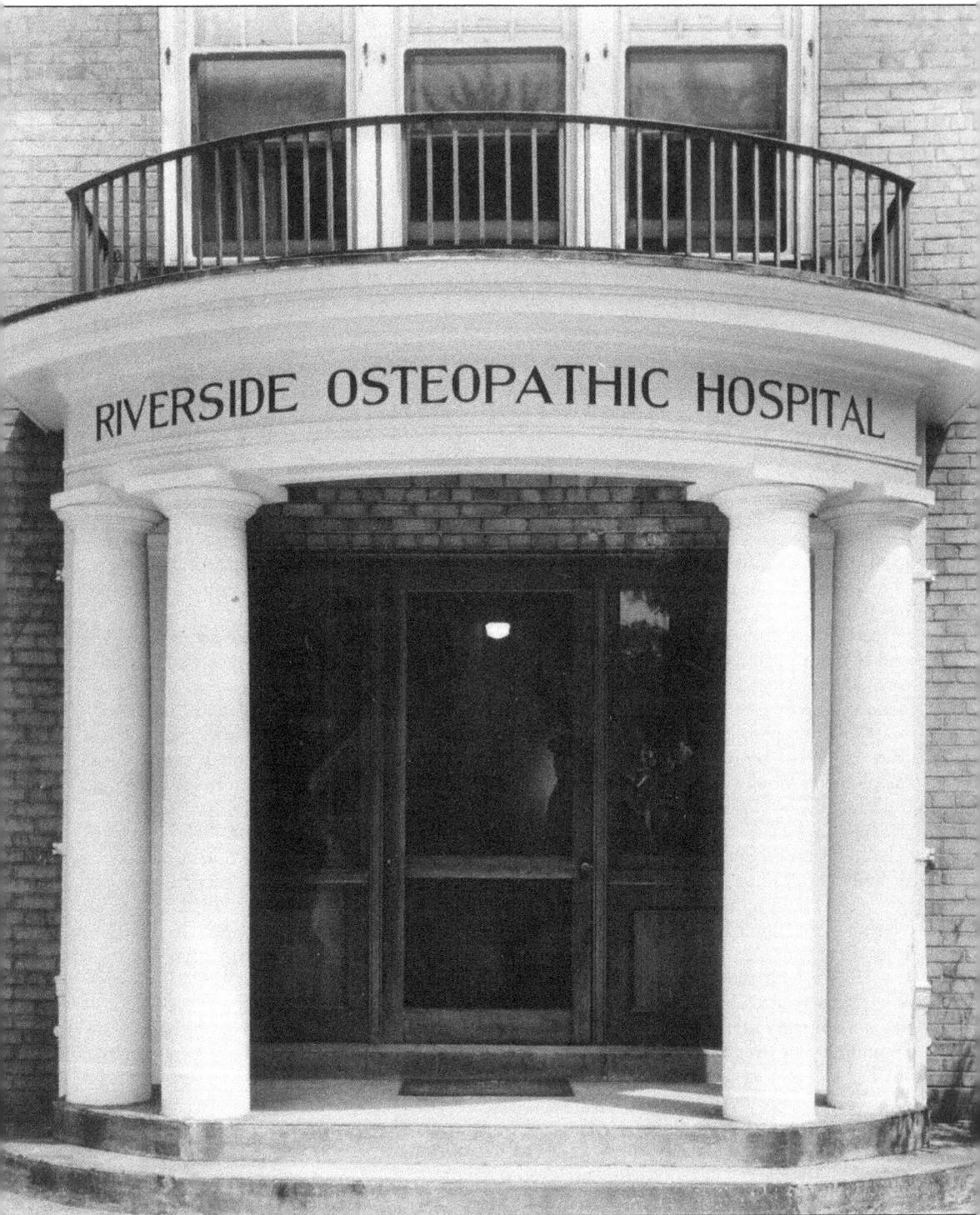

The Church family's home was donated to a group of doctors to start the first hospital in Trenton. Later, Riverside Osteopathic Hospital expanded to include the east side of West Jefferson Avenue between George and Truax Streets. At that time, the hospital contained 162 beds.

This photograph, taken in 1944, shows the interior of Church home/ROH. Once rated as a Class I comprehensive facility, it survived a strike in 1990, but by November 2002 this rating was lost when the emergency room closed. Officials of its affiliate, the Henry Ford Health System, stated that this was based on its financial performance and dwindling patient volume. Monthly losses were averaging $1 million near its closing.

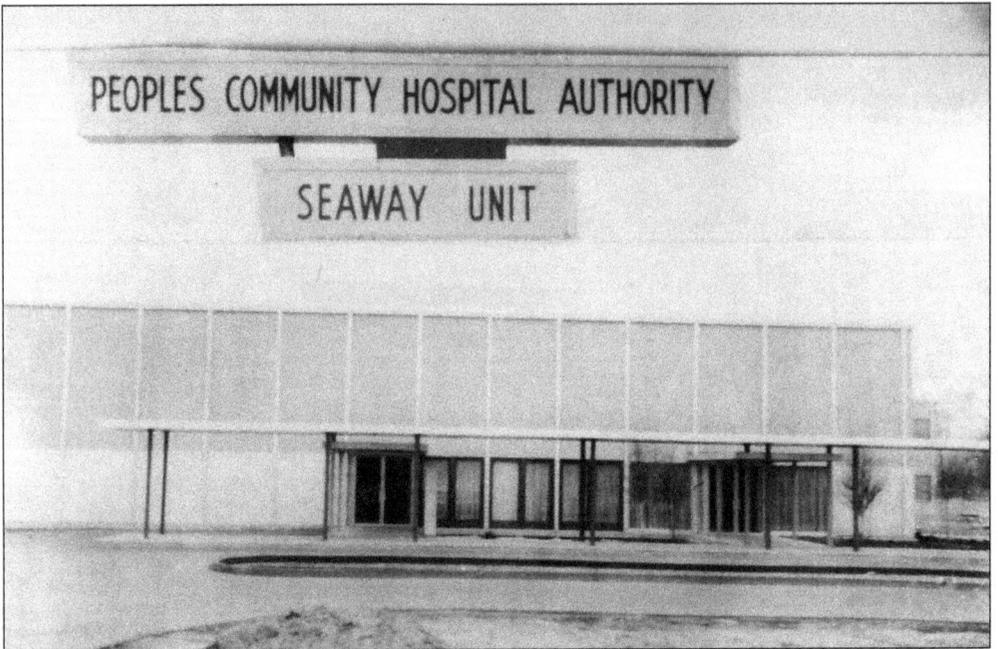

Peoples Community Hospital Authority (PCHA), Seaway Unit, is now known as Oakwood South Shore Hospital. It is relatively new and was built in 1961 to meet the needs of Trenton's expanding population. In 1959, construction began on the new hospital, located on Fort Street north of Vreeland Road, and opened with 86 beds. Over the years, additions have increased it to 193 beds. In 2011, South Shore Hospital celebrated its 50th anniversary.

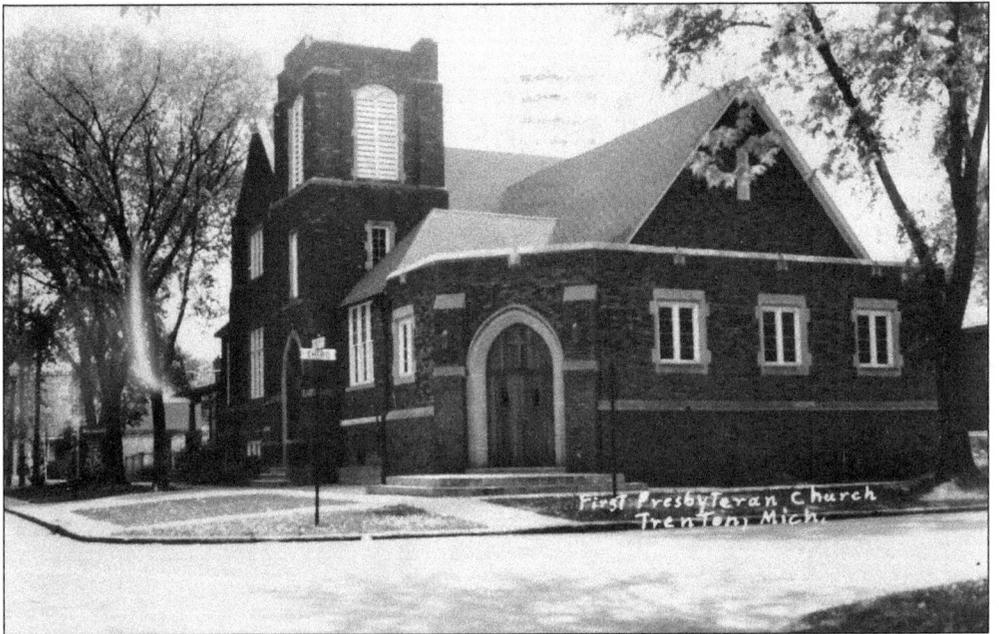

First Presbyterian Church was organized on July 9, 1903, with 39 members, meeting in the Duddleson Building on Front Street. The first church building was completed in 1904 and located at Cherry and Third Streets. (Courtesy of Jeff Wagar.)

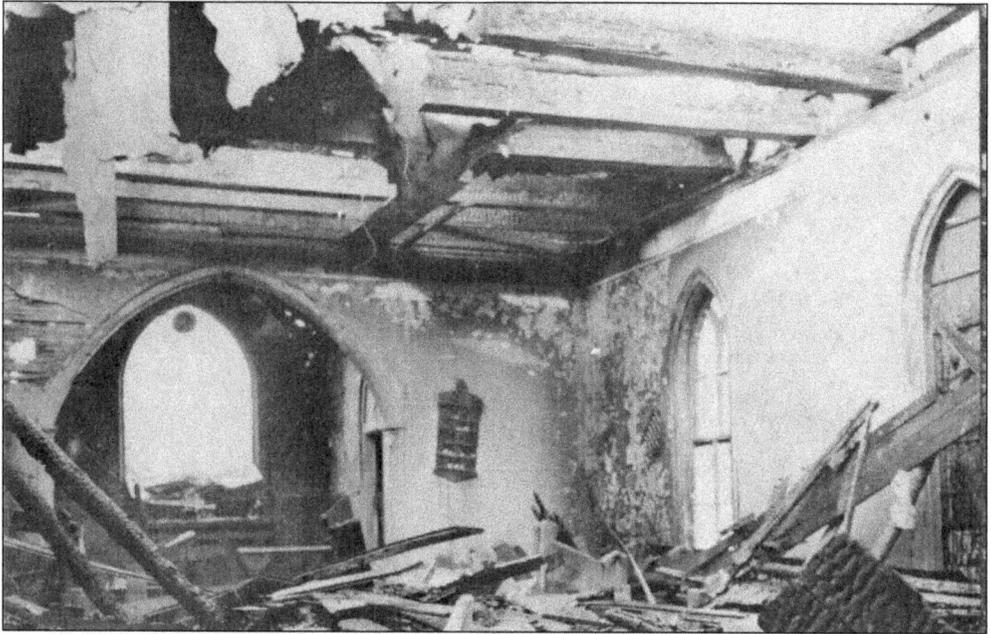

Abram Truax donated the land for St. Thomas Episcopal Church. The church was erected in the summer of 1843. Consecration and the first confirmations were held on January 29, 1844. These events were delayed one day because the bishop, who had been visiting Grosse Ile, was prevented from crossing the river by dangerous ice flows. The original church building was destroyed by fire on December 6, 1946.

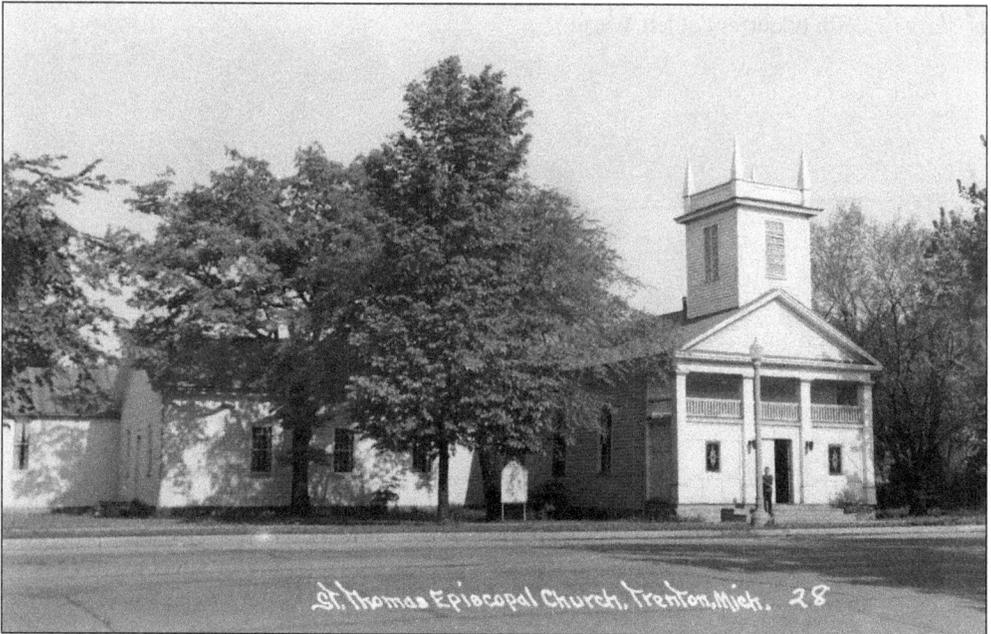

St. Thomas Episcopal Church, Trenton, Mich. 28

The church decided to relocate and rebuild at its present-day location at 2441 Nichols Drive, where Elliott Slocum Nichols (great-grandson of Abram C. Truax) donated two acres to the parish. Instead of building a new chapel at this site, St. Thomas Episcopal Church bid $10,000 to purchase the Martha-Mary Chapel, including furnishings, from the Ford Foundation.

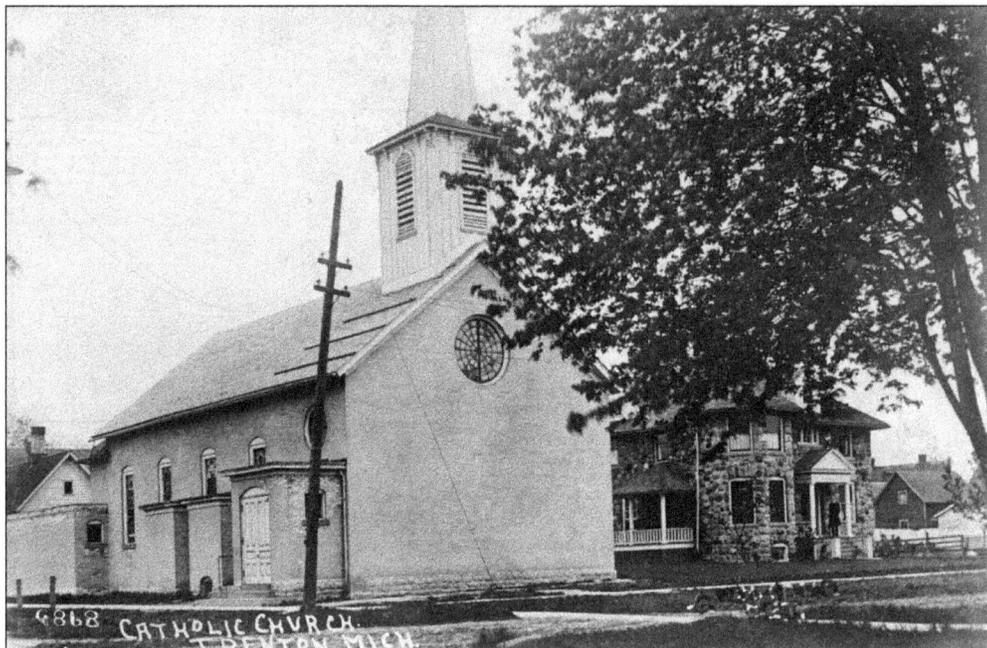

St. Joseph Catholic Church was built on the corner of Elm and Third Streets and could seat 230 congregants. It cost $2,500 to build. The church was a board-and-batten structure, later covered with white brick from the Church Brickyards. A brick stove heated it. No regular priest came until 1895, when Fr. James Calahan arrived to serve the parish. In 1930, the old church was demolished and a new one built, followed by a parish school staffed by the Sisters of the Immaculate Heart of Mary in 1948. (Courtesy of Jeff Wagar.)

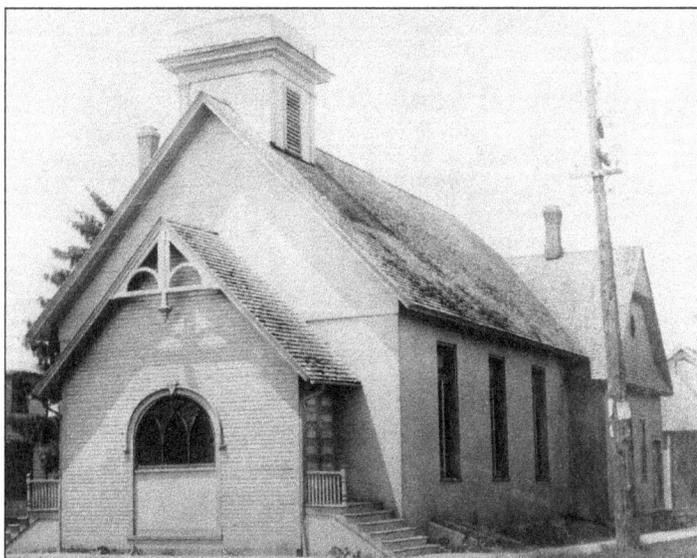

The First Methodist Church was built on land donated by Abram Truax on the corner of Elm Street and Jefferson Avenue. The church was a white frame building constructed in 1845 that seated 200 people. (Courtesy of the Trenton Historical Commission.)

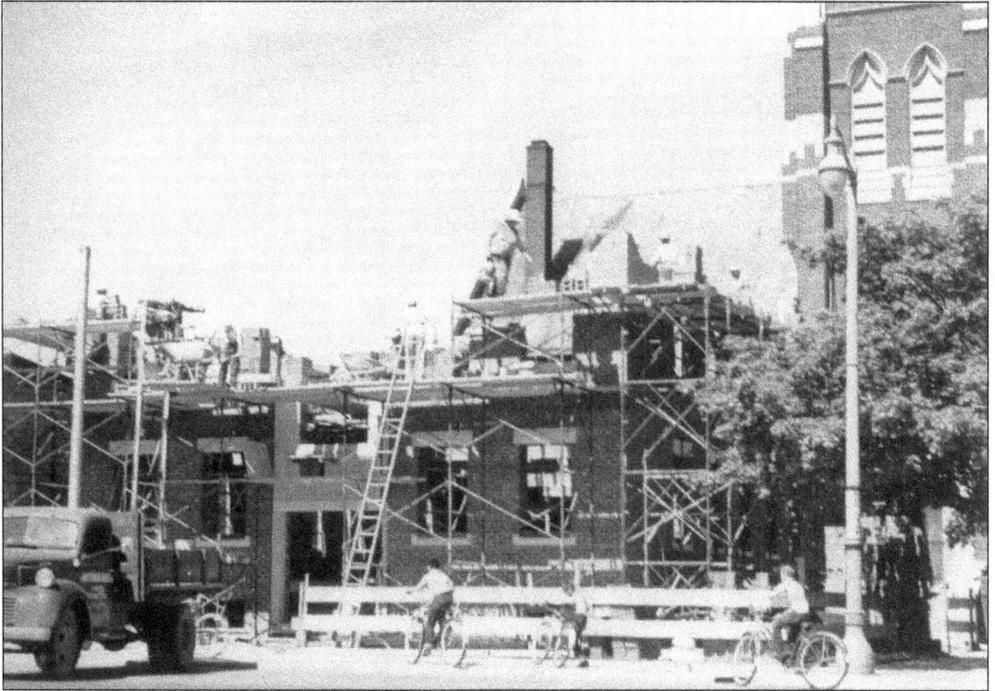

The present structure of the First Methodist Church was built in 1926, with only the original organ room from the old church remaining. (Courtesy of the Trenton Historical Commission.)

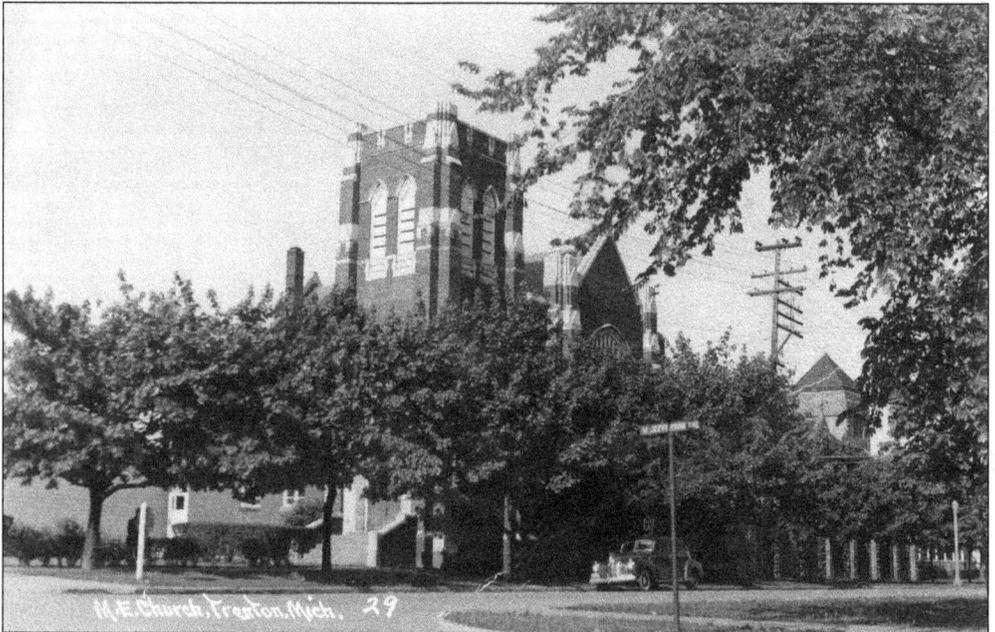

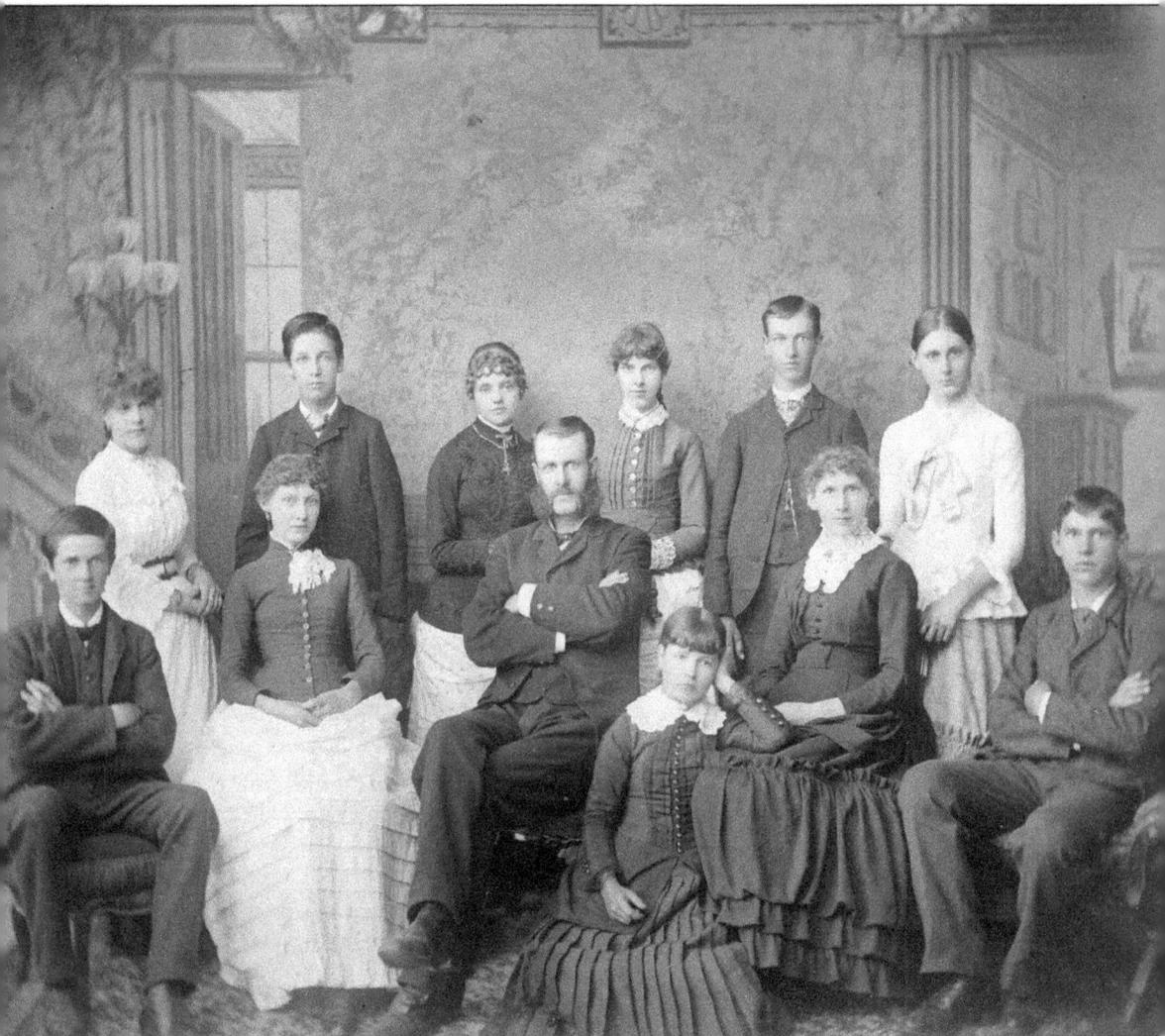

Schools in Trenton began with a one-room log schoolhouse in the 1880s. It was soon replaced with a frame schoolhouse and was called the North School. This photograph was taken in 1883 when a class took a boat to Detroit to have the image taken. Posing are, from left to right, (first row) Richard Foy, Lillian Rose, Mr. Cowl, Agnes Kirby, Eliza Wardell, and Will Drummond; (second row) Mame Saunders, Clark Alvord, Grace Rice, Maude Rose, Frank Bostwick, and Mary Stringham.

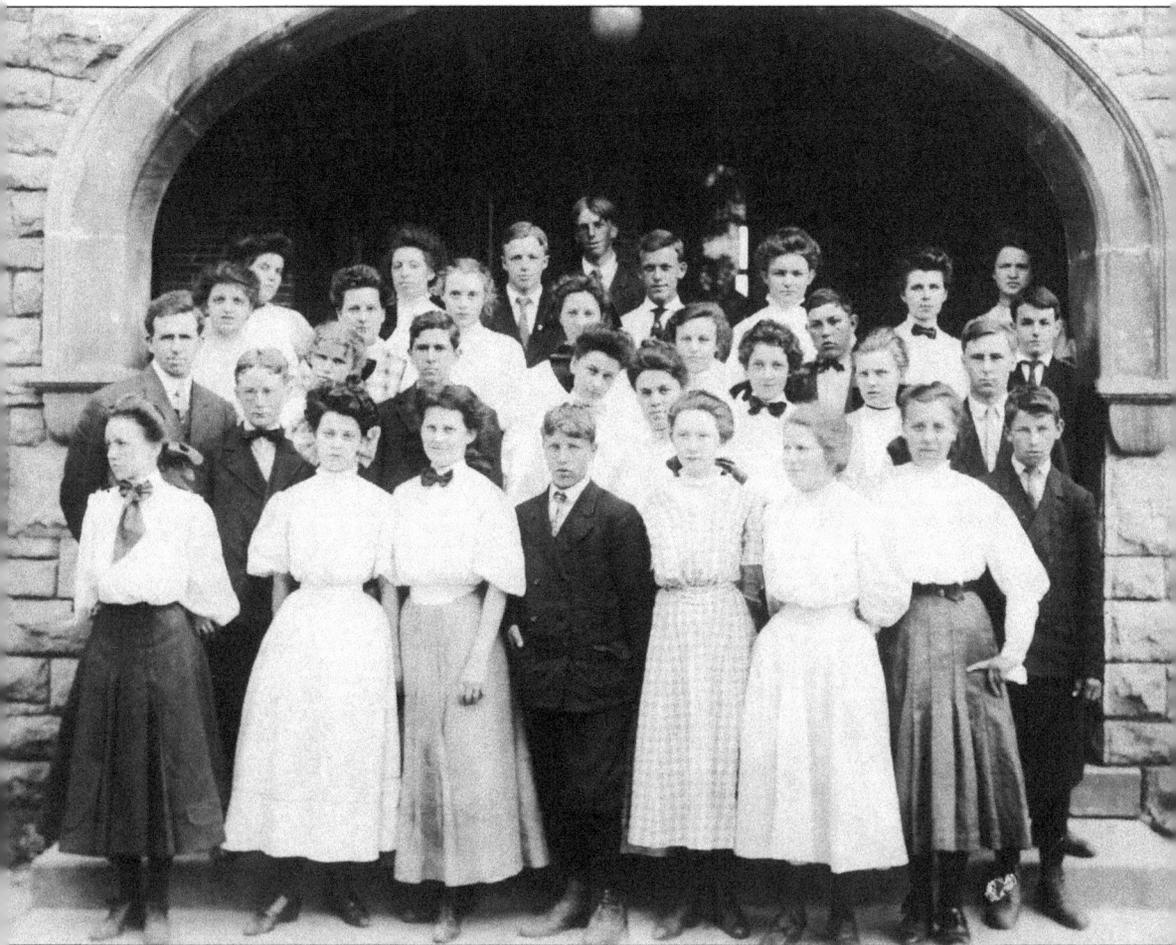

Built in 1900 and located on St. Joseph Avenue and Third Street, this redbrick building served as an elementary, junior, and senior high school until 1924. This 1907–1908 Trenton High School class photograph shows superintendent Albert Sherman and teacher Edith Clawson and students; the other individuals are unidentified.

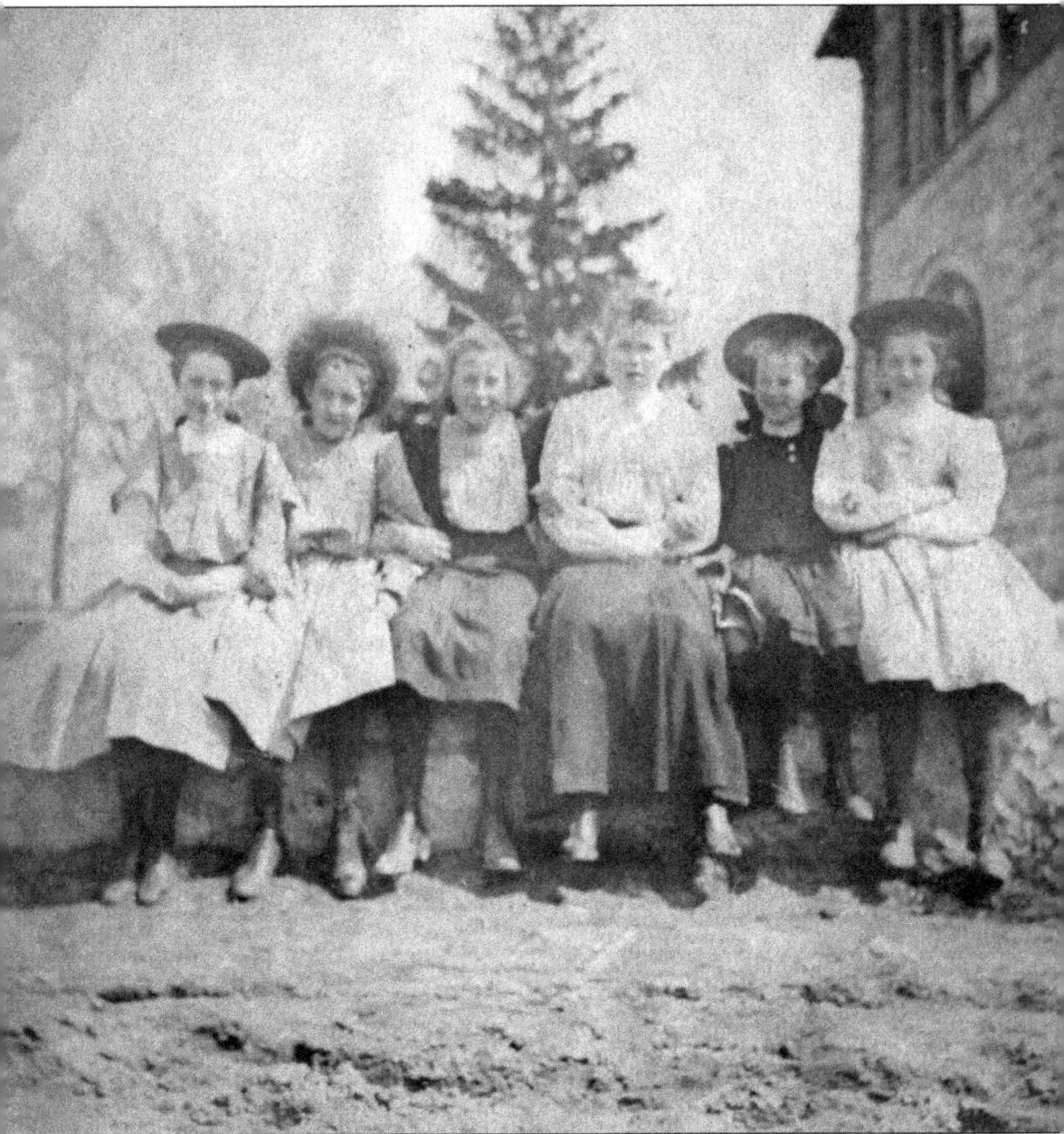

This c. 1903 photograph is of the Trenton School's fifth-grade class. The students and teacher are, from left to right, Inez Ford, Bell Butler, Jessie Cummings, Miss Hentig, Edna Sanders, and Alice Armstrong.

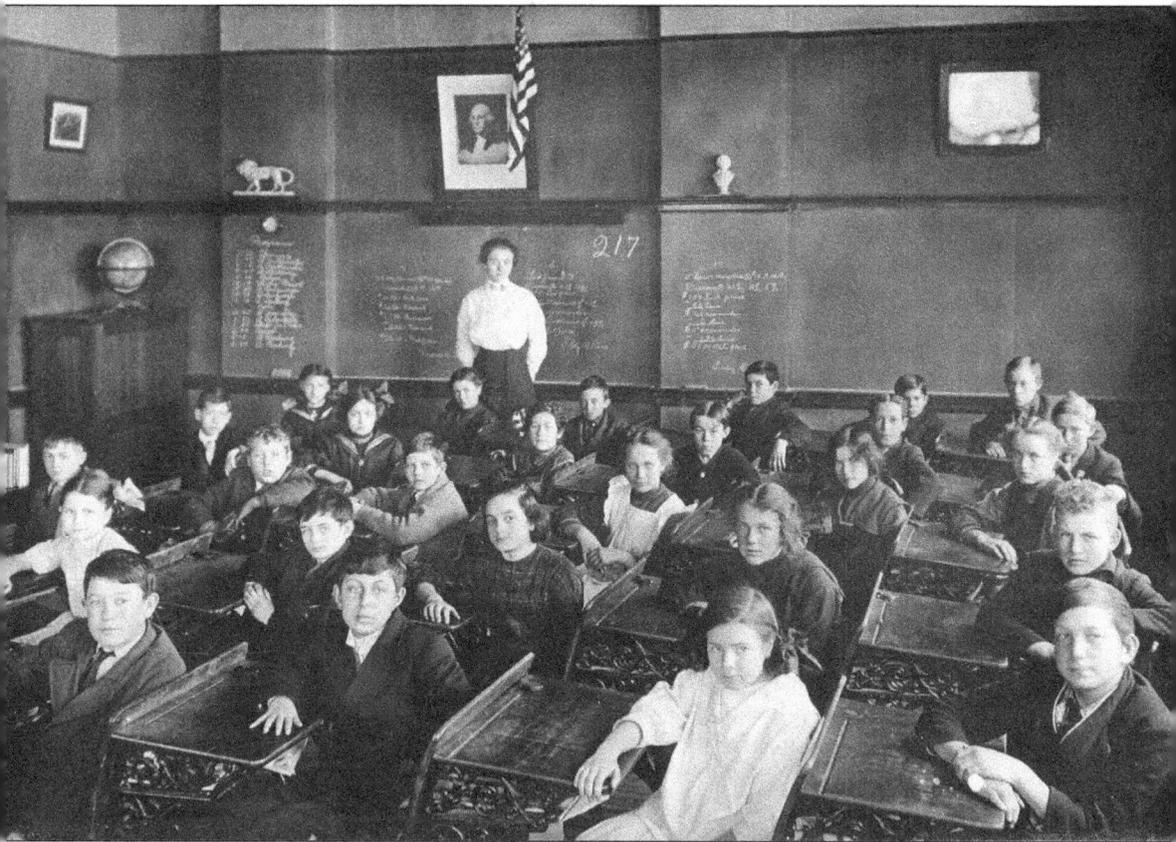

Alice Sarah Bailey is teaching a classroom of sixth-graders around 1913. Trenton schools only went to the 10th grade. If a person passed that grade, it was enough to become a teacher. By going to Detroit and taking—and passing—the necessary exam, future teachers would receive a certificate that permitted them to teach in certain grades in Trenton. Female teachers were not allowed to be married.

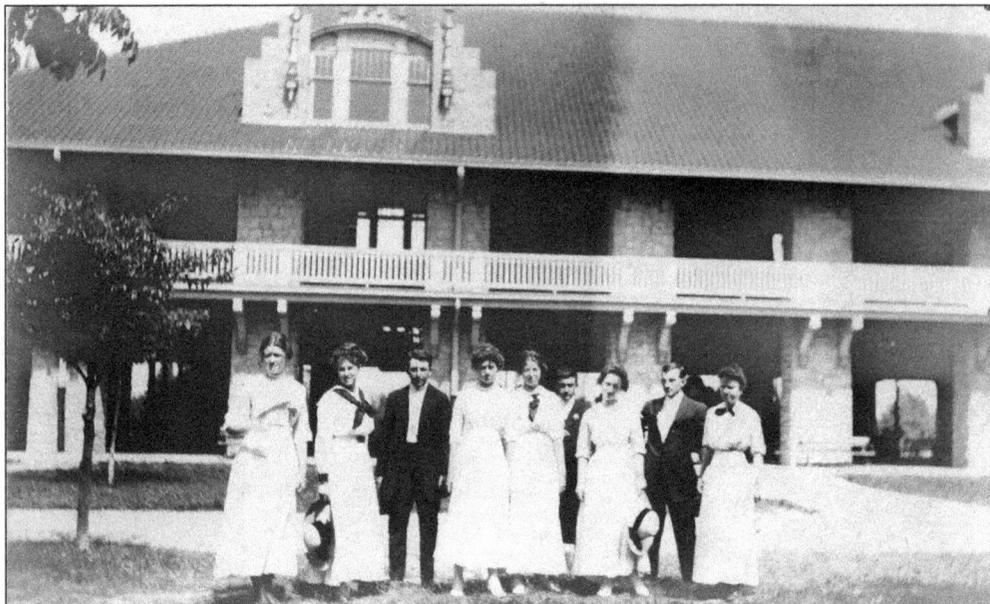

Members of the graduating classes of 1913 and 1914 included the sixth and seventh grades. The photograph was taken on June 14, 1913, at Boblo Park in front of the dance pavilion. Those posing are, from left to right, Esther Fuller (1913), Erna Wiedeman (teacher), George Kittridge (1914), Bernice Reaume (1913), Grace Gillett (1914), Ross Teifer (1914), Irene Beagle (1913), Louis Knaf (1913), and Edna Clawson (teacher).

The first Trenton High School, located at the corner of Third Street and St. Joseph Avenue, graduated one student its first year in 1903. From 1900 to 1924, the high school graduated 116 students. (Courtesy of Claud Owen.)

Teachers in front of the Strohm School in 1937 include, from left to right, Eva Brancheau Fuller, Linne Jo Bernum, Em Wiber, Margaret Westphal, and Betty Mergle Stevens.

Trenton now has four public schools totaling more than 3,000 students. The schools are Anderson Elementary School, Hedke Elementary School, Arthurs Middle School, and Trenton High School.

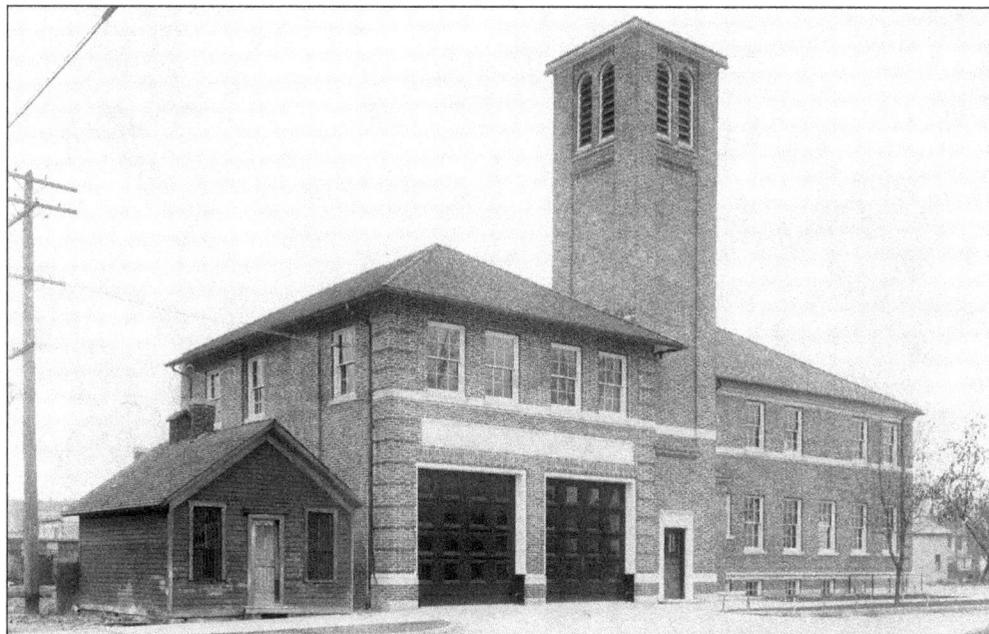

The village jail, attached to the left of the firehouse, was a two-bunk building with doors on the front of the cages. In 1927, the jail housed troublemakers as well as the fire hose. It remained the jail until the municipal building was completed, and then it was torn down. The *Trenton Times* wrote on March 30, 1930, "While under investigation and waiting in the Town Jail, one man, W. [?] 'broke jail' by climbing up on the steel cage, then to two tables that he had placed one on top of the other and out through a scuttle hole in the roof, to liberty. A hunt for him was started immediately."

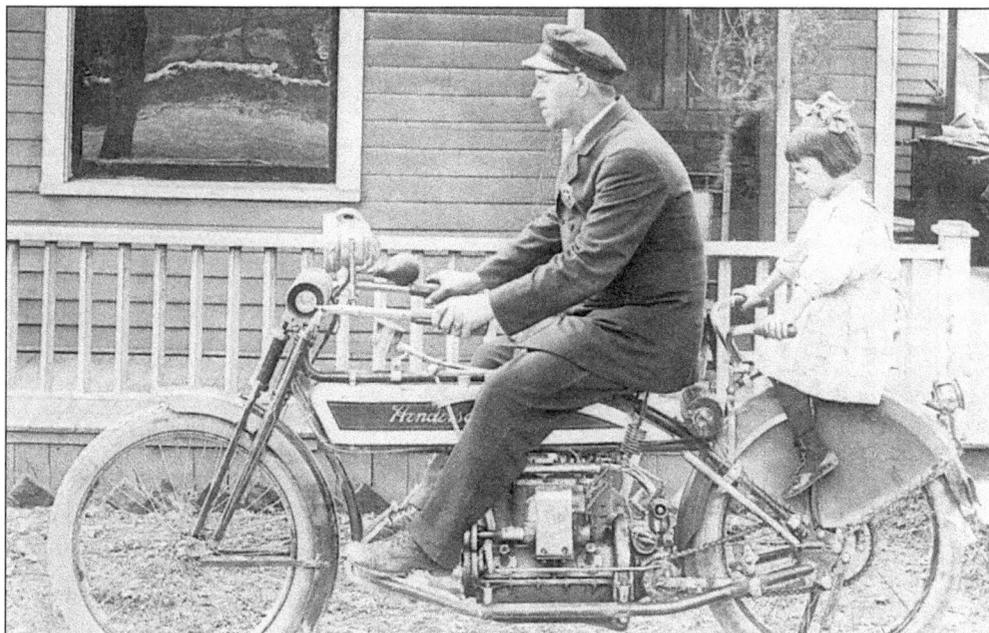

The police opted for motorcycles for travel around 1916. This photograph shows John T. Labo and his seven-year-old daughter Hazel Labo Eichenhoffer. (Courtesy of Judi and James Holden.)

Retired policeman Wayne Fernelius gives a safety talk to Trenton Cooperative Nursery School students in 1980.

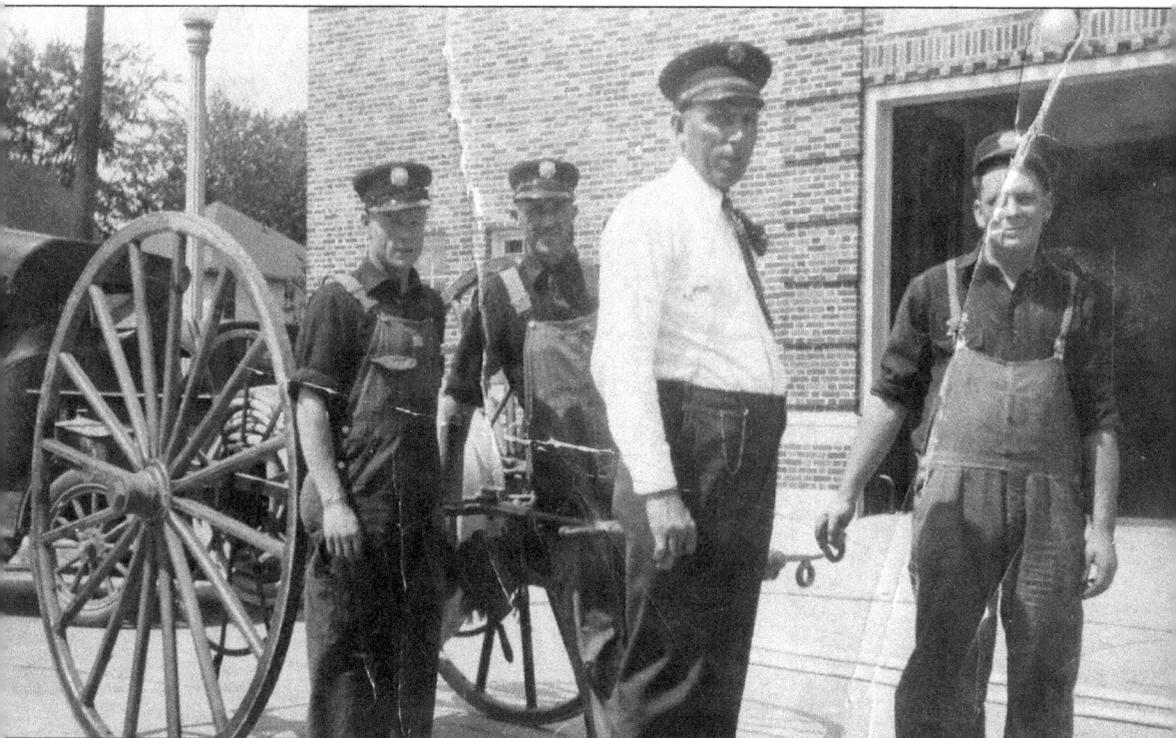

In 1876, the village inaugurated its first water service and soon after was the creation of the Trenton Fire Department. The village council approved "two large wheels mounted on a cart which would be drawn by two or more men." In 1927, the first motorized pumper truck was stored at the Hartrick Garage facility. (Courtesy of Marcy Hartrick Mazza.)

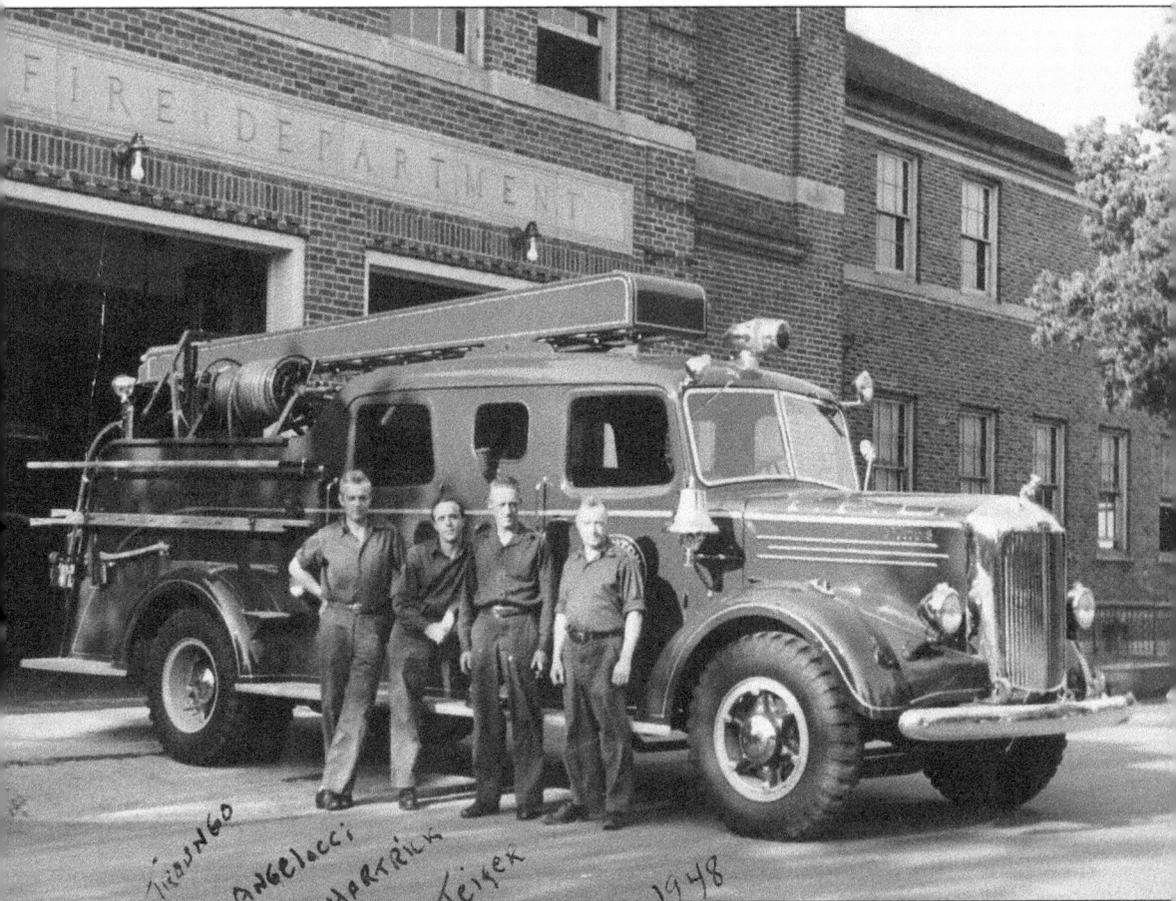

The Trenton Fire Department was officially established as a full-time city force in 1927. A new pumper truck was received in 1948, one of the first new trucks since the 1920s. Standing in front of the fire truck are, from left to right, John Troungo, Aldo Angelocci, Lawrence Hartrick, and Bill Teifer. (Courtesy of Marcy Hartrick Mazza.)

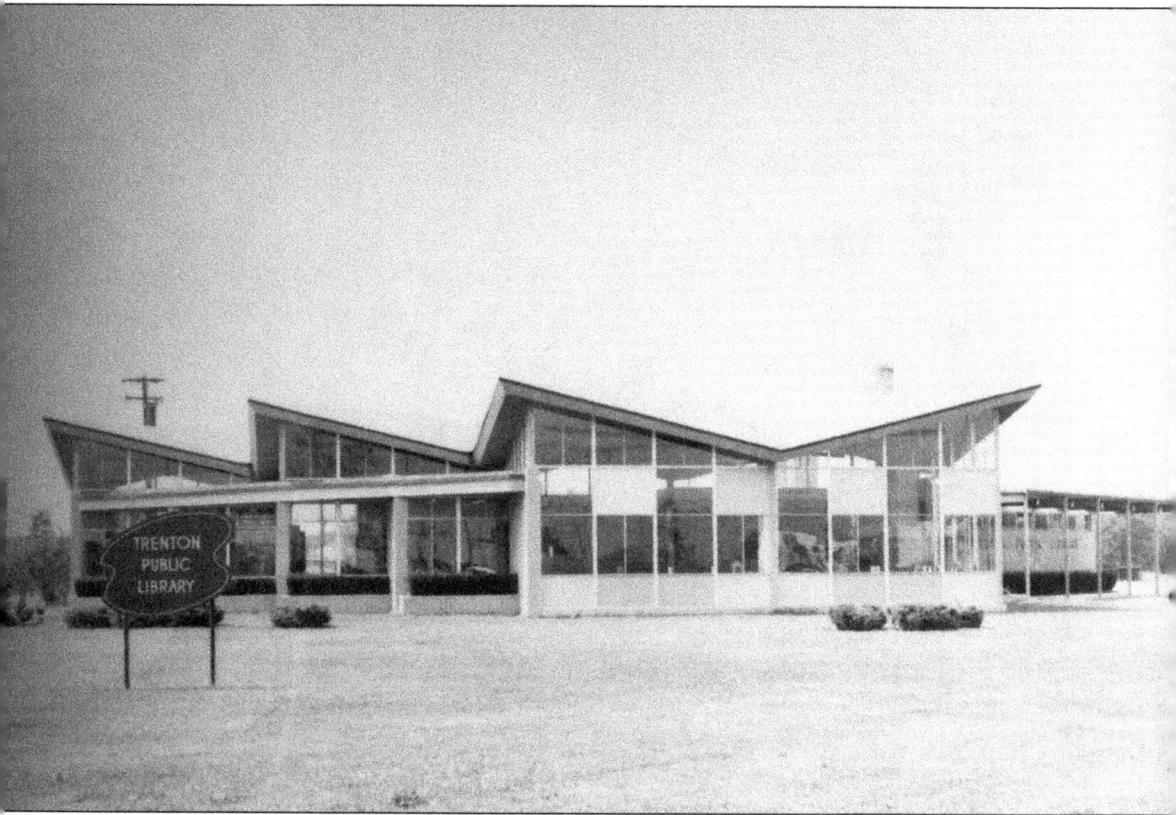

As the village of Trenton expanded, so did its need for easier access to additional reading material. In 1926, a library was located in the basement of the municipal building. The Trenton Library was built and dedicated in 1959 on the corner of West and Westfield Roads. (Courtesy of the Trenton Veterans Memorial Library.)

Eventually, the old library was torn down in order to make way for the new expansion. (Courtesy of the Trenton Veterans Memorial Library.)

The new Trenton Veterans Memorial Library was constructed on the same site. It encompasses 21,000 square feet and has over 90,000 books. Library patrons also have access to computers, e-books, DVDs and CDs, and programming for children. (Courtesy of the Trenton Veterans Memorial Library.)

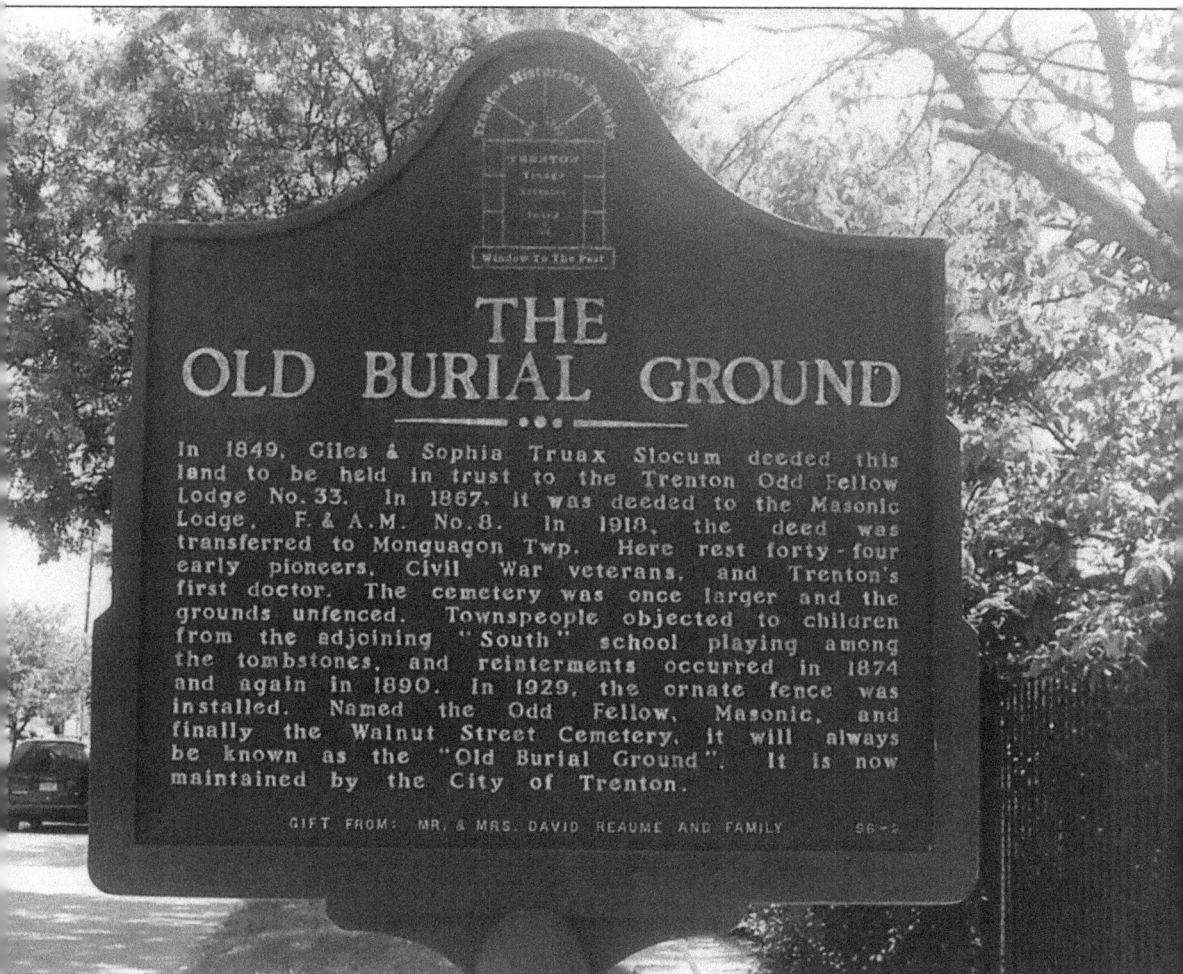

THE OLD BURIAL GROUND

In 1849, Giles & Sophia Truax Slocum deeded this land to be held in trust to the Trenton Odd Fellow Lodge No. 33. In 1867, it was deeded to the Masonic Lodge, F. & A.M. No. 8. In 1918, the deed was transferred to Monguagon Twp. Here rest forty-four early pioneers, Civil War veterans, and Trenton's first doctor. The cemetery was once larger and the grounds unfenced. Townspeople objected to children from the adjoining "South" school playing among the tombstones, and reinterments occurred in 1874 and again in 1890. In 1929, the ornate fence was installed. Named the Odd Fellow, Masonic, and finally the Walnut Street Cemetery, it will always be known as the "Old Burial Ground". It is now maintained by the City of Trenton.

GIFT FROM: MR. & MRS. DAVID REAUME AND FAMILY 96-2

Trenton has three cemeteries. Giles Slocum and Sophia Truax Slocum deeded the land for the Old Burial Ground to be held in trust for use as a cemetery in 1849. In 1918, the deed was transferred to Monguagon Township, and the township gave the cemetery to the Village of Trenton. Eventually, the cemetery was transferred to the City of Trenton. The descendants of the Butler family deeded Butler Cemetery, the family's cemetery, to the City of Trenton. There are approximately 10 graves, the oldest being that of George Butler (1803–1875), who emigrated from England. The Bloomdale Cemetery dates back to the early 1820s, when only a few farmers and trappers occupied the area. Approximately 2,000 people are interred there.

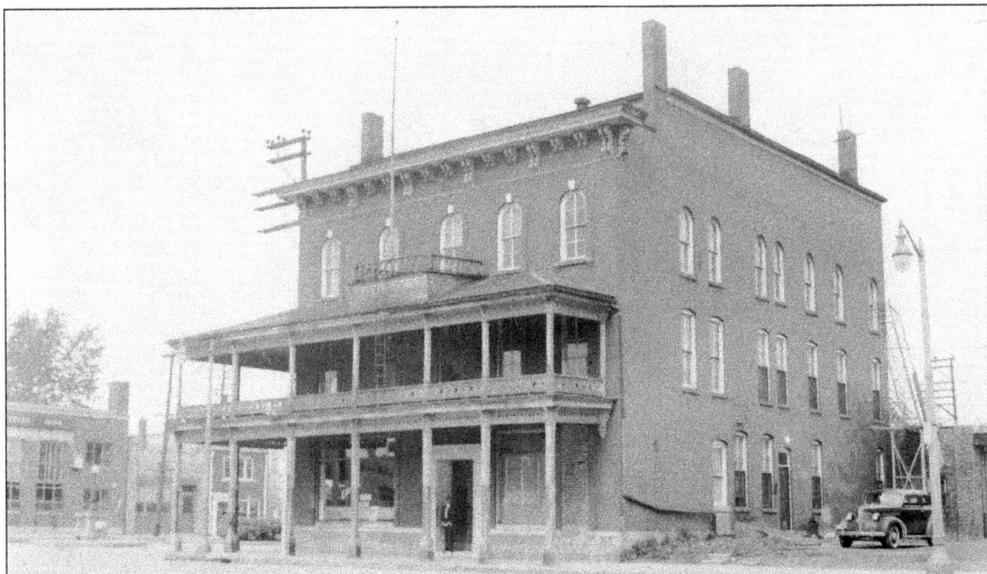

The Trenton Masonic Lodge No. 8 charter was granted on January 11, 1855. In 1863, members purchased Hudson's store and met at this hall until March 1868, when the building was destroyed by fire. In May 1919, the Commercial Hotel on Jefferson Avenue was purchased and converted into a lodge hall. The porches were removed, and the ceilings were raised; the members did most of the work themselves. (Courtesy of the Trenton Masonic Lodge No. 8.)

The lodge hall was dedicated on April 7, 1920, and used until the mid-1970s, when the building was sold and the lodge moved to its present location. In 1955, Trenton Masonic Lodge No. 8 celebrated its 100th anniversary.

In 1971, the cornerstone was laid for the present lodge building. The other side of the cornerstone marks the year the lodge was founded. From left to right are Cornelius Jones, Paul Haviland, and an unidentified person. (Courtesy of the Trenton Masonic Lodge No. 8.)

The Trenton Knights of Columbus was granted a charter on March 29, 1882. The Monsignor Cahalan Council met in various places in and around Trenton. Its new building was dedicated on March 31, 1968. In 1970, the hall was renamed the Monsignor John Eppenbrock Council 3615. Monsignor Eppenbrock, its first chaplain, loved to play euchre, and after the meetings the game was played until midnight, when he always made the men go home, knowing they had families to support and needed to go to work the next day. (Courtesy of the Trenton Knights of Columbus.)

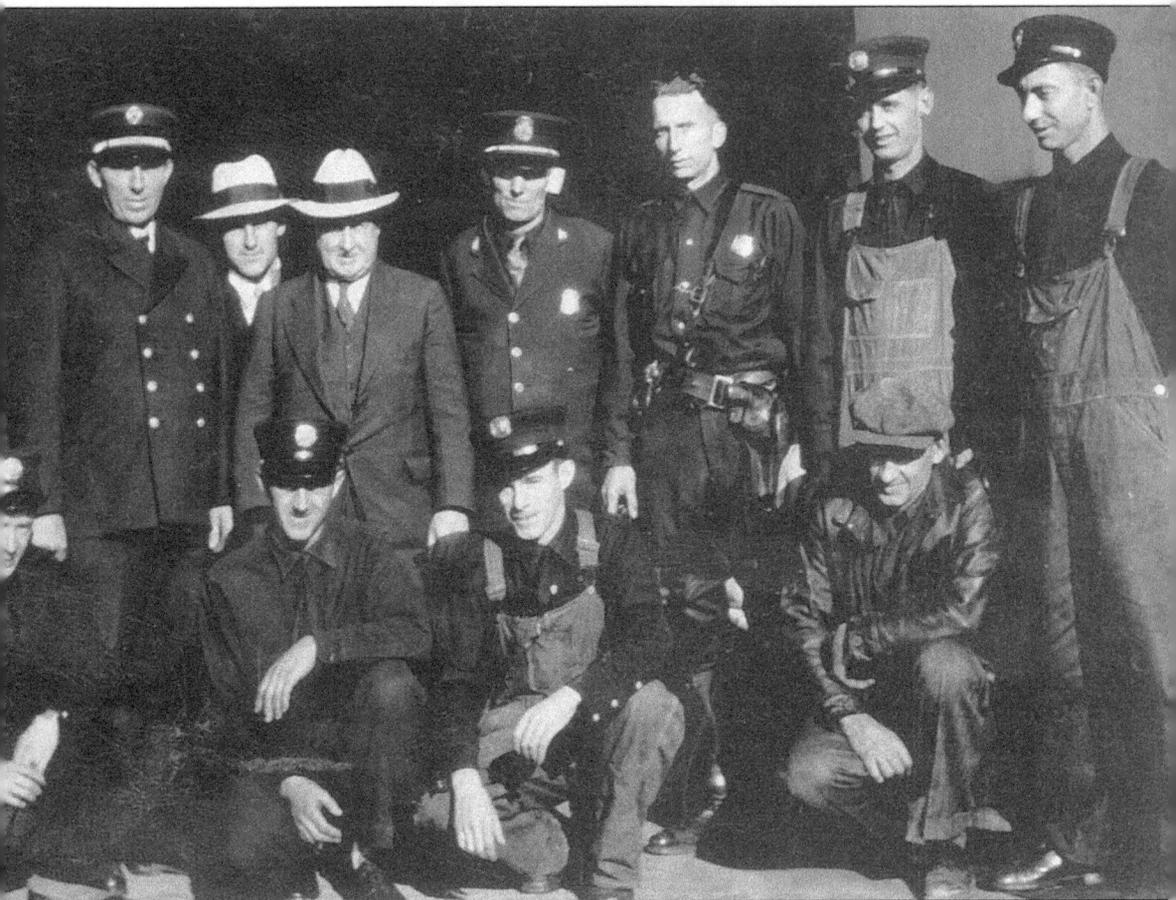

The Old Newsboys Goodfellow Organization began as early as 1911 in Houston, Texas. The group is comprised of volunteers working to ensure that no child goes without Christmas. The work of the Trenton Goodfellows, seen here in 1933, is continued to the present day. Pictured are, from left to right, (kneeling) Bill Teifer, Lawrence Hartrick, Morris Fogarty, and Paul Duchene; (standing) H. Labell, ? Von Moll, William R. Teifer, H. Crooks (police chief in 1933), Napoleon Solo, C. Waldorf, and Leo Mexicotte.

Michigan Prohibition passed in 1916. Residents of Trenton and other downriver communities, being only about two miles from Canada, often tried to bring liquor across the Detroit River to the United States. Enforcement officers were kept busy trying to stay honest and enforce the law. (Courtesy of the Dossin Great Lakes Museum.)

During the Prohibition years, the US Coast Guard maintained a station at the foot of St. Joseph Avenue. The men lived in a barracks built partly over the water with a cement dock on the south side of the building.

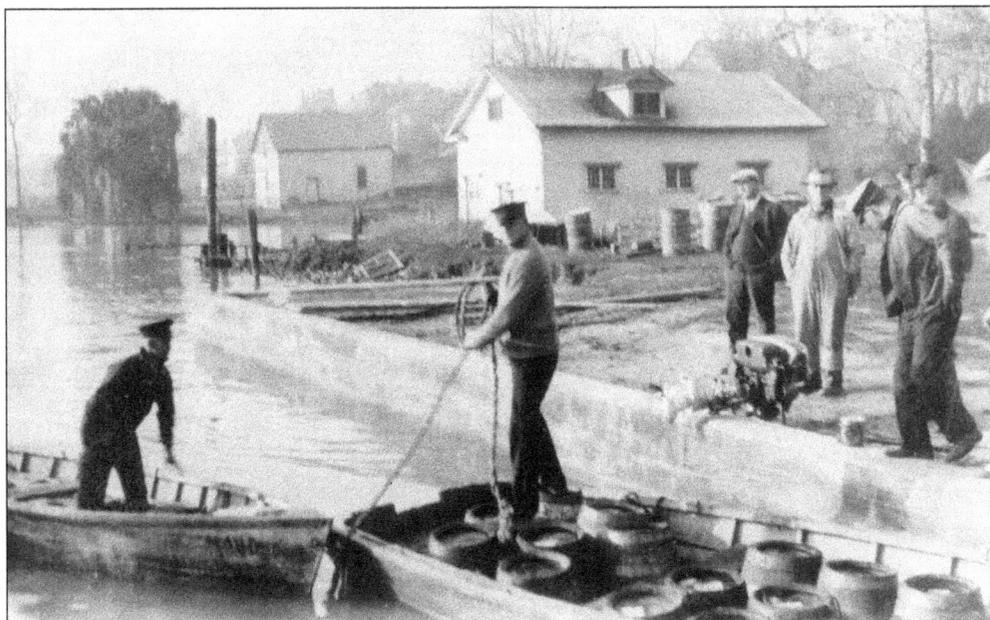

Once the rumrunners were safely across the river, shallow marshes and creeks were perfect passages. The liquor was transferred from a motorboat to a small flat-bottomed skiff, which would float in the shallow water. The load would then be transferred from the skiff and taken by truck or car to its destination. If caught crossing the Detroit River by the Coast Guard, both the boat and the cargo were confiscated.

And for the Ladies, there was the Trenton Ladies Aid. This photograph of the group was taken in 1896. The members are, from left to right, (first row) Mrs. Frank Bailey, unidentified, an unidentified visitor from England, Mrs. Burleigh Keyes, James Bailey, Mrs. Luther Laymen, Inez Ford, Mrs. Arthur Ford, and Mrs. Green; (second row) unidentified, Mrs. L. Turner, Mrs. B. Clago, Mrs. Ira Vickery, and Mrs. Stanford Rice; (third row) Mrs. William Rose; Agnes Armstrong, Mrs. Thrasher Hosess, Mrs. Sandstrom, Mrs. Richards, and Mrs. Hammell.

BIBLIOGRAPHY

Bicentennial Book Committee. *Truaxton, Truago, Trenton.* 1976.

Cleveland, Charles E. *Brief History of Michigan Indians.* Michigan History Division, Michigan Department of State, 1975.

Collins, Gilbert. *Guidebook to the Historic Sites of the War of 1812,* 2nd ed. Toronto: Dundurn Press, 2006.

Dinn, Alan E. *Boats by Purdy.* Easton, MD: Tiller Publishing, 2003.

Farmer, Silas. *Detroit and Wayne County and Early Michigan.* Detroit: Silas Farmer & Co. for Munsell & Company, 1890.

Hines, Edward N. "A History of the River Road." *Motor News.*

Hodge, Frederick Webb, ed. *Handbook of American Indians North of Mexico.* Washington, DC: Government Printing Office, 1907.

Illustrated Historical Atlas of the County of Wayne, Michigan. Chicago: H. Belden & Co., 1876.

Lucy Shirmer Collection. Trenton Historical Society.

Polk, R.L & Co. *Michigan State Gazetteer & Business Directory.* Detroit: The Tribune Printing Company, 1875.

Schramm, Jack E., William H. Henning and Richard R. Andrews. *When Eastern Michigan Rode the Rails, Book 4.* Polo, IL: Transportation Trails, 1997.

Shirmer, Lucy Armstrong. *Snug Harbor, Early Trenton by the River.* Exponent Press, 1983.

Trenton Times. Microfilm 1912–1973. Trenton Historical Society.

www.trentonmi.org

Visit us at
arcadiapublishing.com